GREAT
INSPIRATION

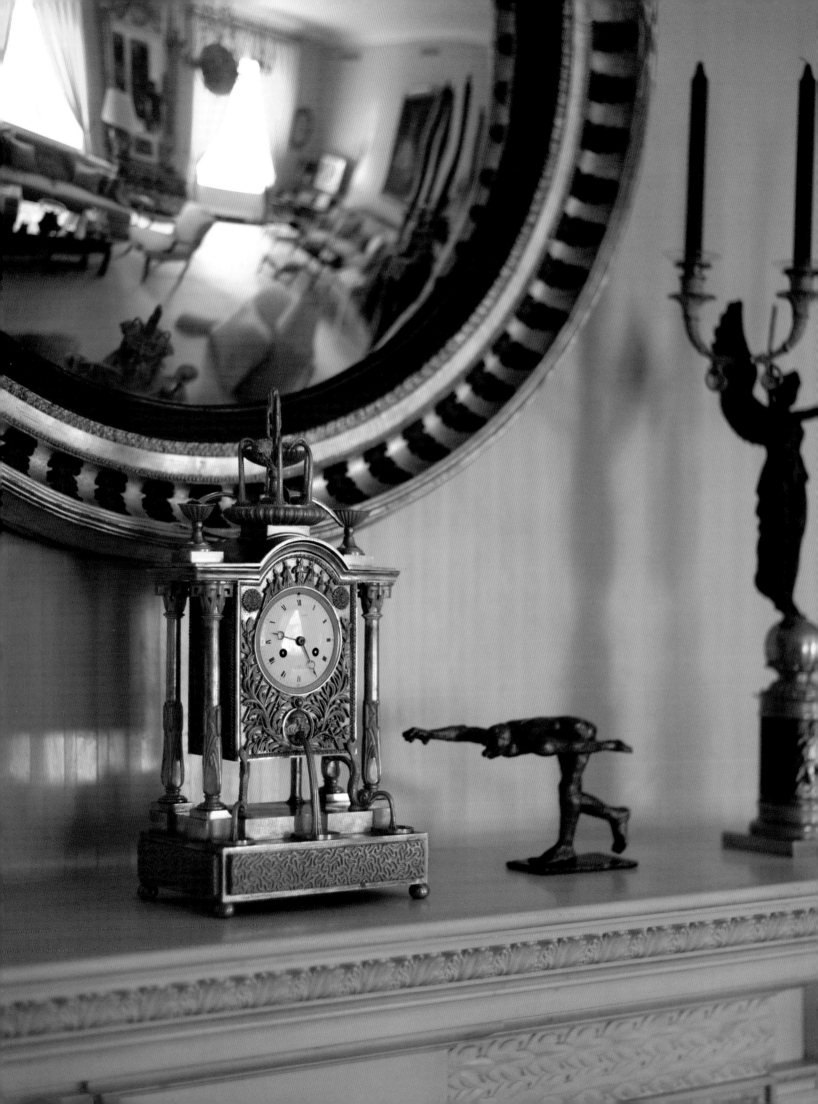

GREAT INSPIRATION

MY ADVENTURES IN DECORATING WITH NOTABLE INTERIOR DESIGNERS

KATHERINE BRYAN

with MITCHELL OWENS

Foreword by ROBERTO PEREGALLI *and* LAURA SARTORI RIMINI

Afterword by GEORGE GURLEY

RIZZOLI
NEW YORK

New York · Paris · London · Milan

CONTENTS

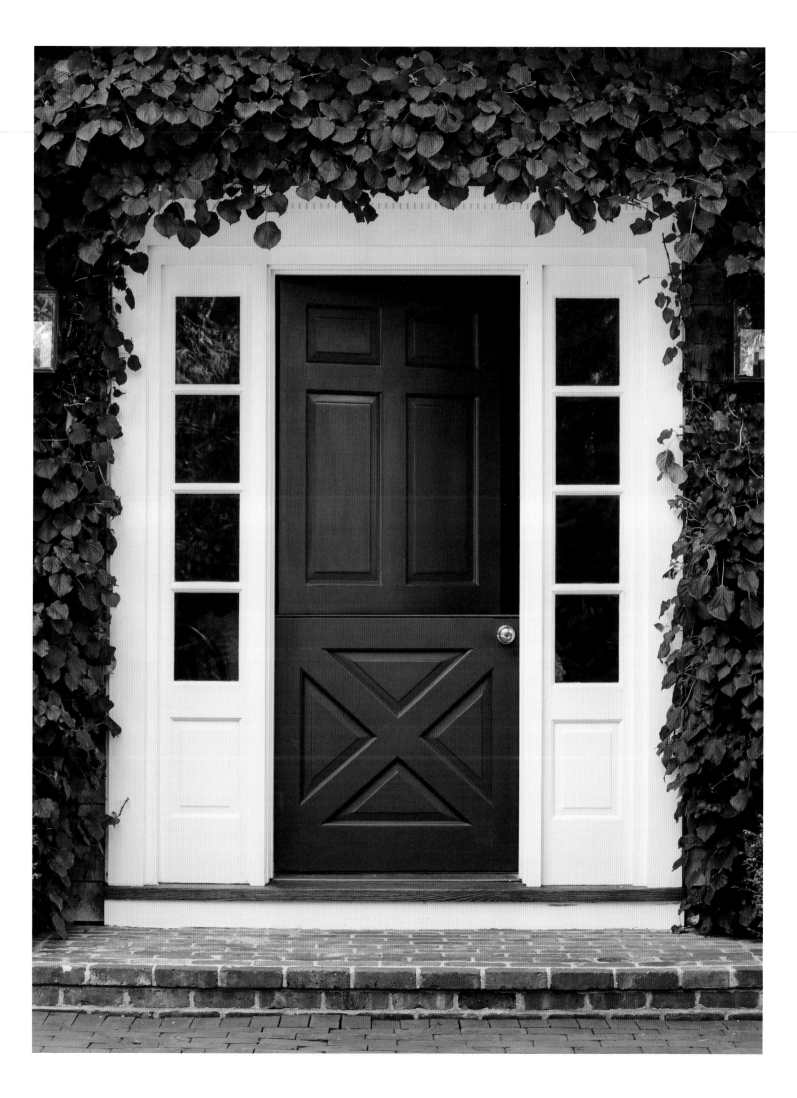

FOREWORD

Remembrance of a Shared Experience

We were in New York on business, and we have a clear recollection of receiving a phone call while strolling in Central Park; it was Katherine Bryan and her husband Damon Mezzacappa, and they asked if we could meet them in the city or, alternatively, in France to discuss a potential project.

Weeks later, when we arrived in front of this eighteenth-century building in one of the most beautiful neighborhoods of Paris, we were struck by the charm it exuded. Some years have passed, but a clear memory of that project remains. Katherine was beautiful, witty, kind, and so in love with Damon and the Parisian flat they had just bought.

Having entered through the door from the rue de Bellechasse, with the former stables on the right, it suddenly seemed as if we had ended up on the pages of Proust's *Recherche* at the residence of the Duchess of Guermantes—it was as if time had stopped. After passing through the cobbled courtyard, a wood-and-glass door at the back led to the main staircase that connects the ground floor to the main floor. Of imposing but pleasing volume, the stone steps and the iron balustrade with the wooden handrail and the high walls in cut stone immediately lent the place a special allure.

From the landing, through a solid double door, you entered the apartment. High ceilings, plaster cornices, period doors, and large windows full of light were the supporting elements. The rest was either in a state of abandonment or the result of hasty refurbishment without sensitivity.

Katherine and Damon wanted a place with a particular ambiance, where they could arrive even at the spur of the moment and find a welcoming environment. We wanted to re-create the atmosphere of a lost Paris, but with a whiff of Italy in the delicacy of the details, without that gloss that French restorations, while admirable, sometimes have. Damon, a true gentleman, was happy to let Katherine make the decisions, but every observation he made was astute and pertinent. He loved Paris because he used to work there, and he loved sharing his passion with her.

We started looking for traces of history, as in an archaeological dream, on the cornices and walls, finding some surprises. We wanted to create a story that

linked the place to the past, with a wealth of imagination. We restored floors from the building's original era and replaced ones that had been installed later. We went around markets and shops with Katherine looking for furniture and objects that would help give the place the atmosphere we wanted.

Once past the entrance—now with its hand-painted wallpaper in an elaborate striped pattern in shades of ivory and black, framed by faux-marble wainscoting and with an ebonized wooden wardrobe with silver detailing against the wall— we entered a windowless gallery leading to the hall. This space, large enough to be considered a room, had no real function, except for passage, when we started. Following our intervention, however, it became, somewhat surprisingly, the dining room, and perhaps the most magical chamber in the house.

We installed a vaulted ceiling and clad the walls with antiqued mirrors cut into squares, which we adorned with a floral motif inspired by Flemish paintings and patterns found in eighteenth-century Spanish and Venetian leatherwork. In the center, a large, gilded iron chandelier hangs above a table inlaid with nineteenth-century floral festoons, this time in a Louis XIV style. The parquet floor and a Cordoba leather screen (which, when opened, reveals the space) complete the effect, in which the light from the salon and the hall reflects on the mirrors to create flashes of luminescence.

In the salon, traces of gilding and a background the color of aged plaster led us to a gray and gold decoration that, illuminated by the sun, took on particular reflections, as in the evening with the aid of candles and soft lighting.

This space is followed, through a large doorway, by a guest room covered entirely in fabric, in which the protagonists are antique Indian *mezzari* framed by hand-painted fabrics and a central niche that houses a daybed. Honoring Katherine's love for our maestro, we created this room as a tribute to Renzo Mongiardino.

Then the bedroom with a floral theme in homage to historic Provençal textiles, and finally the kitchen in period oak and eighteenth-century Portuguese tiles: a Parisian spirit revisited, as if in a dream.

A pied-à-terre imagined as a jewel box, a house that always seemed lived in, even if it wasn't, so that, on arriving from America, a simple bouquet of flowers sufficed . . . *et voilà!*

Roberto Peregalli and Laura Sartori Rimini of Studio Peregalli Sartori

INTRODUCTION

ADVENTURES IN DECORATING

White cotton slipcovers and honey-colored sisal rugs may not seem like earthshaking lessons when it comes to interior decorating, but for me, those two elements were my introduction to the kind of adventures that rooms can spark. I was in my early twenties, living on my own in Kansas City, Missouri, my hometown, and bringing up a young son at the same time I was studying psychology. To be honest, it wasn't so much the slipcovers and rugs themselves that made such an impact. It was the fact that they were seasonal components in the house of a recently made friend, a museum curator who had established a warm, cozy decor that would carry him through fall and winter and then adopted a lighter, fresher wardrobe in spring and summer. Up came the Oriental carpets, down went the sisal rugs; gauffraged wool upholstery in tones of red and blue disappeared beneath the white slipcovers; he even replaced the heavy damask curtains with wooden roller blinds. I had never seen anybody do that before. Since then, I've lived in many houses and apartments—more than twenty at this point—in several cities and states, from Missouri to Texas to New York, and a few countries, including Belgium, England, and France. But that early introduction to the possibilities of rooms, how four walls can embrace many moods—often multiple moods throughout a year, delivering surprises as well as offering an education—has stayed with me. I eventually earned a Ph.D. in psychology, but I think I've also acquired quite a few credits toward a degree in interior decoration.

My Goldendoodle, Jasper, with me in the historic former carriage house where I live in East Hampton, New York. Pine paneling is the backdrop for a decor made up of varied woods brightened by white slipcovers and glints of brass.

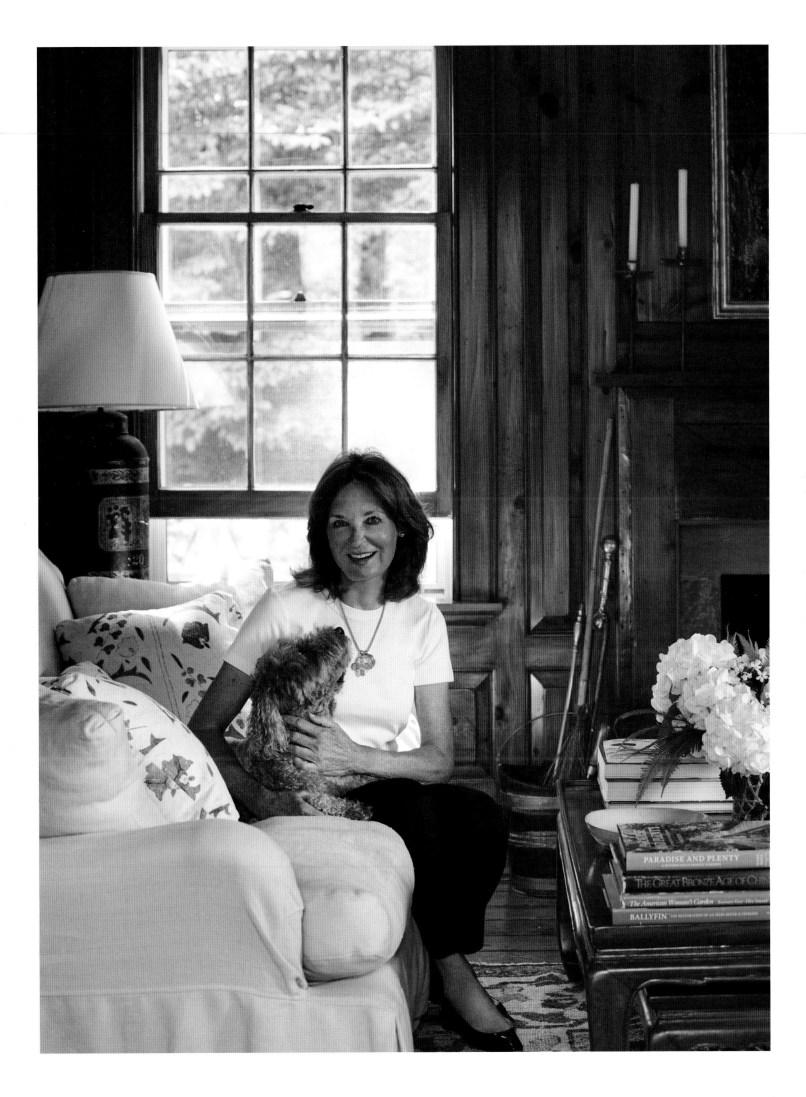

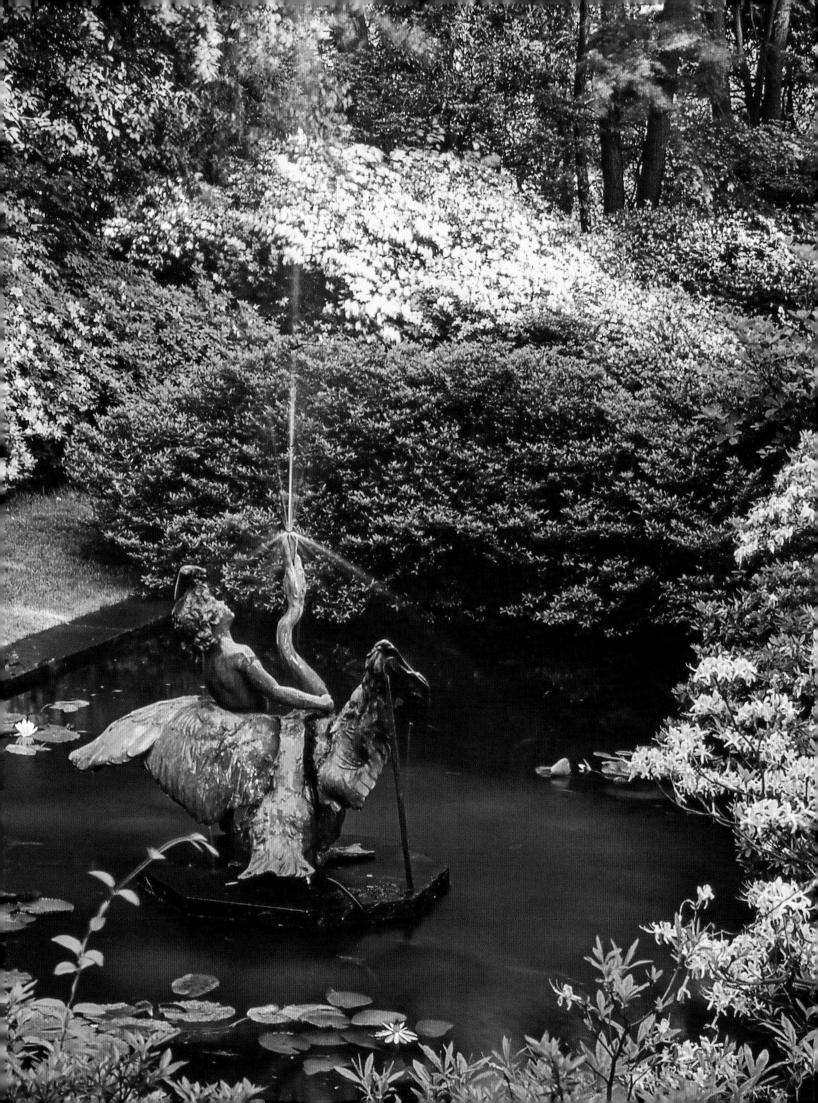

Gloria Vanderbilt, who knew more than a few things about living well and who created some greatly admired homes for herself and her family, once famously said that all decoration is autobiography. The art, furniture, and objects that you live with on a daily basis reflect you in three livable dimensions: past, present, and, presumably future. *Great Inspiration* is a memoir of sorts, one that takes me from untutored and somewhat puzzled to experienced but still eager. Along the way, I've learned that feathering your nest is anything but superficial. It is a personal pursuit that fills me with a great deal of pleasure: the searching, the learning, the acquiring, the recycling, the editing, the conversations, the inspirations, and so much more. Then there are the partnerships, the collaborations with interior decorators—for me, that means Tom Britt, Mark Hampton, Mica Ertegun, Susan Gutfreund, and Roberto Peregalli and Laura Sartori Rimini of Studio Peregalli Sartori—as well as architects, landscape designers, artisans, craftspeople, and contractors. Spouses are an important part of the equation, too. I've been lucky enough to have been married to two men, Shelby Bryan and Damon Mezzacappa, who shared my delight in creating comfortable houses that reflected us and our lives together.

During my childhood, decorating wasn't so much an act of creativity as a template to follow. Kansas City was and remains a place of culture and beauty, as so many Midwestern towns and cities are, where founding fathers and mothers opened museums, pursued collecting, commissioned handsome houses and gardens, and oversaw the development of tree-lined neighborhoods such as Mission Hills and the Country Club District. A lot of first-time visitors, especially people from the east and west coasts, can be shocked by how attractive that part of the country is and how rich its cultural institutions are. That being said, the decoration of those houses—Tudor Revival, Colonial Revival, Neo-Georgian, and the like—was very English, at least among my parents and their friends. They tended to follow a particular format. Every dining room had its Oriental carpet, every library had a tall secretary with a fall front, and we all slept in four-poster beds or, if we didn't, we wanted to. Fabrics were either solid damasks or cheerful florals or toiles, with some steadying stripes in the mix. Modern art was appreciated but seldom incorporated in decor.

My parents' house in Mission Hills, where my siblings and I spent our early childhoods, was similarly decorated to most houses we knew. It was very comfortable but understated. My mother was an independent thinker and a huge influence on me—she earned a master's degree in art history when she was sixty-five—but her taste was pretty conventional, despite her being open-minded. Her

OPPOSITE *Garden design is as much a passion for me as interior decoration. A bronze swan fountain centers the azalea garden at our former house on Feeks Lane in Locust Valley. To create a greater sense of calm, I had the existing multicolored planting scheme reduced to largely white varieties.*

family house, Price Villa in Atchison, Kansas, was built in 1872, and she grew up a few blocks away in a large, redbrick Victorian house. It felt haunted. Looking back, I can absolutely understand what the pioneering American decorator Elsie de Wolfe was rebelling against when she turned her back on Victorian clutter and dark interiors and embraced neoclassical simplicity and white paint. My mother's childhood house was full of antiques, just not the kind of antiques I was interested in owning.

Soon after I was born, my parents moved to Kansas City from Atchison, about an hour and a half away. That's where they found the house on Morningside Drive, which my mother decorated by herself, following the example of her friends. There were a couple of popular interior decorators in Kansas City, such as Peggy Sloane; she was very talented and admired by a lot of people, including Tom Britt, who

My parents' house on Morningside Drive in Kansas City was as English on the inside— Oriental carpets, brown furniture—as it was on the outside.

would make a huge impact on me, when I first began paying greater attention to decorating. Once you furnished a room in Kansas City, for the most part, it stayed that way for years. Most people didn't give the space any further thought, except maybe to replace a worn fabric or to repaint. It was a very stable world for the most part, straight out of the pages of Evan S. Connell's novels about the Kansas Citians Mr. and Mrs. Bridge.

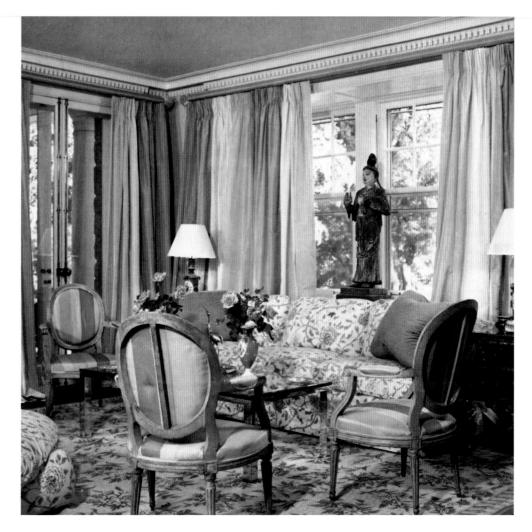

A complete departure from standard Kansas City taste was Millie and Frank Paxton's exuberant house, decorated by Tom Britt with crisp colors, layered patterns, pink lacquered walls, and a combination of wide-striped upholstery and floral carpets. It had a huge influence on me.

A few people broke out of the mold, though. Mrs. Sloane was one, a traditional decorator but with an interest in periods other than just English classicism. There also were women who weren't professional decorators but whom other people watched with great interest: how they dressed, how they decorated, what they collected. Millie Paxton was the primary one for me, a combination of the traditional and the artistic. She was one of Kansas City's style-setters, who had an understanding of Elsie de Wolfe, Edith Wharton, and Rose Cumming. I spent a lot of time at Millie's house when I was a teenager; one because her stepdaughter Margie was my best friend, and another because I didn't like my parents' new country house. My father, who was a real estate developer, bought a large piece of property in the country, and decided we should move into a log cabin–like house there. It was basically a big lodge, on twenty acres, with a pond, a stable, horses, and woodland; it was an amazing place to grow up but my friends, everyone I knew, were forty minutes away.

Decoratively speaking, though, the house offered very few options; the interior was just as much of a log cabin as the exterior, with a huge ponderosa pine tree trunk beam cut in half (six feet wide) that formed a catwalk across the living room into the middle of the big stone fireplace. My mother just ignored the architecture and used the English-style furnishings that we had in the city and amplified that with more of the same. It wasn't my favorite place to live, largely because I missed being with my contemporaries in Kansas City. I loved being with my parents during the week but preferred to be with the Paxtons during the weekends where I was with my friends; their house was a place that welcomed me unreservedly. Tom Britt, another Kansas City native, had decorated it, and its impact and its lessons have stayed with me my entire life. It was unlike anything any of us had ever seen.

Anybody familiar with Tom's work knows that his schemes have always had great drama, the effects as bold as his own personality. His decors don't just catch your eye; they swagger. Millie's house was no exception. For her and her husband, Frank, he conjured up sunny rooms that were filled with soft pink flowered chintzes and carpeted with dhurries that were woven in India—one of his clients was the maharani of Jaipur—to Tom's specifications and in his hallmark brilliant

My father sold the Morningside Drive house and moved us to a log cabin outside of Kansas City. It was a paradise—with stables, a boathouse, a pond for ice skating—but I felt isolated from my friends closer to town.

Decorator James Ruddock and four of his clients in a 1980 Town & Country *article, photographed at my first Manhattan apartment. I'm at his right, with Carey Clark, Averil Meyer, and Kathryn McGraw.*

palette. Vivid yet welcoming, it was the perfect background for Millie, who was very blonde and very glamorous but also very relaxed and, for me, hugely inspiring.

Strangely, though, my admiration for Millie's house didn't carry through into my own first house, where I lived with my son George. I pulled together what seemed fresh and current at the time, and with the advice from my curator friend, we put together a wonderful environment. I bought two of Marcel Breuer's Wassily chairs, a secondhand Eero Saarinen dining table, an antique Louis Vuitton trunk to serve as a coffee table, and a Flos Toio floor lamp, and also had curtains made from paisley-printed Indian bedspreads. A Pop Art poster advertising *The Paris Review* hung on one wall. There was also an English chest of drawers that had been a wedding present, and my mother gave me an Oushak rug. Potted and hanging plants in an adjoining sunporch were part of the decor, too. I loved that house.

Eventually, I decided to complete my doctorate in psychology in Manhattan, and I found an apartment on East Sixty-third Street. I left pretty much everything behind in Kansas City and started fresh. Architecturally, the apartment was nothing special, with shoebox rooms and eight-and-a-half-foot ceilings. At first, I worked with James Ruddock, an up-and-coming young guy whose life partner, a psychiatrist, was one of my professors. He upholstered my resale-shop sofa in a Brunschwig & Fils print and worked with the few things that I brought with me. It was very basic, but I was just happy that I had a comfortable place for George and me to live. That

My sons Austin and Jack Bryan in our Manhattan apartment. It was a family base for years, no matter how many times we moved. Vitruvian-wave (detail below) and Greek-key borders, hand painted under the direction of Tom Britt, gave the living room architectural order.

being said, I kept thinking about Millie's house, so I called Tom Britt, who indeed is the foundation on which *Great Inspiration* is built. He taught me so much, primarily that all decorating is built on ideas, and that fantasy is a huge part of the equation. The main thing he did at the Manhattan apartment was to divide the L-shaped living room, putting up a wall to make a small but proper entrance hall, and adding another wall, with double doors, to create a third bedroom. He placed a dining table at one end of the living room, next to a window, where we could have meals and look down at the building's garden. He also brought in a number of elements that gave the living room more of a presence than I could muster on my own, like two big four-by-four mirrors in black-and-giltwood frames that gave the illusion that the room was bigger. A simple gesture, but it transformed the whole apartment.

Tom also transformed the white living room with shades of blue, creating a virtual wainscot that was pale blue above and darker blue below. The bands of color were separated by a painted border with a Greek-key motif, a sort of a faux chair rail. At the ceiling, where there was no cornice, Tom installed another painted border, this one with a classical Vitruvian-wave motif. Even from the

moment when the paint was being brushed on, the apartment felt better. It felt dignified but also had a sense of cheerfulness and invention. Except for the construction of the walls, Tom's work was all about the magic of paint and illusion.

Creating the entrance hall was the most important act in the transformation. No longer did you walk straight into the living room when the front door was opened. Instead, you stepped into a small space that served as a place to catch your breath before stepping into the apartment; it provided a pause. In contrast to the living room's shades of blue, Tom had the entrance hall painted in two colors: yellow above another painted-border chair rail, and off-white below. Arrangements of botanical prints gave the space rhythm and pattern, almost the way paneling does. The only piece of furniture was a Régence-style commode with ormolu mounts, over which Tom had placed a wonderful English gilded mirror—a great accent but also highly useful, if you wanted to check your appearance before heading out for the day. Tom's knowledge and his enthusiasm were infectious but his joie de vivre came with a solid

RIGHT Like many old-school decorators, Tom Britt has an immense talent for designing fantastical party settings. Inspired by Georges Bizet's Carmen, he created a Spanish ambiance for the 1984 Houston Opera Ball. Sheriff's deputies were costumed as picadors, and I wore an Oscar de la Renta column of ruffles. Shelby and I are accompanied by friends Sheila and Tom Wolfe.

OPPOSITE For an event I hosted at the historic Southampton Polish Hall, Tom (winking, in the top left image) created a stylized nightclub with rosy lighting and an entrance with striped fabric that evoked the South of France.

education. Who knew that erecting a simple wall could add a sense of graciousness to an unresolved floor plan? I certainly didn't. Or that colors could shape the spaces so formally but without resorting to the use of any architectural elements? Tom is incredibly inventive—he also designed several fantastically atmospheric parties for me in Houston and on Long Island—and helped me visualize the possibilities.

The Orchid Room

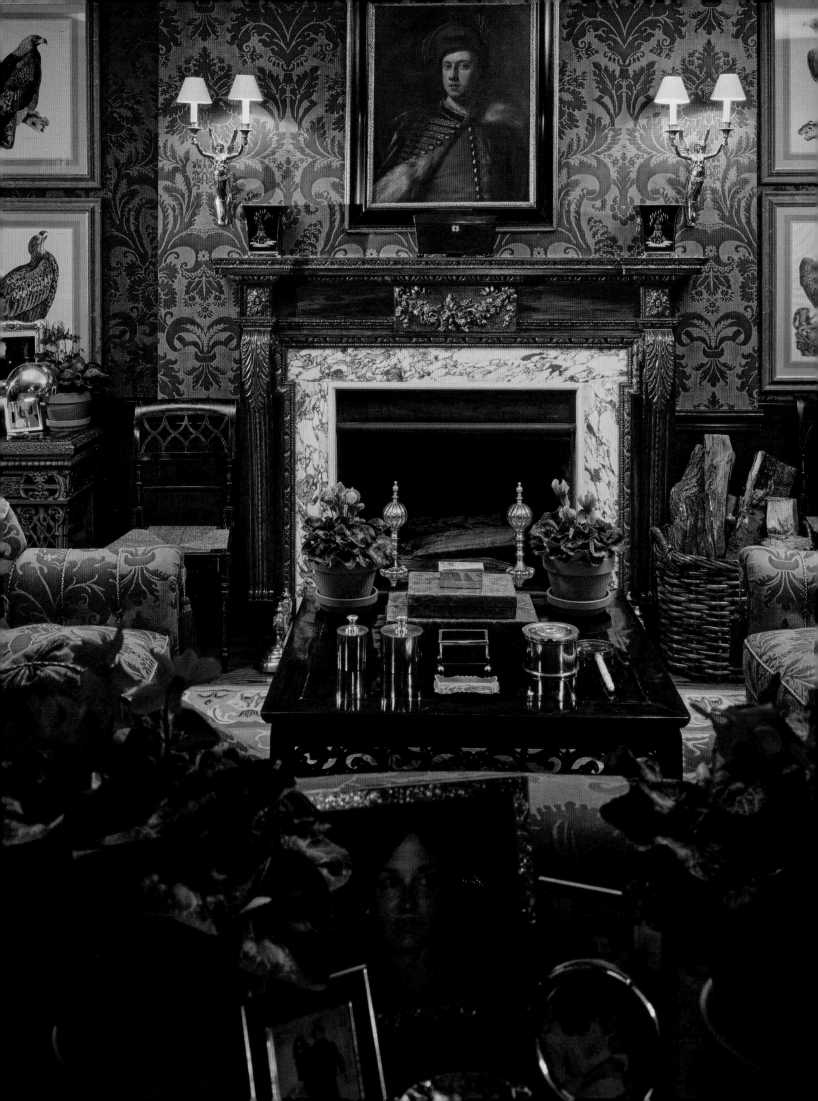

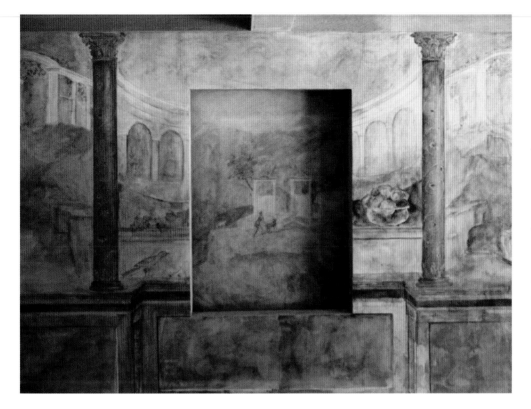

When I married Shelby Bryan and moved to Houston in the 1980s, Tom guided us to another level at our new house in River Oaks, where we felt comfortable not only working with a decorator but also contributing our ideas. I was still mesmerized by Millie Paxton's house, and in Houston, a bit of her style and Tom's trickled in. Everything was much more colorful than the Manhattan apartment, with floral chintzes, scenic wallpaper, blue-and-white ceramics, and, of course, Tom's famous dhurries. The decors weren't entirely me, or maybe they were me, at *that* time. Taste changes or it should, as you learn more and become more comfortable and adventuresome; my taste certainly has. Unfortunately, the Houston house wasn't entirely finished, because we decided to move back to New York for business reasons.

Even though other interior designers came into my life and pushed me in other directions over the years, Tom has remained a close friend, always enthusiastic and always encouraging. Every interior decorator I've been privileged to work with has taught me more than I knew before, and each one has been generous with their time and their ideas even when they weren't formally working with me. Albert Hadley, one half of the legendary Manhattan partnership of Parish Hadley, which had an important hand in the Kennedy White House, drove out to see me on Long Island once just to advise me on what color to paint my living

RIGHT Susan Gutfreund, my longtime friend and decorating cohort, poses with Jasper at my house in Palm Beach.

OPPOSITE My East Hampton living room walls were painted a sunny yellow at the suggestion of interior designer Albert Hadley. An antique Chinese model of a sedan chair centers the mantel.

room, because I couldn't decide. He looked around, saw a painting that I have, and spotted a fresh shade of yellow in it. That was that; the living room would be yellow, we agreed. Decorators come up with solutions and help you to make decisions that will improve your life, give you extraordinary rooms, and help you understand how to make an impact in ways you never thought possible. Susan Gutfreund, who is a close friend as well as an inspiring decorator, has worked with one of the greatest interior designers of the twentieth century, namely the French tastemaker Henri Samuel, and she has a connoisseur's eye when it comes to art and antiques. Susan also looks much more widely than that aesthetic experience might suggest. She once brought me a sample of a floral fabric from IKEA and talked about how great it would look in my living room at the time, covering the walls, the windows, and the furniture, and though I was surprised by the source, I

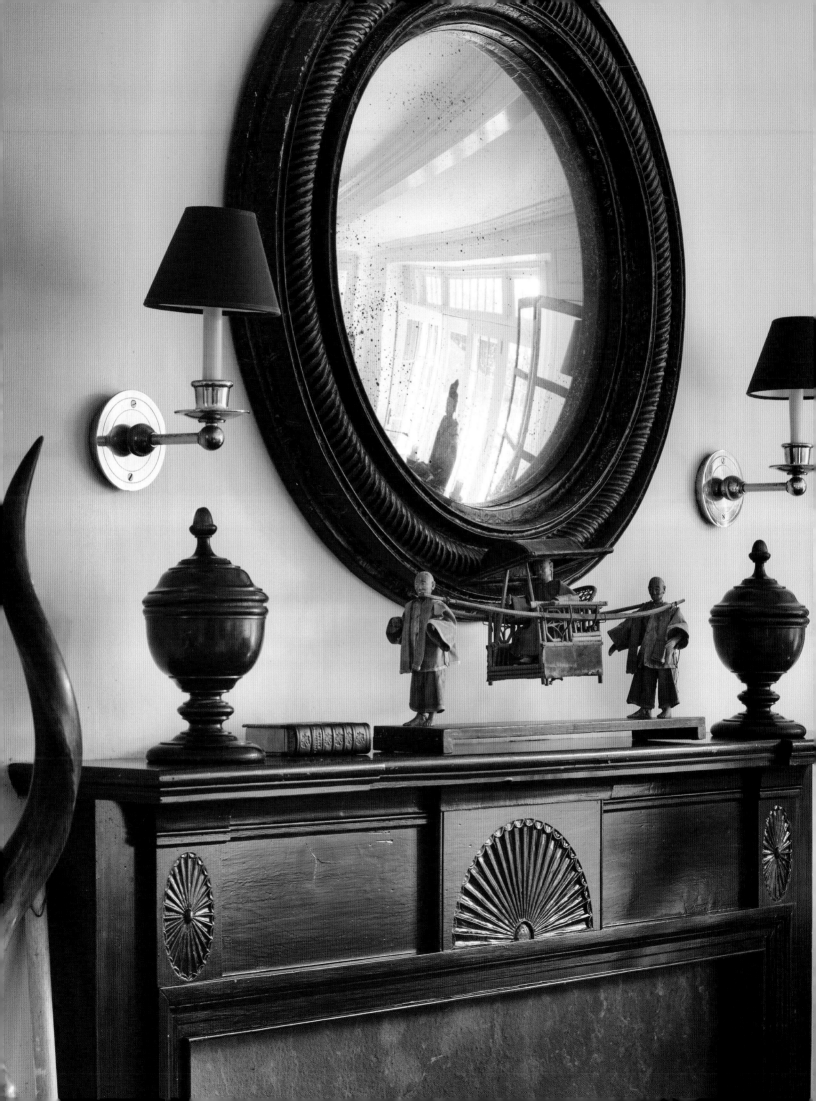

knew she was right. Using such inexpensive fabric in such a lavish way was another unexpected step for me, and by then I'd already been involved in decorating more than a dozen houses and apartments. The learning never stops.

Just as your tastes change and your eye becomes more assured, you want the freedom to explore other associations, to call on other decorators and architects and landscape designers, experts who will bring a different perspective and cause you to

RIGHT At the house Shelby and I rented in Belgium, my friend antiques dealer Juan Portela and I made measurements of each room and sent them—along with photographs—to Mark Hampton in New York. Mark referenced them when preparing furniture plans and ordering curtains and carpets. He sketched ideas for curtain designs onto some of the snapshots.

OPPOSITE The entrance to the main bedroom at the Cartier mansion in Manhattan, where we lived for several years. Mark Hampton decorated it, here using one of my favorite floral fabrics, Roses & Pansies by Colefax and Fowler.

think in a different way. Every house, every room, and every garden offers you the chance to reflect on what came before and what is newly possible, what is right for you and your family at a certain time in life. Mark Hampton, a fellow Midwesterner, was one of those thought-provoking people, one of the most important, in fact. He stage-managed six houses for me, one of them long distance, in Waterloo, Belgium, where his advice was largely followed via fax and photographs on which he had sketched out ideas with a black pen, such as a photograph of a window on which he had quickly drawn a proposal for a curtain treatment. Thanks to Mark, I not only grew increasingly confident but also became acquainted with another side of traditionalism, namely the atmospheric decors seen during the Gilded Age and the Belle Époque, periods with cocooning comforts that turned

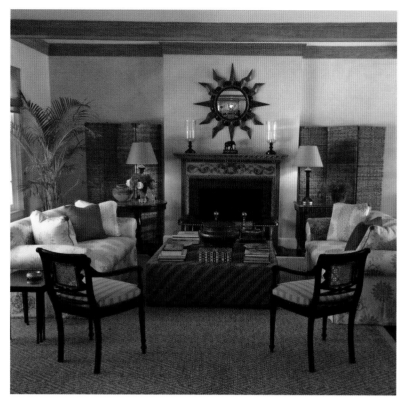

out to be surprisingly welcoming to a growing family—and great fun to shop for. We would also put our heads together on a Shingle Style house on Long Island, one where the warm reds and deep fringes of the late nineteenth century that we had used in one Manhattan town house gave way to the cool clarity of Swedish country style, all whites and blues, checkerboard-painted floors, and garlands of stenciled flowers.

Regretfully, there was one big project that both Mark and I were enthusiastic about but which sadly never got off the drawing board: an early nineteenth-century house in Washington, D.C., that Shelby and I had purchased and planned to renovate. It had previously belonged to Evangeline Bruce, the hostess and biographer of Napoleon and Josephine, and, in addition to the house, I bought much of the furniture that she and her husband, David K. E. Bruce, one of the United States' most distinguished ambassadors, had collected over several decades and had used at their residences in Paris, London, Versailles, and Bonn.

Many of Mrs. Bruce's beautiful paintings and furnishings have circulated through my own rooms, including my current Manhattan apartment. Though we ultimately did not move into that rambling house, I still treasure the sketches that Mark produced and the notes that I scribbled down from our discussions over our three years of planning.

He would sketch a room and create a furniture plan in a manner that seemed instantaneous. Watching Mark at work was like being in the presence of an artist who also was a scientist, a master of the creative and the practical. He could see a blank white space and outfit it in his mind so clearly, and so perfectly, that the sketches he produced for my consideration rarely needed much editing. He knew me and my taste so well that it was easy to accept the schemes he came up with. More important than agreeing with his concepts, though, I paid a lot of attention to how he developed them.

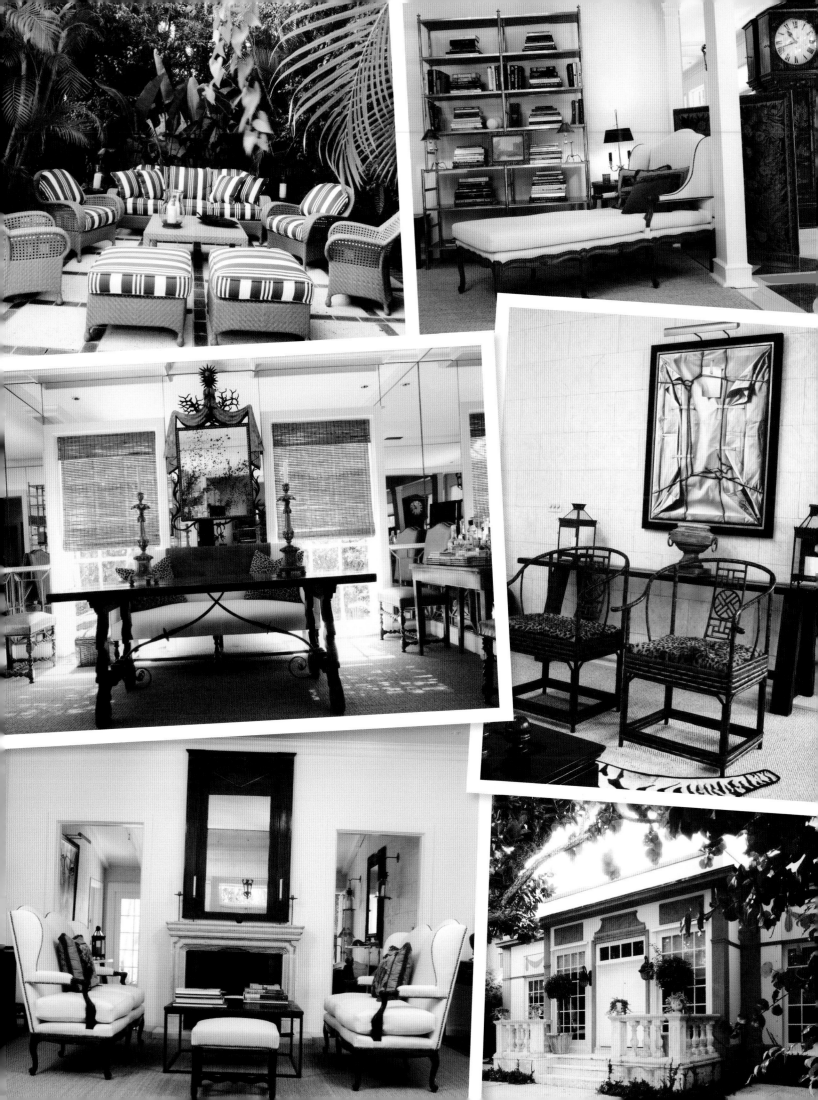

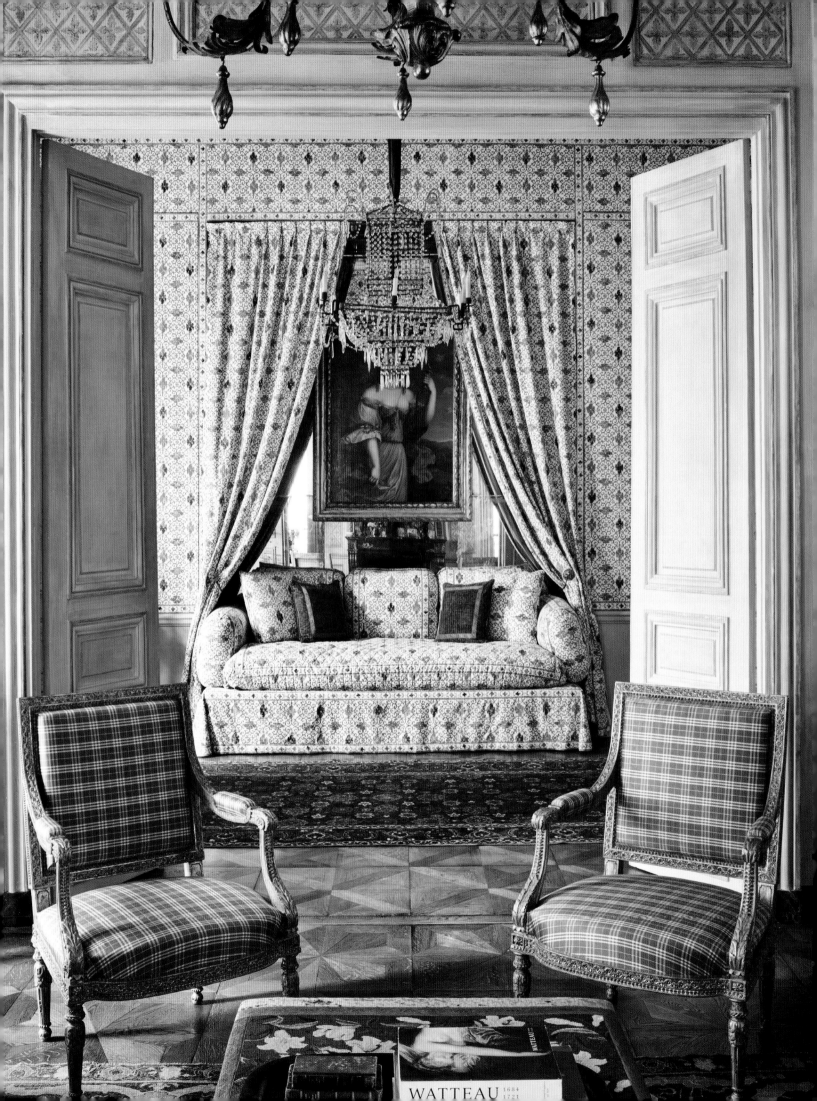

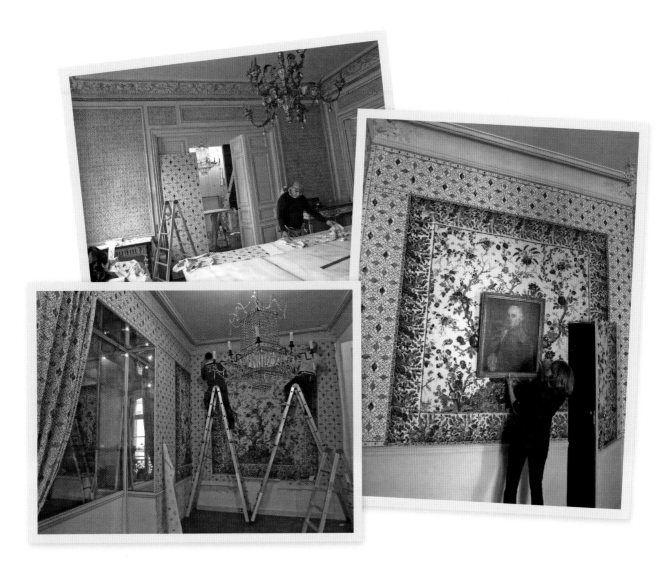

Decorators are teachers, and if you're lucky, you will become a good student as well as a grateful client. Not as talented as Mark, surely, and others, but, after a certain point, you can find yourself comfortable enough to begin creating your own spaces without a lot of advance assistance. Though I treasure the working relationships that I've had with all the designers featured in *Great Inspiration*, I've been able to decorate a few projects without anyone's help, but always mindful of the lessons I've been fortunate enough to absorb: apartments for my sons and an apartment that I have in Palm Beach, as well as a couple of houses there. Even now, when I sit in my Manhattan living room, I'm always pondering what I can accomplish on my own: having the walls painted a different color, ordering white slipcovers that will make the room feel casual rather than formal, and hanging a contemporary work of art in the place of a traditional portrait just to shake things up a bit. That's the joy of decorating: no room is ever finished. ❦

OPPOSITE A view from the salon of my Paris apartment into the guest bedroom. A daybed sits in the mirrored alcove.

ABOVE For the guest bedroom, Studio Peregalli Sartori commissioned artisans to stencil and install a custom-made cotton wallcovering that was keyed to antique textile panels from the dealer Patrick Fremontier.

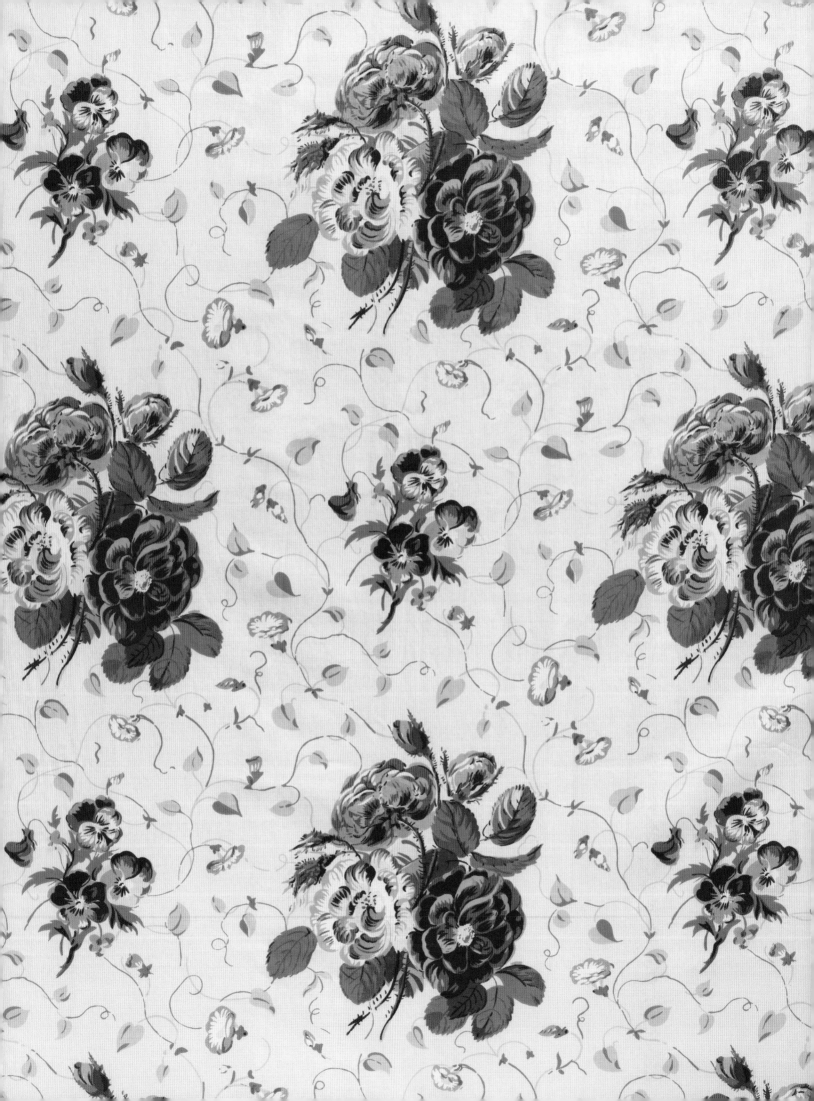

SELECTED PROJECTS

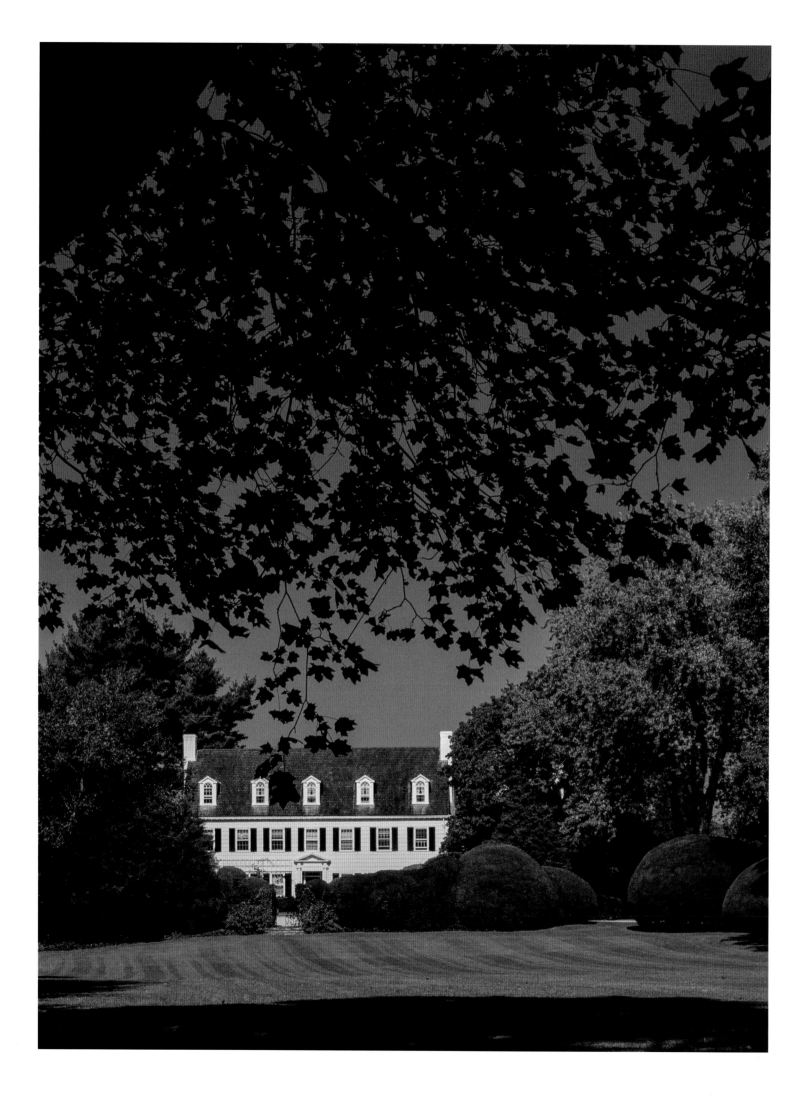

FEEKS LANE

Locust Valley | *1985–2000*

Everything seemed to be in bloom when Shelby and I pulled into the drive of the house on Feeks Lane in Locust Valley, New York. The magnolias were filled with huge pink blossoms. The cherry trees were covered with fluffy pink flowers that look like powder puffs, and roses—pink, red, white, yellow—scented the air. Boxwood punctuated seemingly every corner—each sphere and hedge impeccably manicured. It was one of the most beautiful properties I'd ever seen. I was amazed, and Shelby was stunned. I remember him saying, "I can't believe that we can actually buy this."

We did, and it turned out to be a wonderful family house, as nurturing to live in as it was breathtaking to look at. We were always shaking our heads in disbelief that we had the good luck to live there. Originally built as a farmhouse in the middle of the nineteenth century, it had been handsomely expanded in Georgian Revival style in the 1920s by architect R. Barfoot King, with wings, porches, and sheltering roofs. There was a big veranda at the rear of the house, with a stretch of columns, that reminded me of Mount Vernon. A previous owner planted acres of gardens designed by Noel Chamberlin, who is best known for creating Florida's Fairchild Tropical Botanic Garden. We hired landscape designer Adèle Mitchell to expand the gardens, and with the groundskeeper, we created a paradise of a vegetable garden, which the boys loved.

The late 1980s was a wonderful time in interior decoration in the United States, with many designers being influenced by the comfort, color, and traditions of British country houses. From flowered chintz to Chippendale chairs to polished silver, it was a style that lent itself to the architecture of the Feeks Lane house.

The Locust Valley, New York, house was architect R. Barfoot King's 1920s makeover of a farmhouse for a rayon manufacturer. Its mature gardens, which we edited and augmented with landscape designer Adèle Mitchell, captivated us from our first visit.

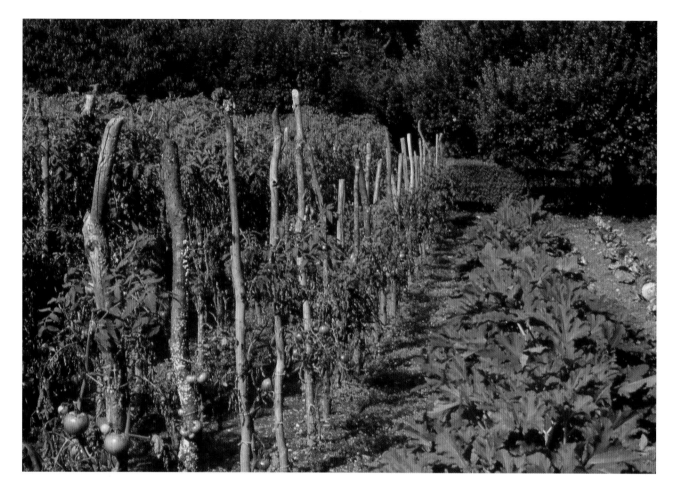

We expanded the existing vegetable garden on the property, which had originally been a working farm. Its produce delighted our children and ended up on our table.

Though Mark Hampton and Mario Buatta were two of the leaders in interpreting that style for American clients, we asked Tom Britt to work on the rooms; for one reason, he had become a close friend, and for another, we regretted that he hadn't been able to complete the house in Houston as we had all planned.

Although the theme for the rooms may have been Anglo-American, Tom didn't subscribe to a formula. He's always been a daredevil of a decorator. Given that the sunlight on Long Island is brighter and clearer than that in the English countryside, the colors had to be amplified, which was one of Tom's hallmarks. We all thought that the backgrounds of the main rooms could be much warmed up, so the vintage pine woodwork in the living room was stripped of white paint and bleached to the color of pale honey. In the library, the paneling had a gloomy stain, so Tom stripped that off, too.

Tom cheered up the entire house. Floral-patterned fabrics echoed the gardens that Shelby had fallen in love with on our first visit. Generous splashes of scarlet added another level of energy in the library and the main bedroom. For years, Tom had been working with artisans in India who made special dhurries, and

he commissioned several of them for Feeks Lane, the graphic overscale patterns a departure from the typical Turkish or Oriental carpets that might have been used by other designers. He based them on motifs found in antique Indian rugs that he had been collecting for years, but reinterpreting them in a larger scale and with bolder colors.

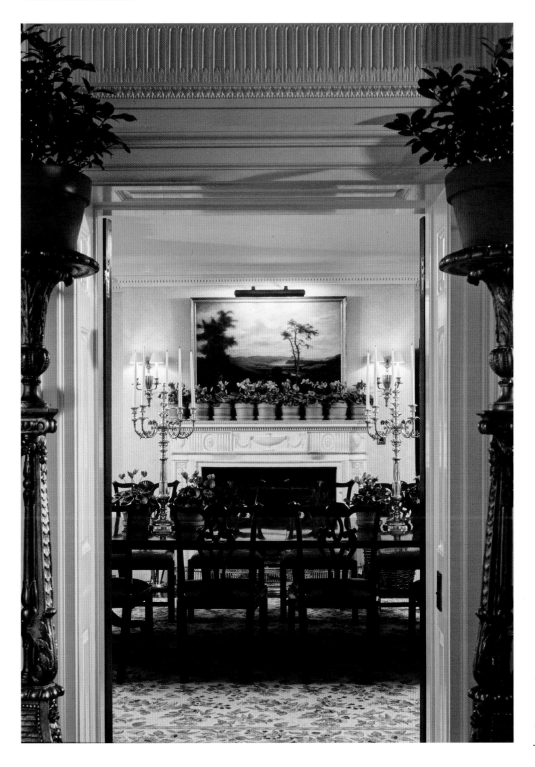

Tom Britt finished the dining room in a cloudy sky-blue and carpeted the space with flowers that echoed the gardens, so that the room almost felt like it was outdoors.

Feeks Lane really was the first house that Shelby and I had together that was fully furnished and completely finished, thanks to Tom, and we lived there for almost fifteen years. Over the years, of course, some details were changed, as my taste matured. The living room's lively chintz ended up being replaced by one of my favorite fabrics from Bennison, which was subtler in palette and feeling. The dhurries were eventually removed in favor of neutral seagrass carpets, which felt more casual and better suited to the countryside. Despite those and other smaller alterations, though, the house still felt the same: comfortable, fresh, and, for all its size, very cozy. 🐝

RIGHT Glicine is a handmade Fortuny pattern that we used in the upstairs sitting room (see pages 46–47). A stylized depiction of wisteria, the fabric's scarlet colorway made the library cozy.

OPPOSITE We used the dining room carpet pattern in the entrance hall, too, a profusion of flowers that further grounded the house in the landscape.

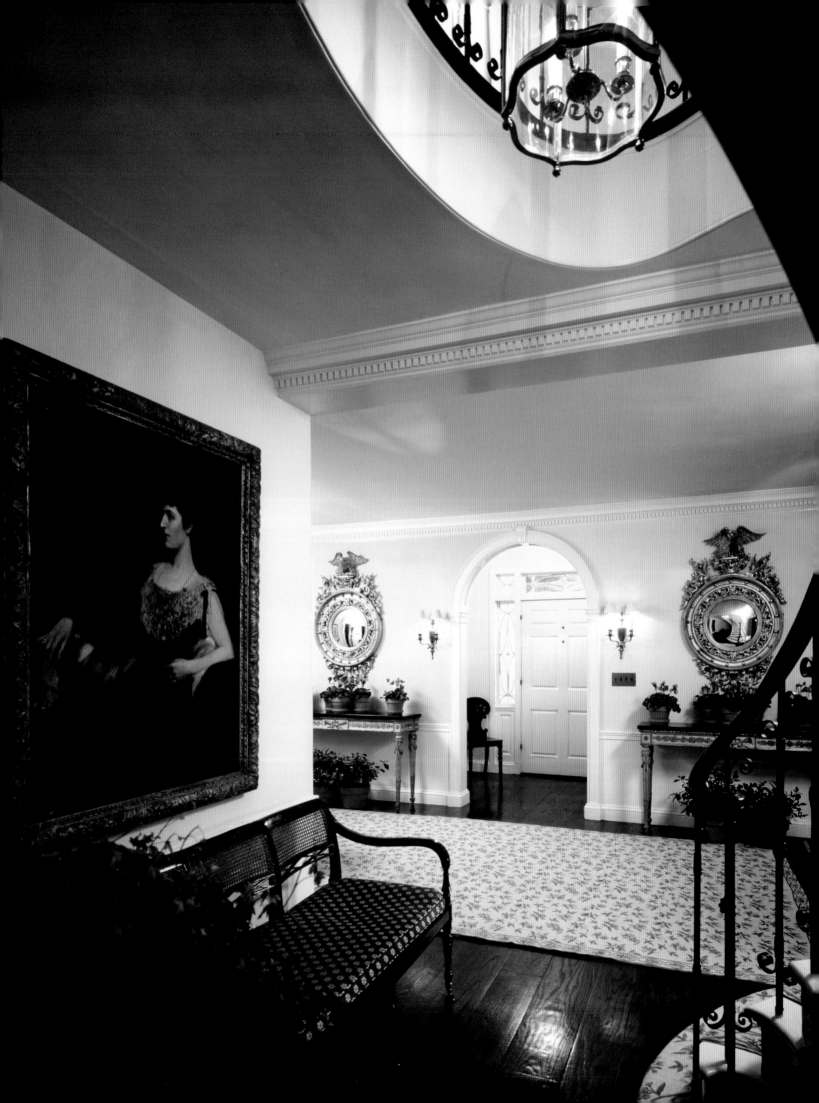

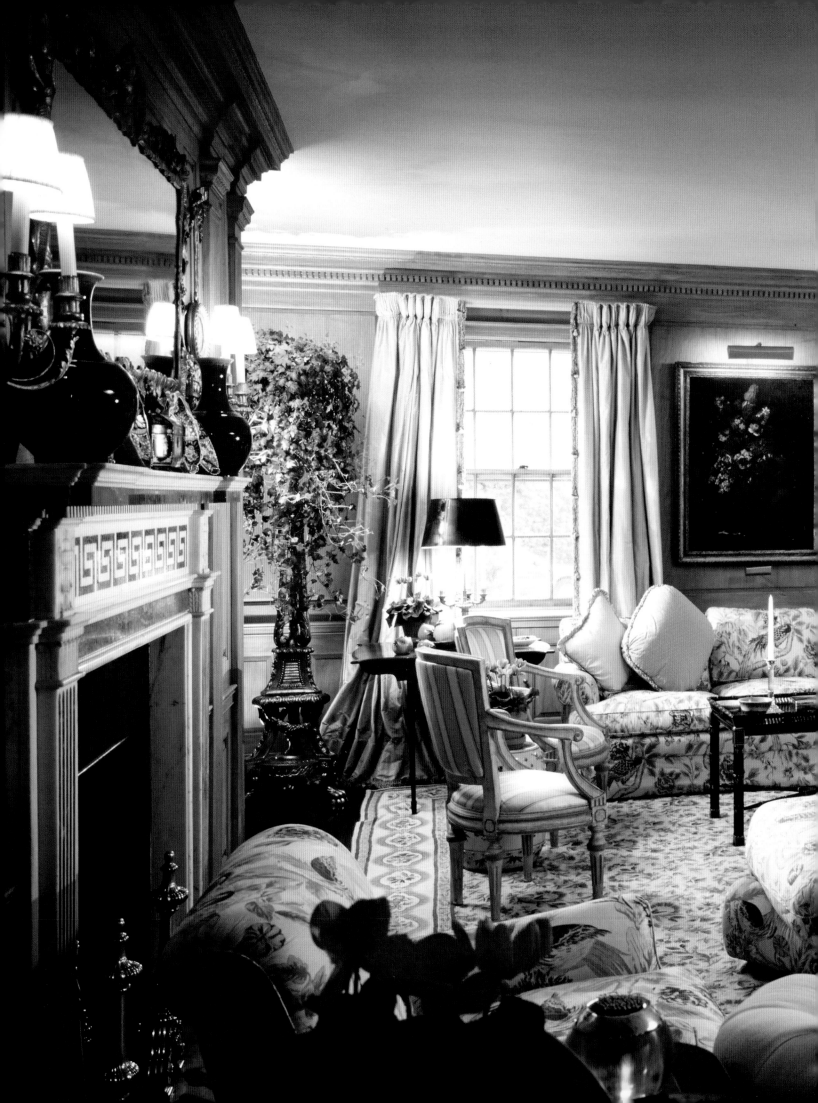

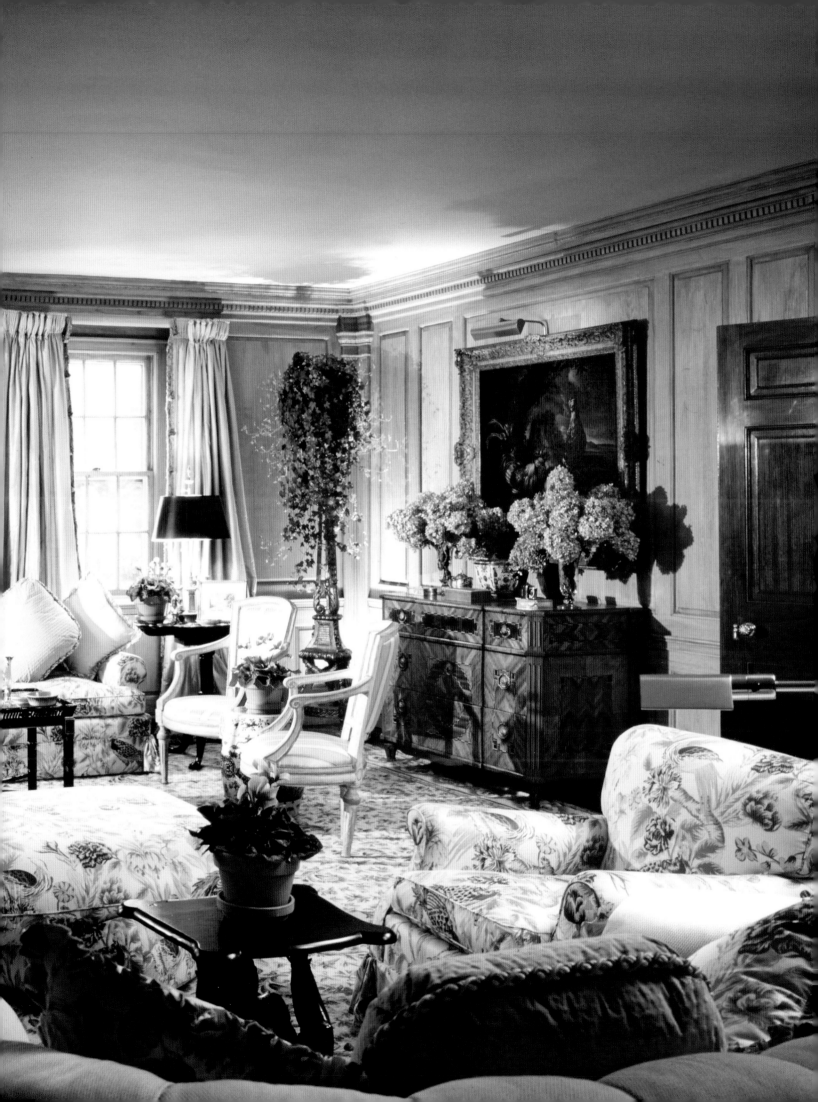

PRECEDING PAGES AND ABOVE *The living room offered Tom another chance to underscore the landscape. He used a similar carpet as in other rooms, but complemented it with a magnified floral fabric for the upholstery, bold stripes, and sky-blue curtains. A previous owner had painted the paneling white, which was too harsh. Tom stripped it back to the knotty pine, which was mellow in tone and more English country house in feeling.*

OPPOSITE AND FOLLOWING PAGES *Tom's fanciful take on Anglo-American traditions resulted in a vibrant library. Shots of black leather and lacquer clarified the saturated colors and patterns. Tom removed the dark stain of the paneling and then further lightened the wood.*

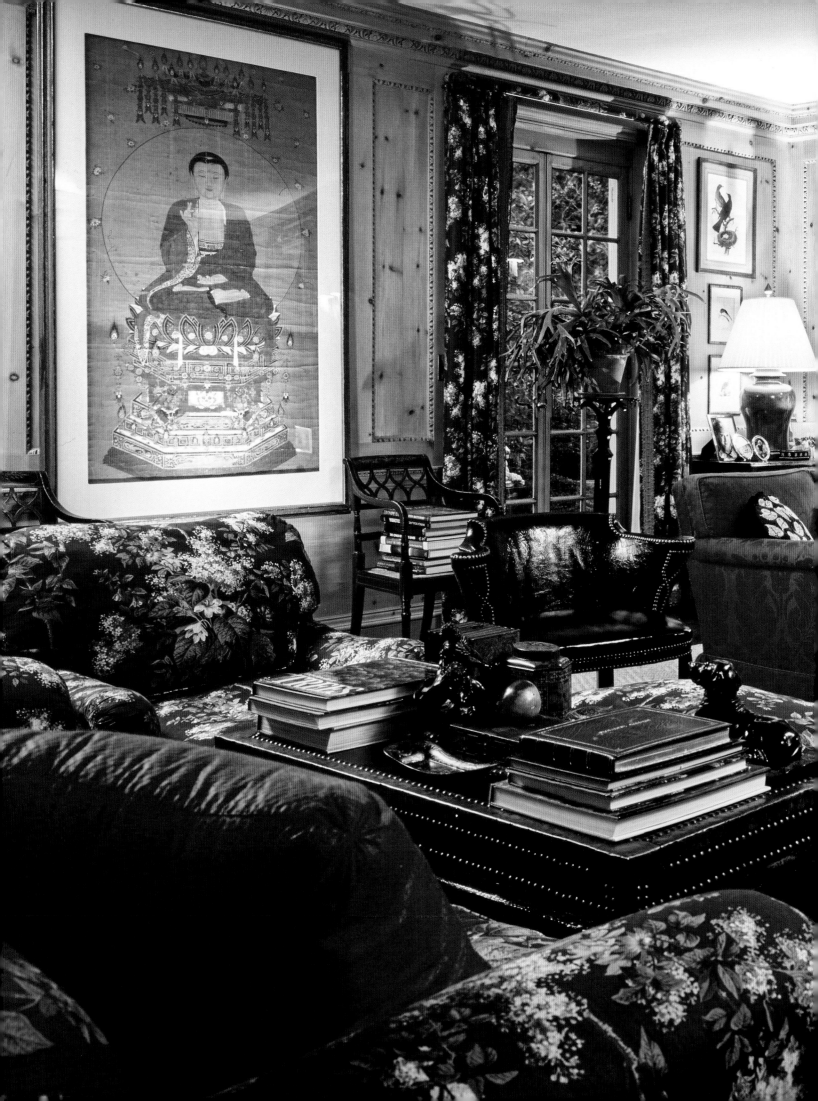

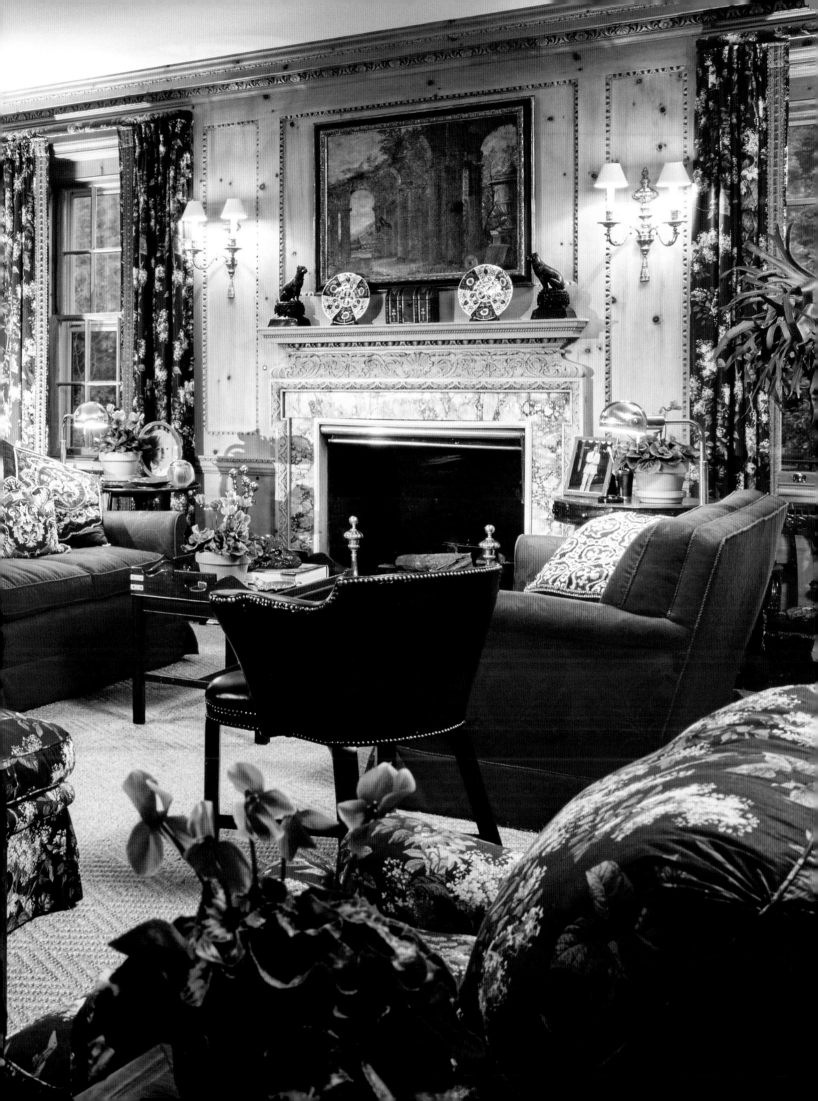

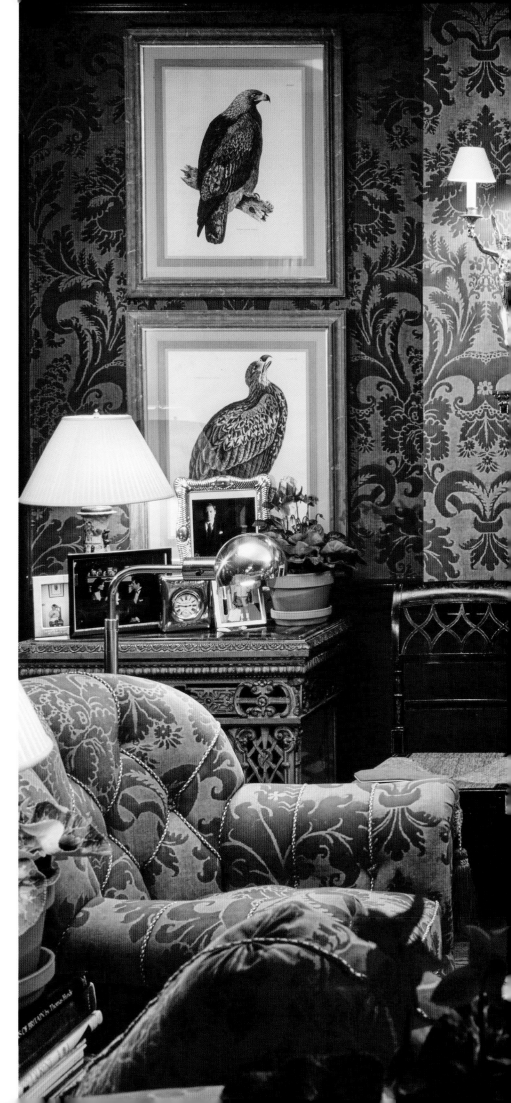

RIGHT *Tom's decorative vision has always been meticulously conceived, in every detail. An eighteenth-century military officer surveys the upstairs sitting room, his figured coat echoed in the room's Fortuny wall covering and golden accents: Empire sconces, ormolu table, giltwood frame, brass andirons, and vermeil boxes.*

FOLLOWING PAGES *Exuberance was a hallmark of Anglophile decorating in the 1980s, and I totally succumbed. The main bedroom exemplified that moment. It was a hugely romantic space, with pink walls, accents of Chinese Export lacquer, and a floral chintz.*

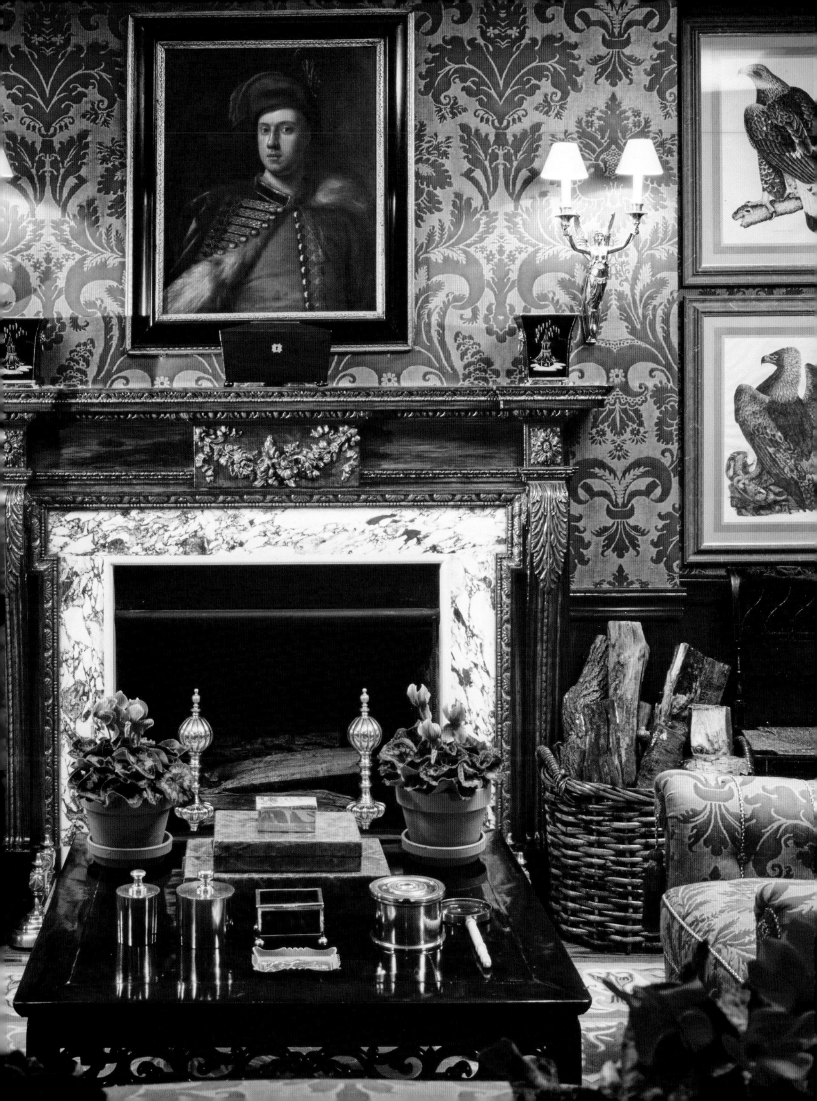

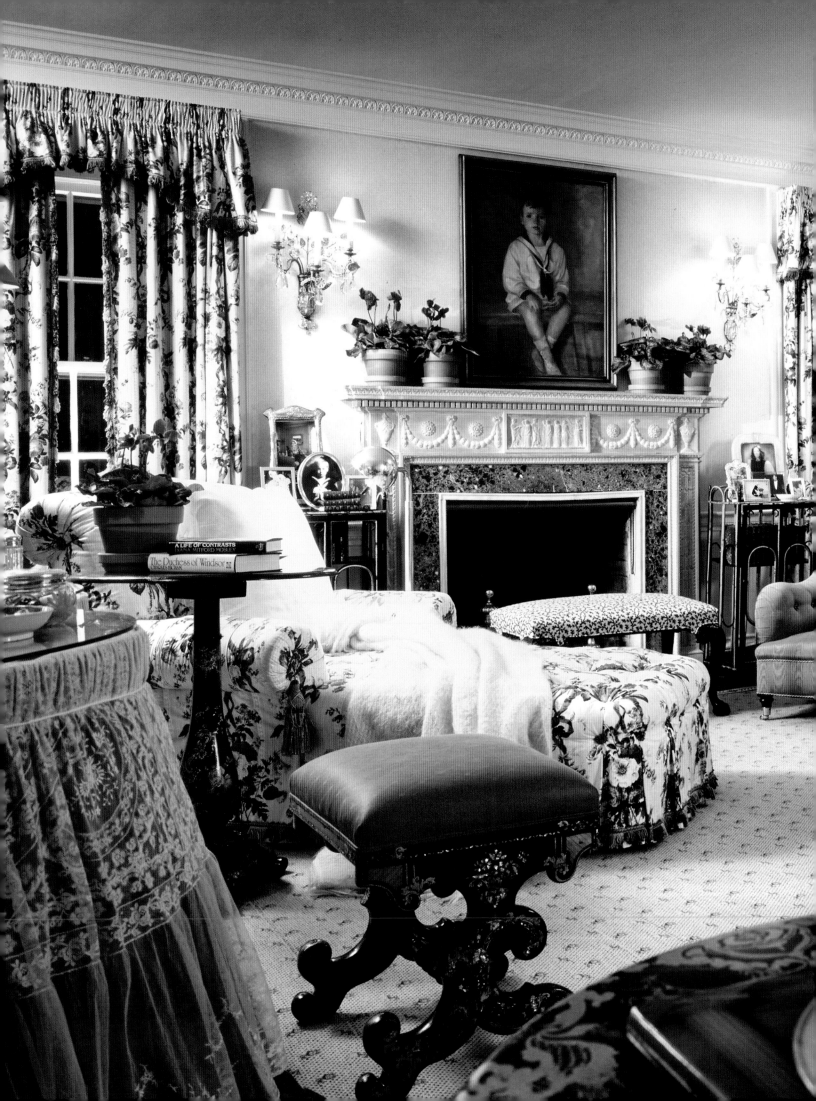

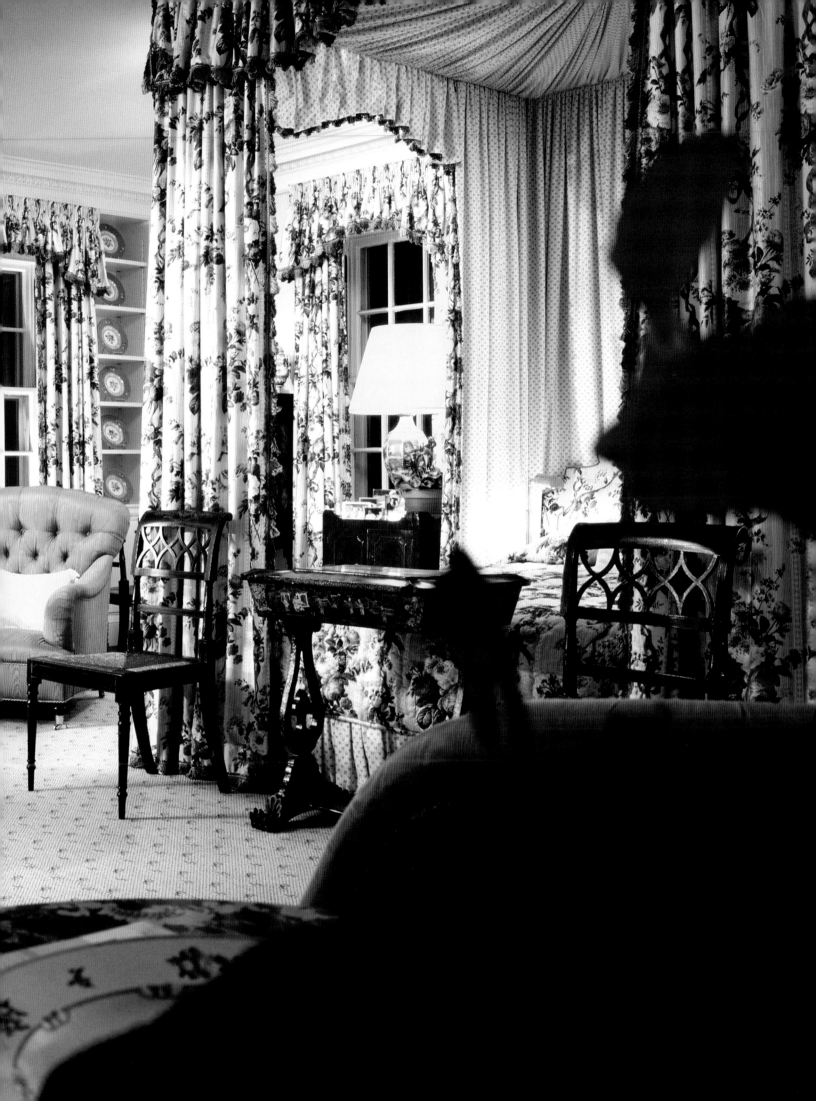

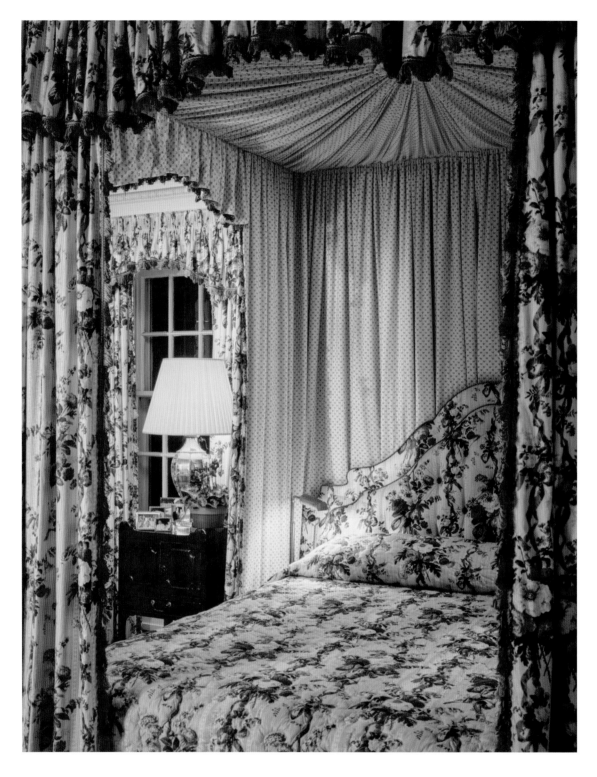

ABOVE *The canopy bed was a room within a room, like a swagged tent and gathered with a rosette. The bed curtains were lined with a small-scale Colefax and Fowler print, while the coverlet was quilted.*

OPPOSITE *An English portrait of a child was displayed above the chimneypiece, a neoclassical Adam-style accent presumably added to the house during the 1920s remodeling.*

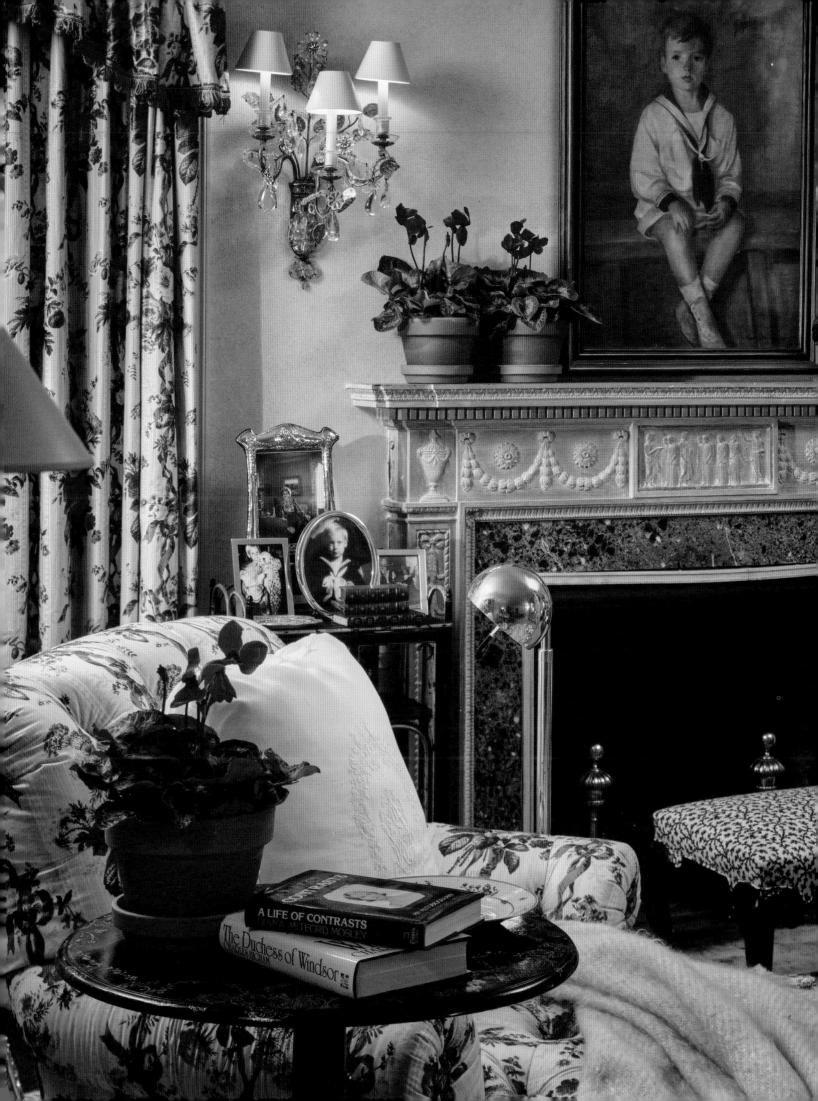

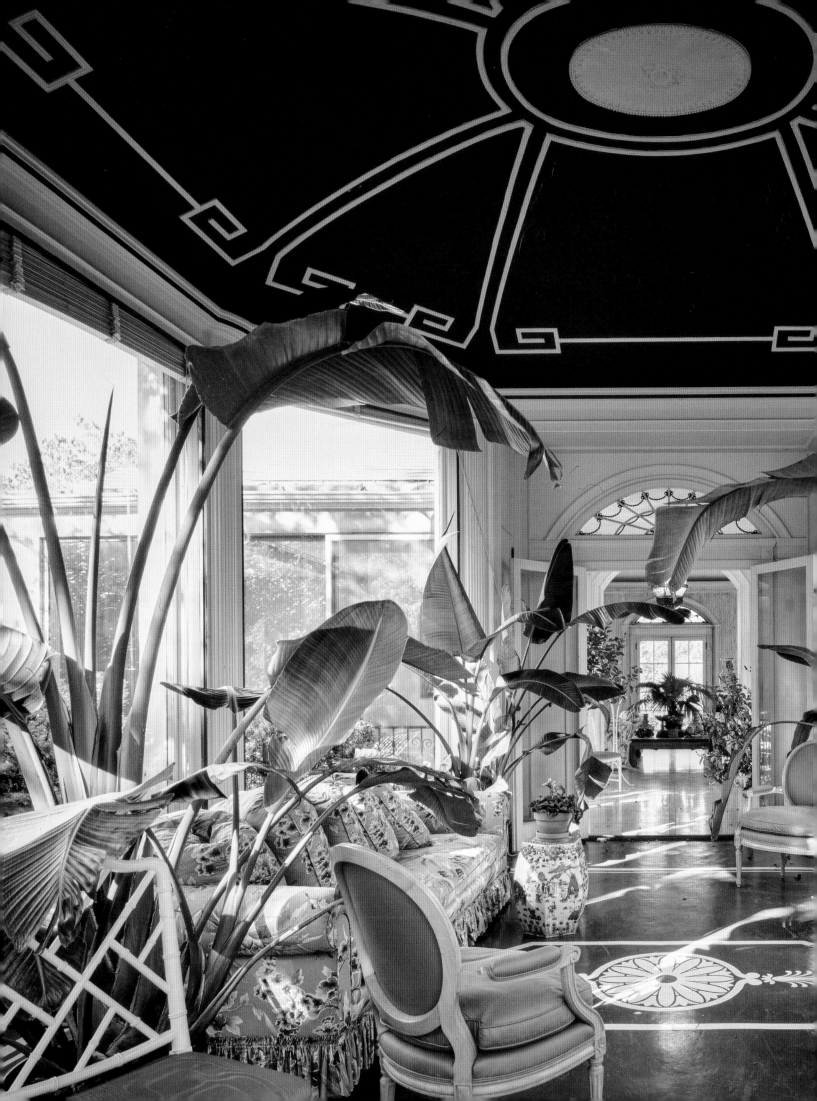

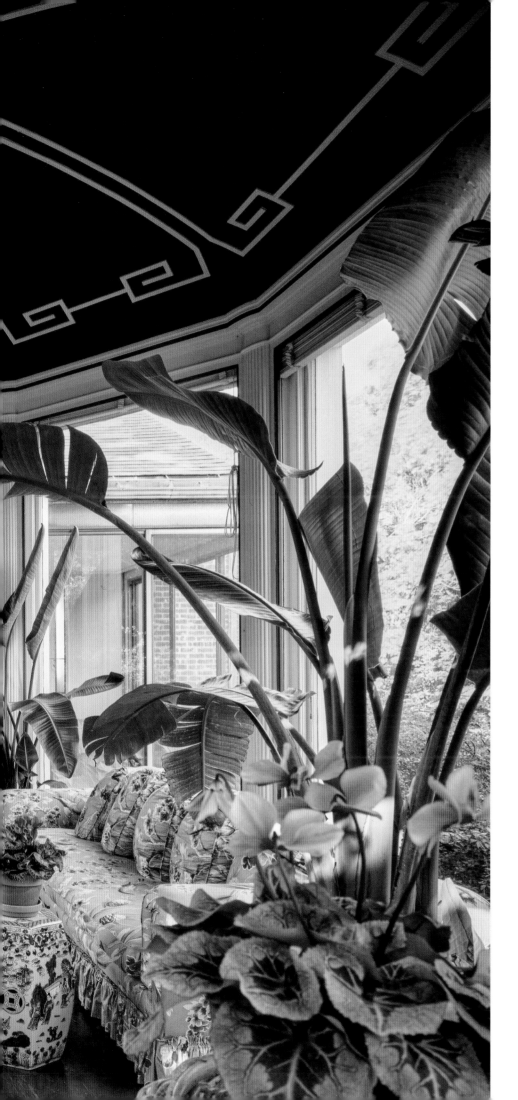

LEFT *The octagonal pavilion was a wonderful surviving feature of an earlier period in the house's history. It had been originally designed as a card room, but we used it as a solarium.*

FOLLOWING PAGES *The rose garden was designed as a parterre enclosed by a turf path and ringed by plump topiaries.*

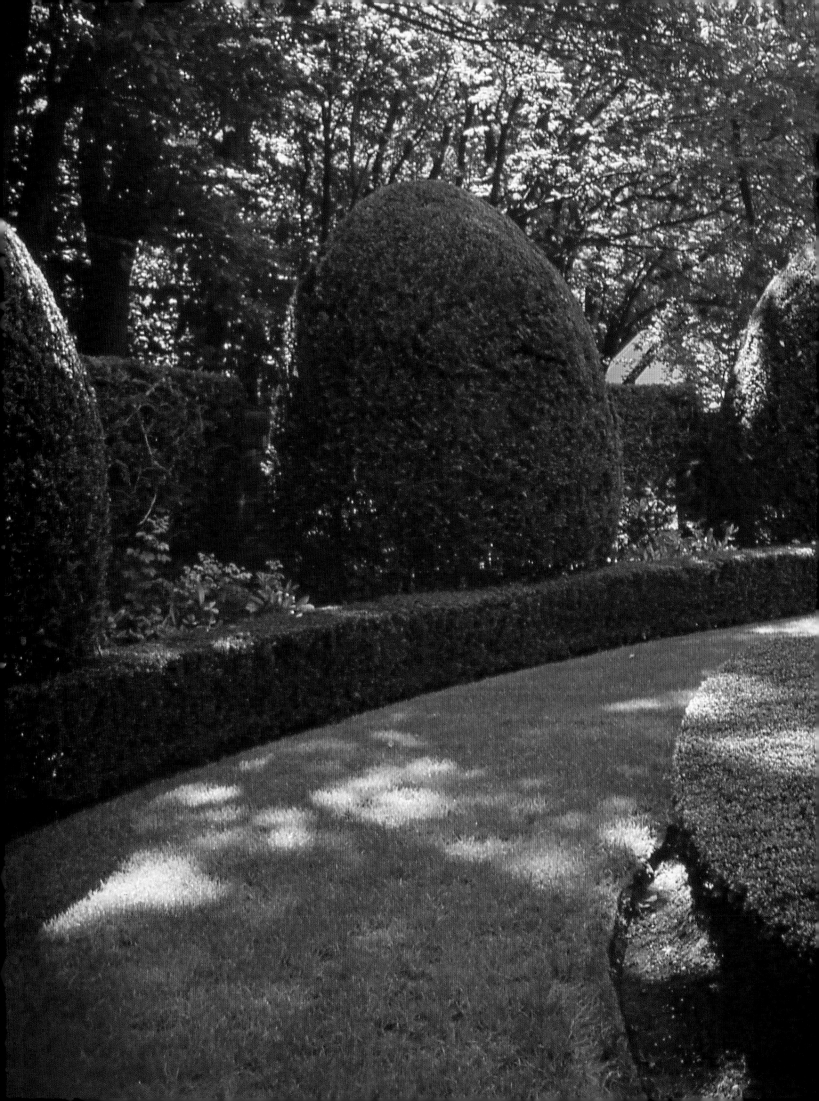

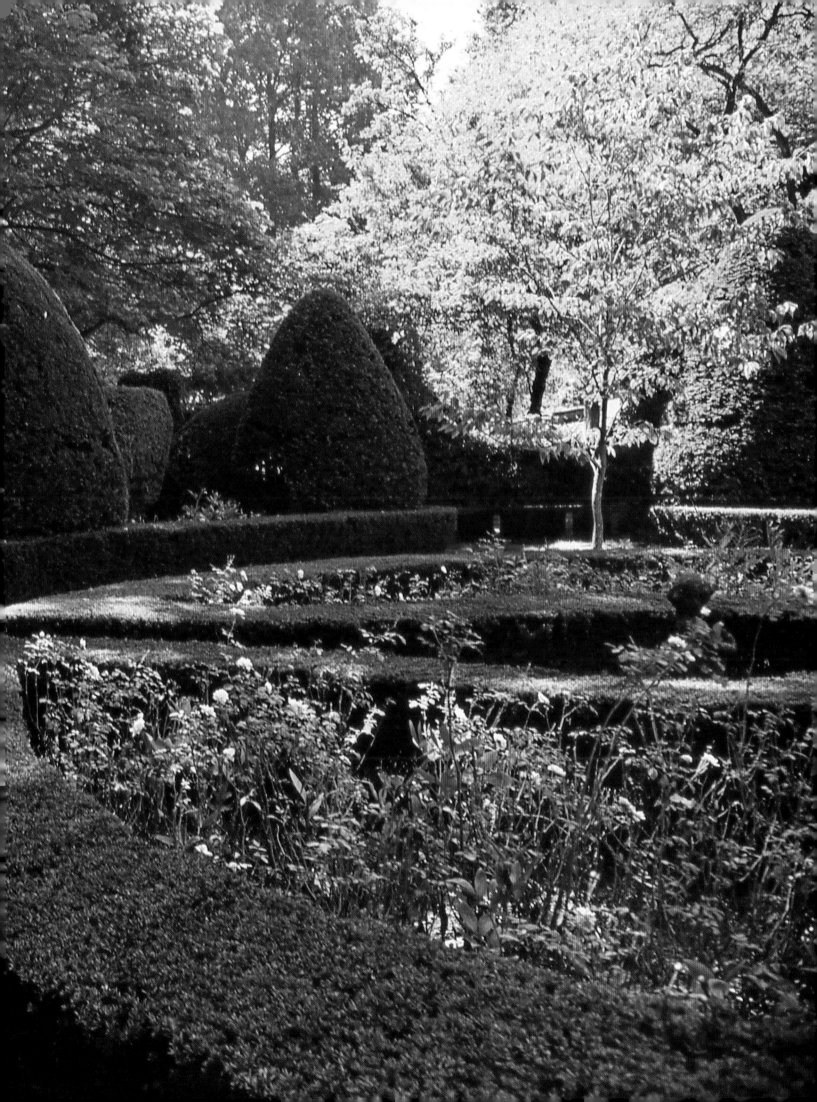

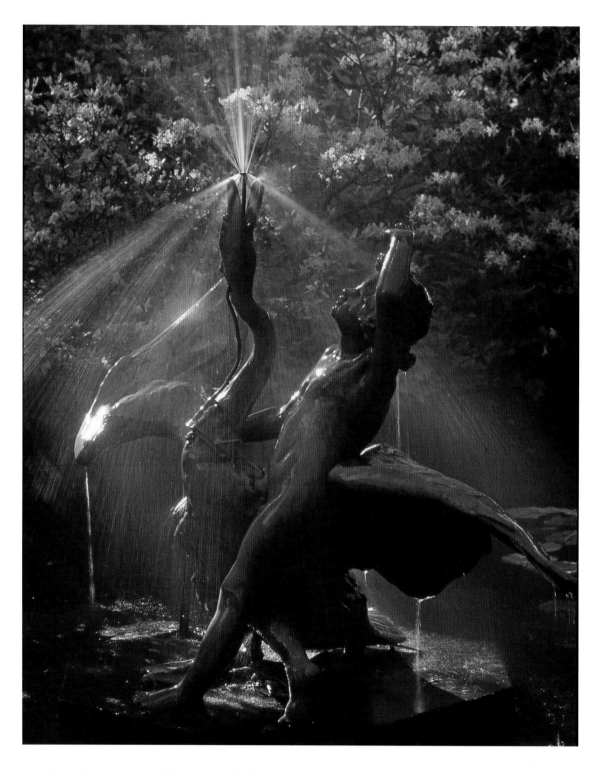

ABOVE The centerpiece of the azalea garden's ornamental pond was a later cast of an 1836 Theodor Erdmann Kalide fountain depicting a swan and child. Queen Victoria owned a copy that stands at Osborne House.

OPPOSITE In the verdant iris garden, the wedge-shaped beds—planted in shades of purple—radiate from a classical statue.

FOLLOWING PAGES At the rear of the house was a cutting garden, captured here at the height of tulip season. The double-height veranda, added in the 1920s, was inspired by the piazza at Mount Vernon.

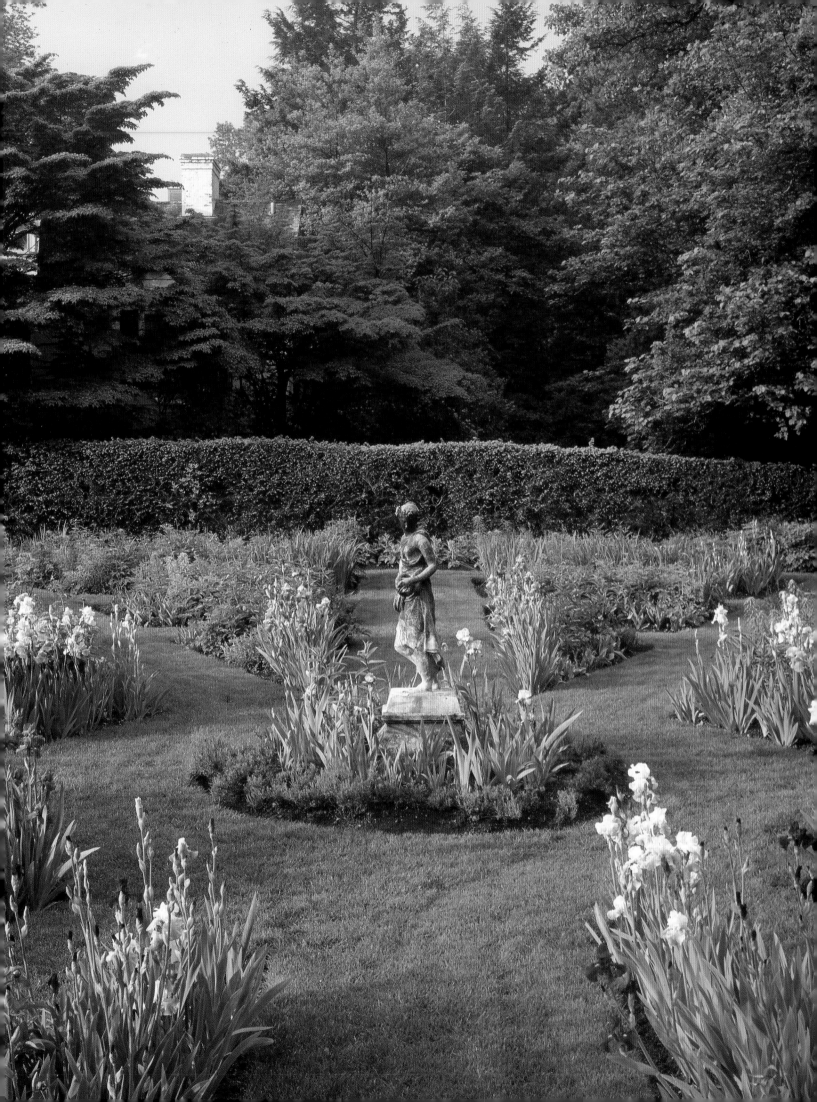

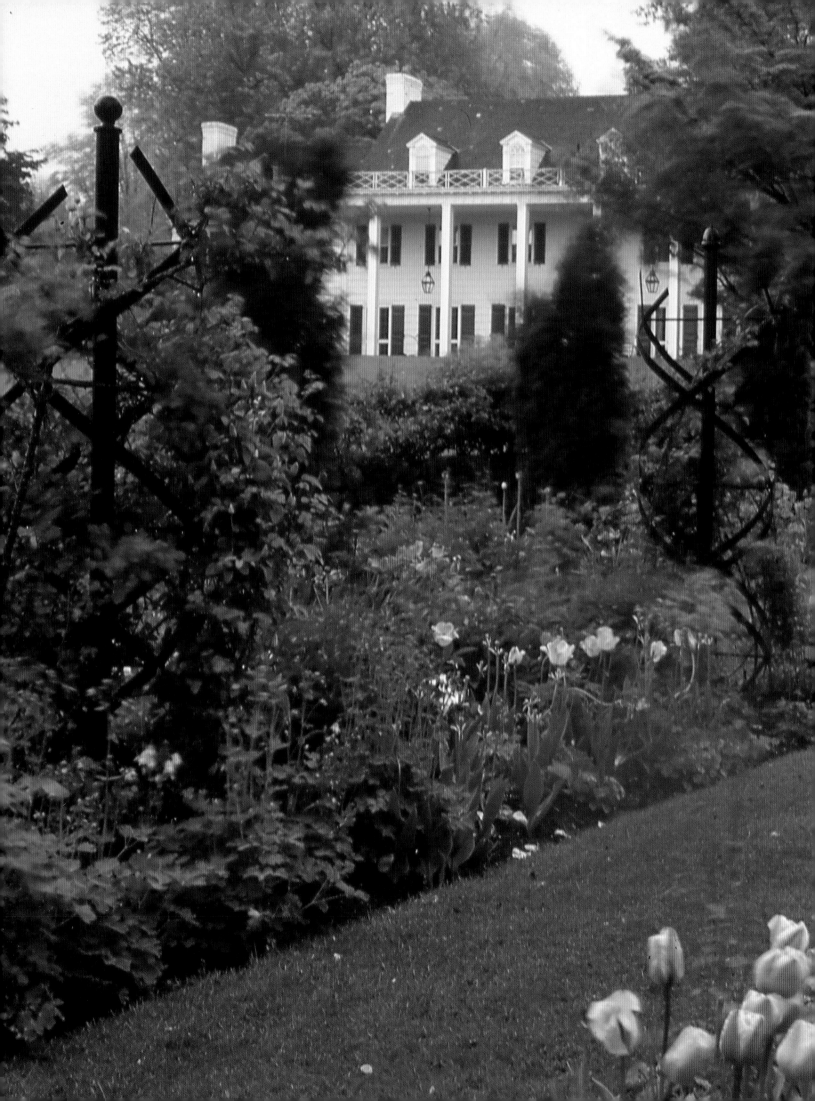

EAST SEVENTY-FIRST STREET

New York | *1986–1991*

When the subject turns to American decorators in the last quarter of the twentieth century, Mark Hampton stands out as one of the very best in the field. His ability to draw and paint was unique and put him in a different category. Upon seeing a room for the first time, he would conjure up a furniture arrangement and bring a room to life. For me, one of the most perplexing aspects of pulling rooms together is a cohesive arrangement of sofas, chairs, and tables. Being able to see a perfect layout immediately, on paper, through Mark's eyes, was a big step for me—and you were lucky if you also received some of his beautiful drawings or watercolors.

Mark was not only a decorator but also a scholar, and I was one of many fans of the column that he wrote for *House & Garden*. Like me, he was a Midwesterner, and though he was erudite, he wrote in such an easygoing way that you never felt that he was delivering a lecture. He was just joyfully sharing what he knew and what he thought everyone who loved design should learn. I didn't know him very well, beyond being a guest at his and his wife Duane's Southampton house. My firsthand introduction to his work and his taste, though, was a Houston house that Mark had decorated for Christina Hudson and her husband, Joe, friends of mine who had wonderful taste. The house had been designed by the renowned neoclassical architect John Staub and was located in the Shadyside neighborhood. The rooms were impeccable in my opinion: the colors, the fabric, the furniture.

Like many Manhattan brownstones of the early 1900s, under the influence of decorator Elsie de Wolfe and architect Ogden Codman Jr., our first house on East Seventy-first Street had had its stoop removed and its entrance shifted to ground level.

I learned so much by studying that house. It doesn't seem unusual now, but I remember that the powder room's basin was set into an antique chest of drawers; it just seemed brilliant to me, a sink that combined history and utility.

Shelby and I decided to move back to Manhattan from Houston in the 1980s, and after some house hunting, we rented a nineteenth-century brownstone on East Seventy-first Street, just off Lexington Avenue. Its exterior had been remodeled along more classical lines in the early 1900s, and its entrance, previously reached by a flight of stairs, had been lowered to street level. The house had been neglected, but it had so much potential. We knew that Mark would approach the rooms with scholarship but also comfort and invention. It was a house that didn't want to be contemporary or modern; neither Shelby nor I wanted to erase its history by painting all walls white or gutting the interior, which of course wasn't an option. The period architectural details of the five-story building were completely intact, from the paneling to the staircase to an extraordinary leaded-glass bay window in the living room. Coincidentally, the twin brownstone next door was the home and gallery of Juan Portela, a dealer of nineteenth-century European antiques, who would become a good friend and an expert adviser when Shelby and I rented a house outside of Brussels.

Mark's vision for our new rooms was Belle Époque Paris meets Edwardian London, like the fictional salons described in the novels of Marcel Proust, one of his favorite writers. We left the dark woodwork as it was—it was a rental, after all, and historic—but the decor framed by it was full of color and pattern. Mark brought in deep-seated, button-tufted upholstery dripping with fringe, swagged doors with portieres, laid lots of soft Oriental carpets, and accented corners with tall Kentia palm trees in pots. Some walls were tinted a creamy white; others were painted a deep red. I often went with Shelby to London, where he had an office; there, I would visit Colefax and Fowler for fabrics and shop the Pimlico Road for antiques and textiles. A flowered chintz I particularly loved was called Roses & Pansies. An 1840s motif, it had been revived by John Fowler in the 1950s and became my favorite pattern the moment I saw it; we used it in the main bedroom. The bay window was already a focal point, architecturally, but when Mark framed it with a Bennison flowered linen—

Roses & Pansies is a classic Colefax and Fowler chintz rooted in Victorian times—and a favorite of mine.

Another beloved floral that Mark Hampton used at East Seventy-first Street: Bennison's Roses, in the brown-on-beige colorway.

lined and interlined in classic fashion, so they're a bit like thin summer quilts and hang beautifully—and filled it with a big window seat, it became an even more prominent feature, creating a proscenium-stage effect.

Shelby, Mark, and I were always on the prowl at auctions, and whenever we traveled, finding such treasures as gilt-bronze clocks and English tables and a big Japanese vase with a blue glaze so murky that it seemed like a night sky. As Mark wrote in a *House & Garden* column, "By the Edwardian era, sitting rooms and drawing rooms were loaded with every conceivable sort of piece." Our rooms weren't quite so crowded, but they were certainly outfitted with decorative objects and upholstery shapes and were very atmospheric. Shelby found a wonderful

flowered carpet on a trip to Mexico, and we put seagrass in the living room so as not to compete with the beautiful Bennison fabric. David Kreitz, a carpenter and jack-of-all-trades who frequently worked for us, fitted one room with bookcases so it could serve as a library. He also built a playhouse for the boys, with a slide and a firefighter's pole, at the back of the house.

Though we lived in this particular house on Seventy-first Street for only a few years, before heading to Brussels, it remains a very beloved place for me. It was the first house I lived in that was completely created by me and a decorator, from the first floor to the fifth floor, with no detail overlooked. Mark taught me how careful planning, meticulous execution, and a nostalgic vision could result in a time-travel escape from the real world, the noisy world of honking taxis and busy sidewalks. We were a young family, and the romantic settings that Mark put together with us felt not only relaxing but also welcoming. With three young boys, the pattern-on-pattern schemes also camouflaged wear and tear better than I imagined. �

RIGHT A simple improvement that brought much joy was the playhouse, in the back garden, that master carpenter David Kreitz built for our sons Jack and Austin.

OPPOSITE Kreitz also constructed the faux-mahogany bookcases for the library, which we also used as a dining room.

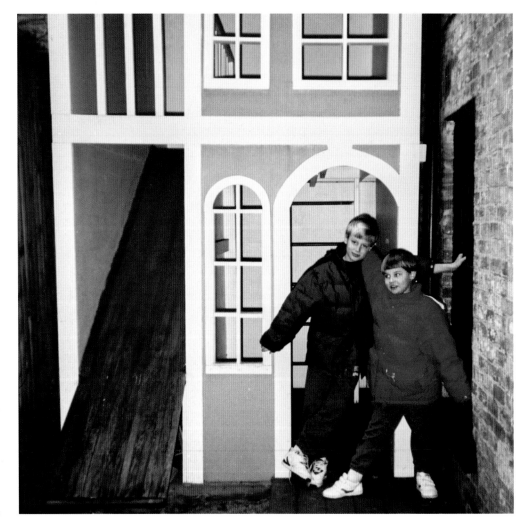

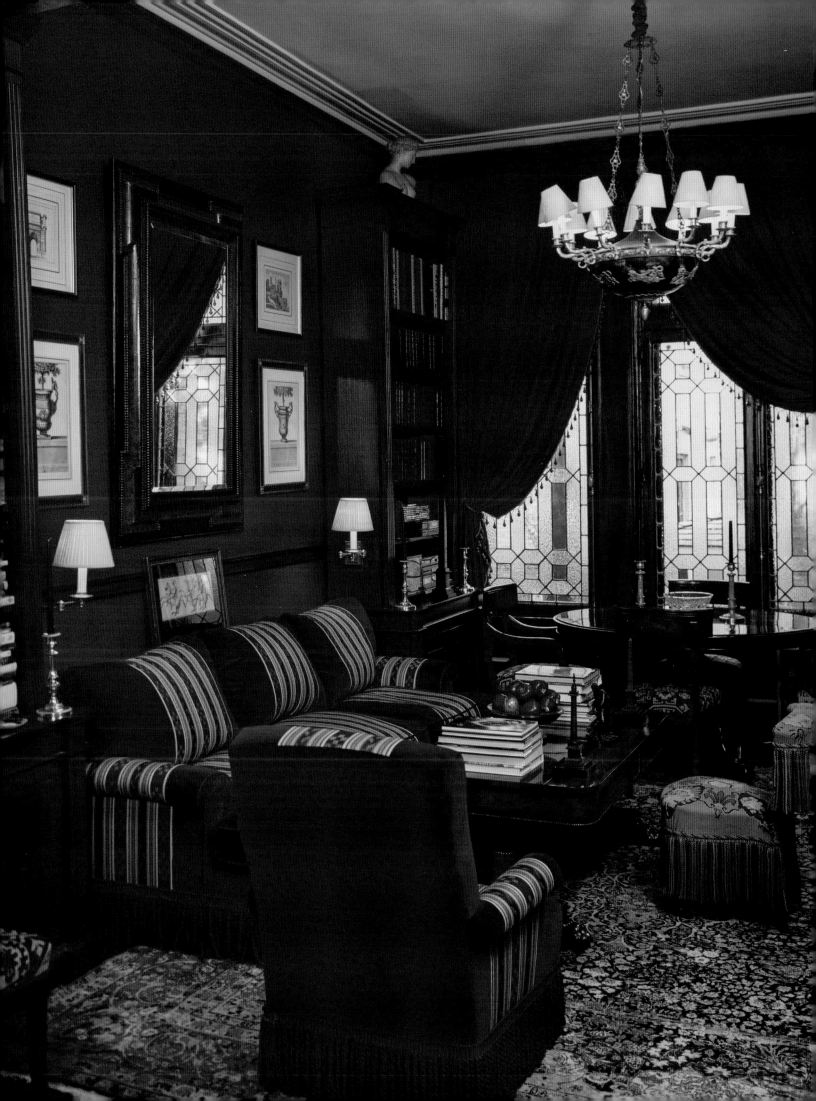

ABOVE *Prints and etchings brought a scholarly air to the library, while a nineteenth-century portrait of a turbaned military officer added a note of Orientalism.*

OPPOSITE *Mark mined nineteenth-century design for ideas, from velvet upholstery enriched with appliquéd panels to lush portieres that curtained doorways.*

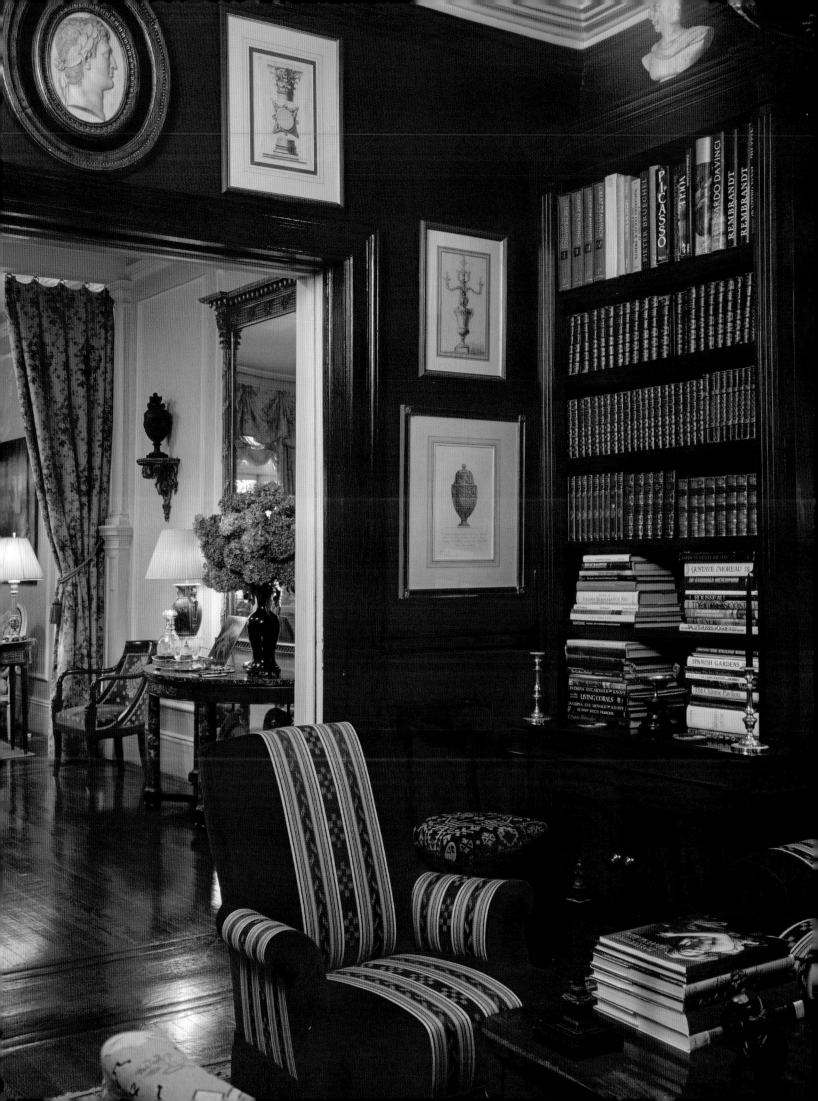

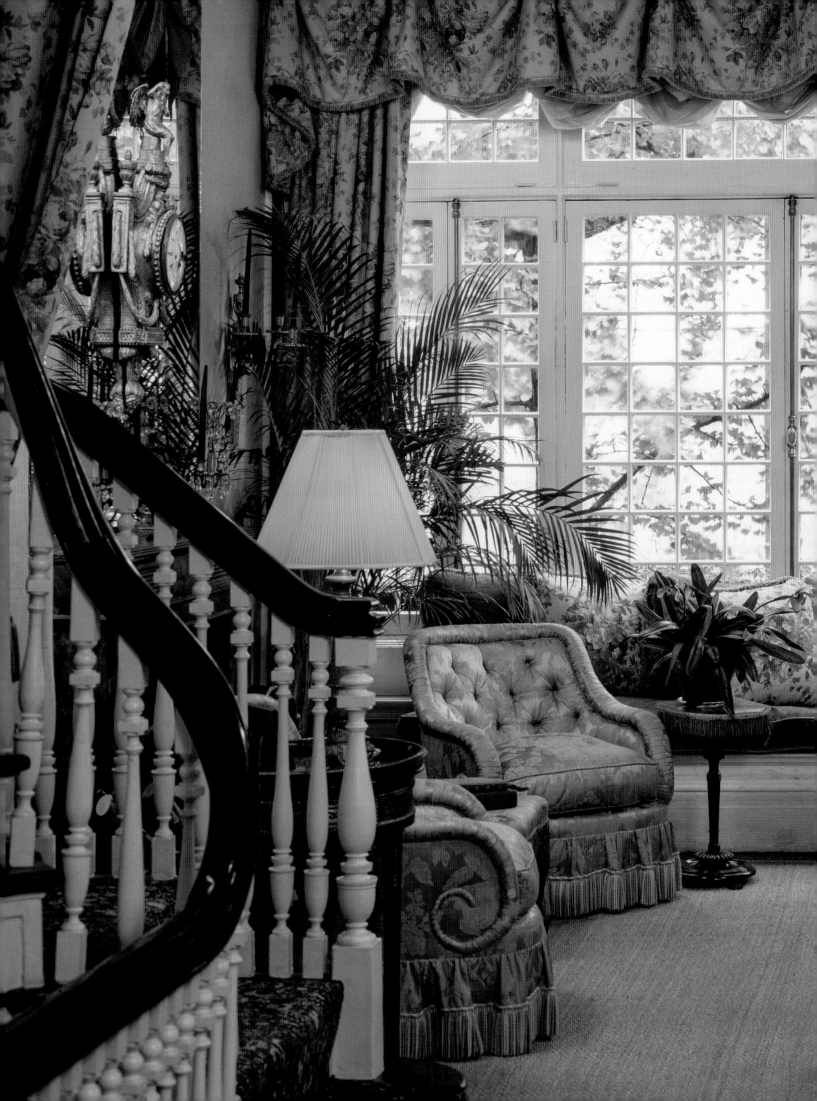

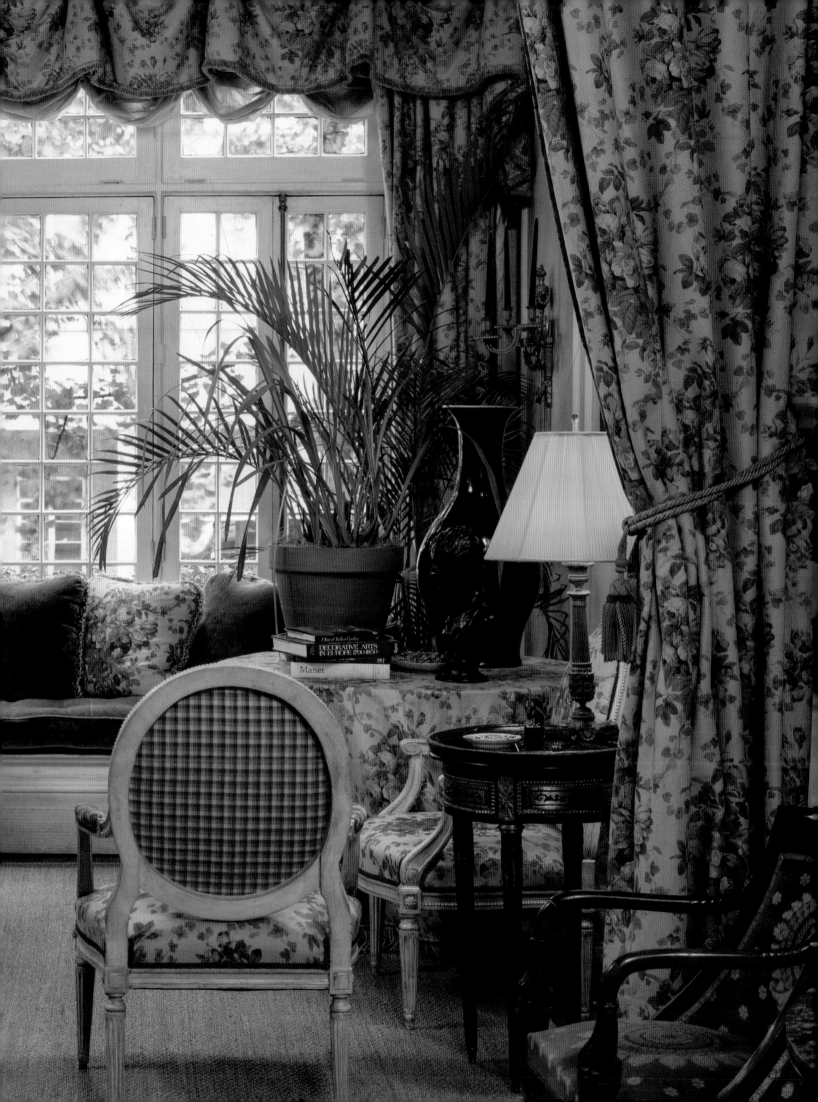

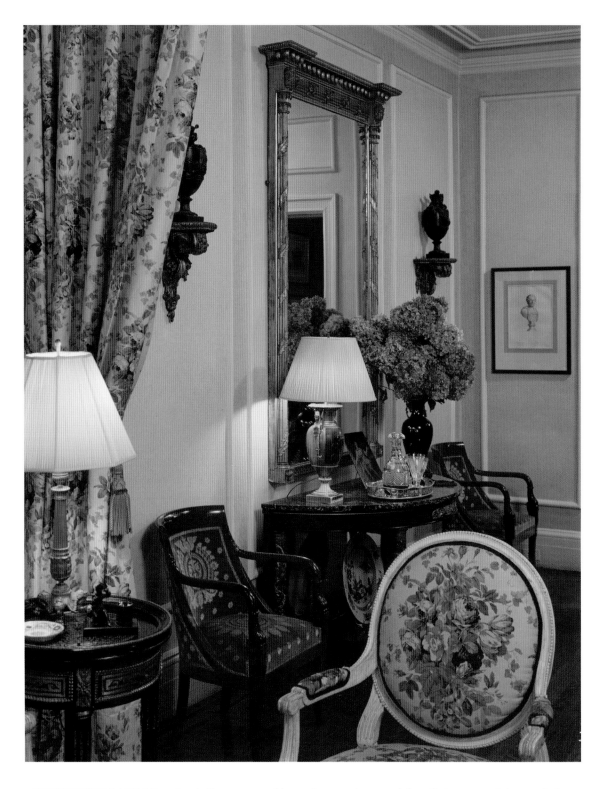

PRECEDING PAGES *Bennison's Roses pattern bloomed across the second-floor living room. A large window seat overlooked the street, and potted palms referenced Gilded Age interiors.*

ABOVE *Empire armchairs flanked a giltwood mirror in the stair hall next to the living room.*

OPPOSITE *Mark had the living room mantel loosely marbleized, not to copy a particular stone but to give an artistic feeling.*

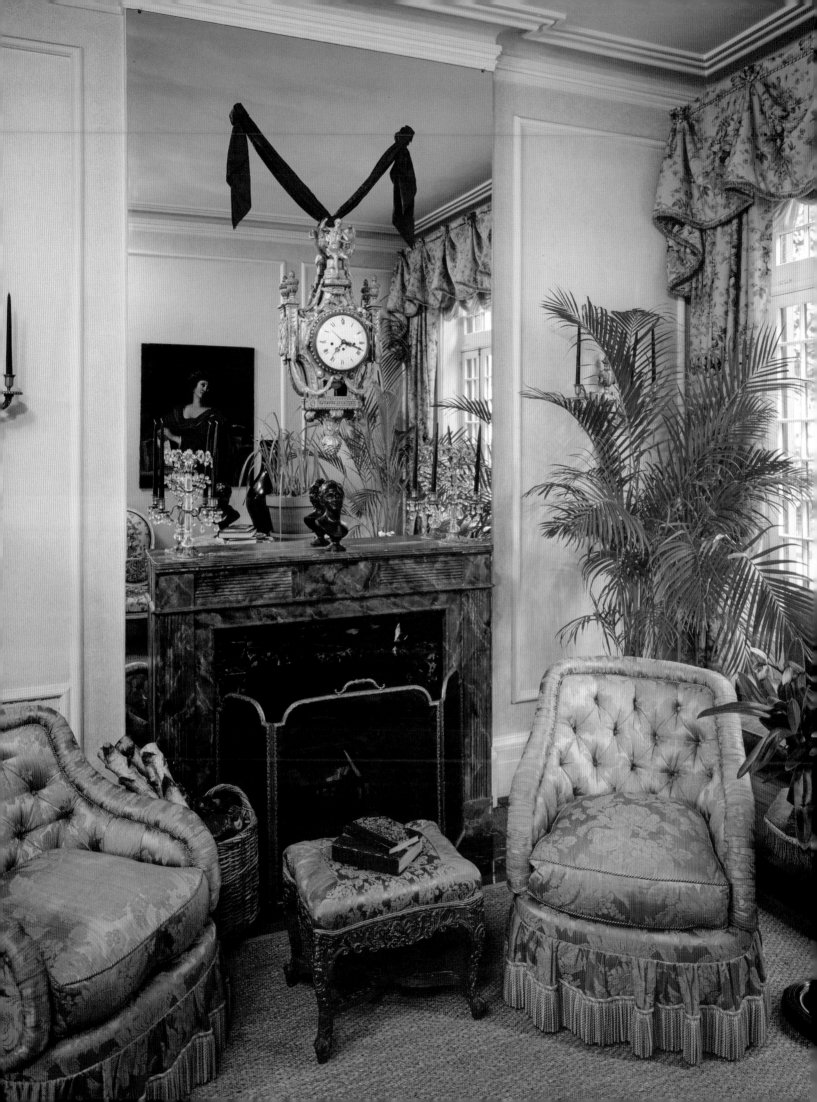

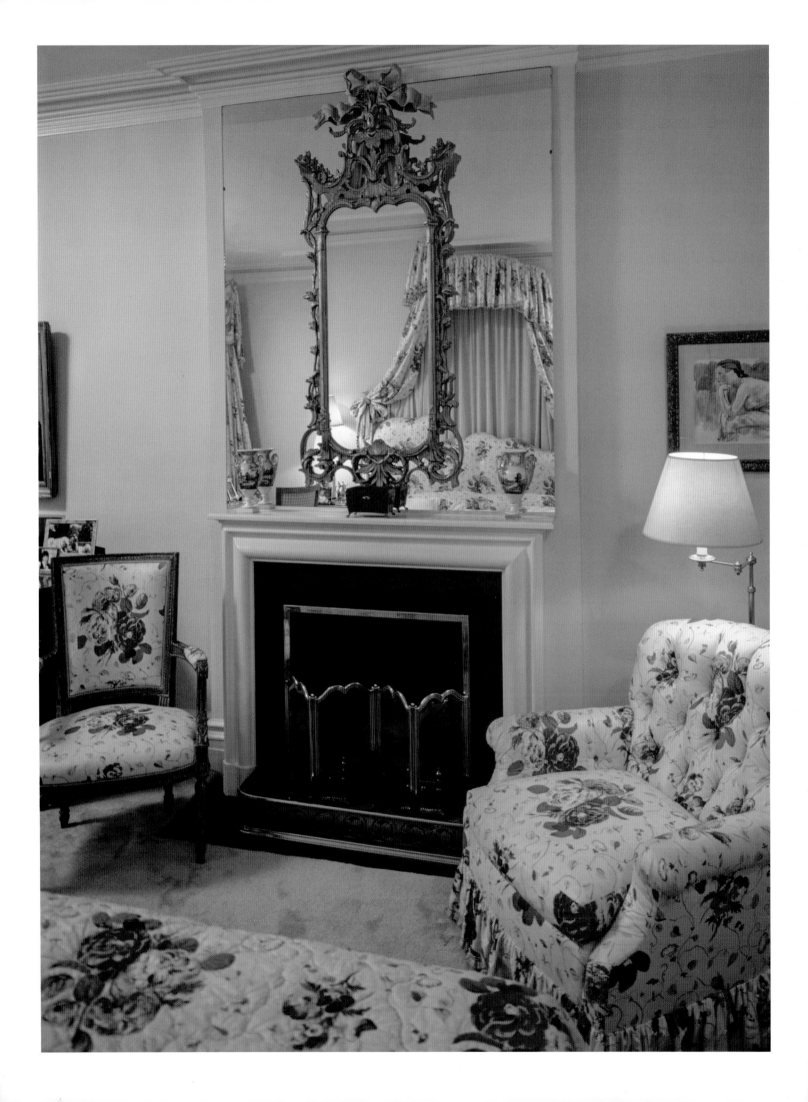

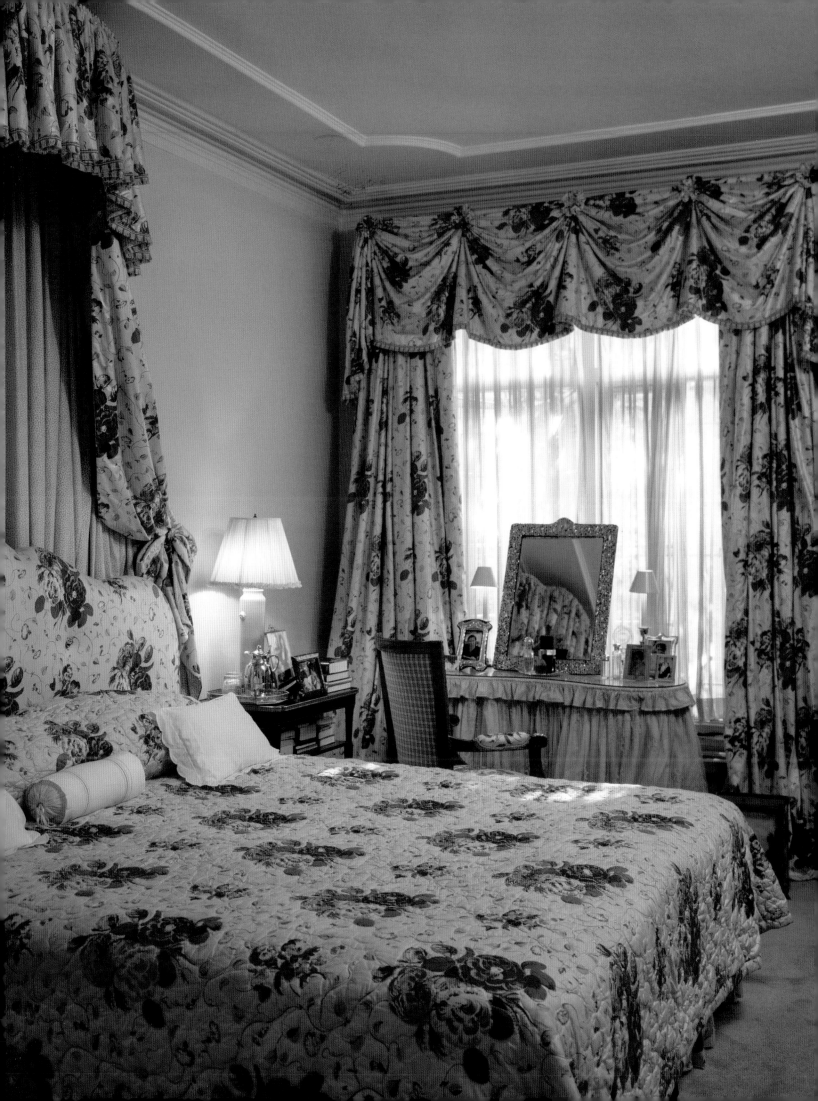

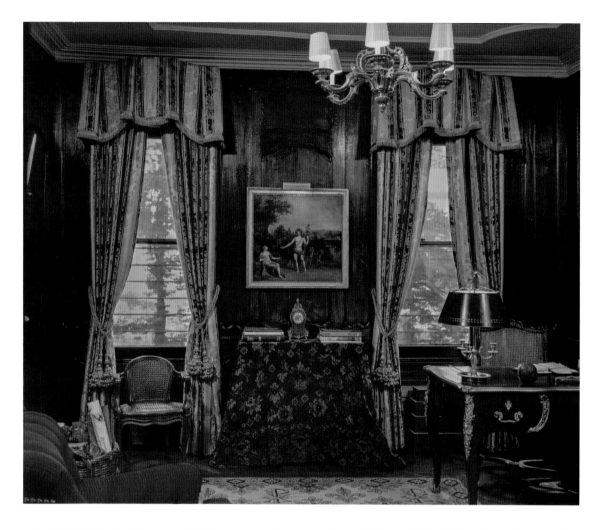

PRECEDING PAGES *The main bedroom was given over to Roses & Pansies by Colefax and Fowler, a textile that I've used in several subsequent schemes. To take advantage of natural light, the dressing table faced the room's sole window, which was framed by a swagged valance and voluminous panels.*

ABOVE *With its luminous wood paneling, shades of red, and French antiques, the guest bedroom felt the most Gilded Age of all the interiors.*

OPPOSITE *The twin bed was tucked into an alcove that Mark lined with ruched fabric and framed with a striped curtain. An antique landscape hung at the rear of the space like a virtual window.*

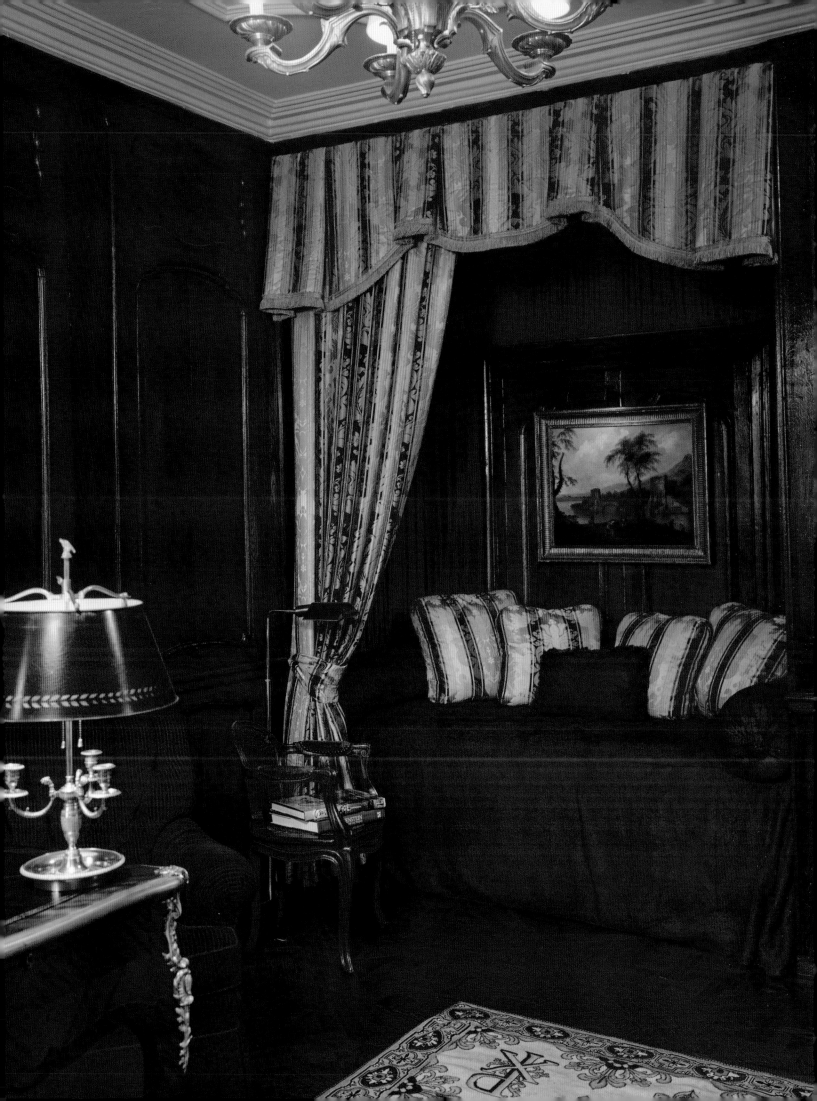

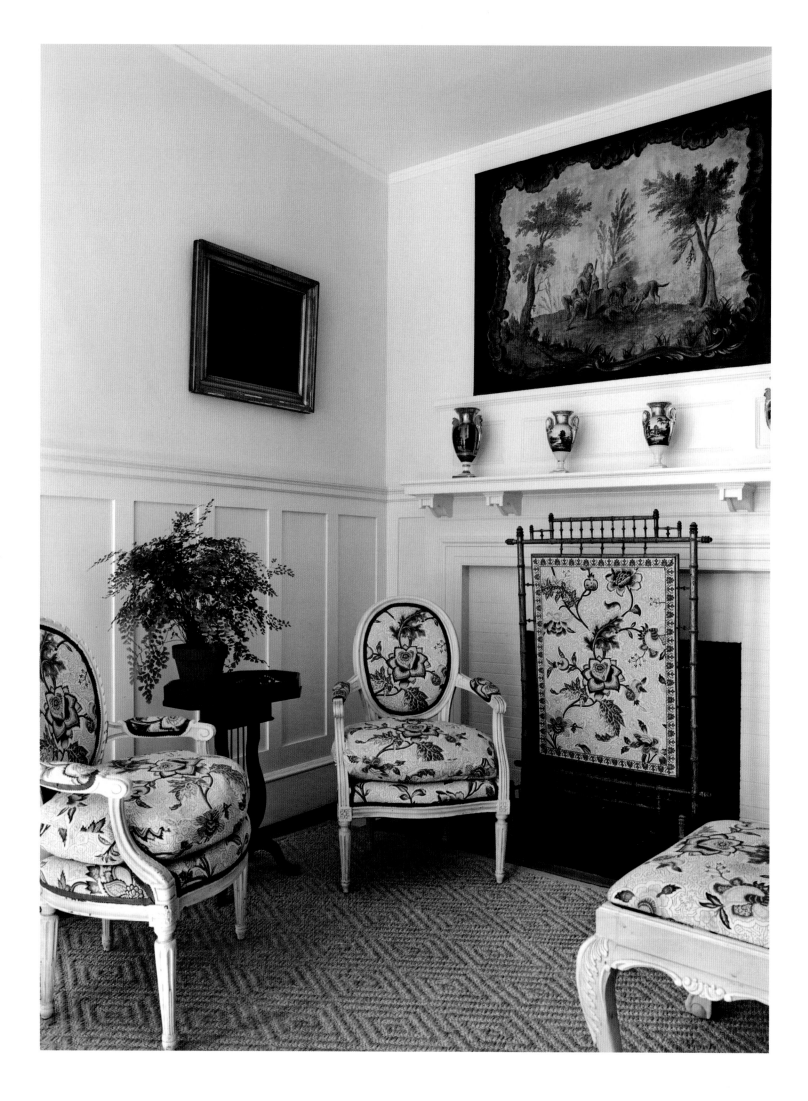

LILY POND LANE

East Hampton | *1986–2003*

The house that Shelby and I owned in East Hampton, on Lily Pond Lane, was the house I wish I'd never sold. In addition to the high ceilings and wood floors of a classic Long Island country house, it had one unusual spatial aspect: it was just one room deep, which meant that the interior was flooded with light from both sides all day long. And at night, when all the lamps and chandeliers were turned on, the house looked like a lantern.

That the rooms were sunny all the time led me, for some reason, to imagine that it was a house in Sweden, a house by the seashore. There was a freshness about the spaces, as well as a simplicity that I associate with classic Scandinavian houses, even though it was all American in every other detail. Architect Joseph Greenleaf Thorp, best known for designing the East Hampton house known as Grey Gardens, had created it in the 1890s for a Manhattan real estate developer and his family. The exterior was dressed in shingles—that decade was the heyday of the Shingle Style—and some of the windows had diamond panes, which added an accent that was part medieval and part cottage. Two large interlocking hip roofs sheltered it all, which made Shelby, me, and the children feel like we were protected—a characteristic that any really good house should offer.

We'd had such a good time working with Mark Hampton on our house on East Seventy-first Street, so we asked him to take a look at Lily Pond Lane. He fell in love with the house the moment he saw it, too, and for much the same reasons. Mark also felt that the all-American house and my Swedish visions were a good match, and since he was a connoisseur of Scandinavian style—from its neoclassicism to the storybook illustrations of Carl Larsson—the project

Chairs, with gray-white frames painted by Lucinda Abbe and batik-like upholstery, gather in our East Hampton weekend house. The subdued palette and simplicity provided a refreshing contrast to the red-and-floral Manhattan brownstone where we lived during the week.

gave him an opportunity to revisit some of his inspirations from that part of the world. It would be a completely different environment than the Edwardian-meets-Victorian scheme, all dark reds and densely flowered, that he developed for our Manhattan town house.

For East Hampton, we chose a palette of blue and white—visually uncomplicated, Scandinavian, and difficult to get wrong—and Mark handled this simple

A portrait of me by Sébastien de Ganay was installed in the stairwell. We painted the Arts and Crafts woodwork white and the walls pale blue, to enhance the Scandinavian sense of light and air.

formula with expert finesse. From the wainscot in the living room to the balusters of the staircase, everything was painted a crisp satin-finish white, reflecting more light, even on cloudy or stormy days. Blue paint was applied, too: pale on the floors and the beadboard ceilings of the porches and on the inner panels of the dining room's wainscot. We used a darker shade of blue, a sort of slate color, to transform the dark wood floors inside the house into bold checkerboards that regularized the floor plan, knitting everything together, and also providing a crisp framework that was a counterpoint to the Arts and Crafts architecture. It was a pattern that also echoed, in much larger scale, the motif of the diamond-pane windows. I think that relationship was unexpected at first, when Mark and I discussed the floors, but it seemed predestined once the floors were painted.

The textiles were almost entirely blue and white, too, but in varied patterns and textures, in much the same way that you approach decorating an all-white room. Simple color schemes need variation to add depth and interest. At Lily Pond Lane, Mark used mattress-ticking stripes, overscale gingham checks, nubby rag rugs, and, in my bathroom, white curtains trimmed with ball fringe in navy blue.

The furnishings were fairly eclectic, too, but it all worked because of the pale tones; everything related, so the rooms felt seamless. Decorative artist Lucinda Abbe painted a frieze-like floral swag along the top of the walls in the main dining room. I filled the corner cabinets with blue-and-white Chinese Export porcelain, and the rag rug was mostly blue and white, though some stripes were green and others were pink. Lucinda painted the floors of the house, too, and would eventually create a Pompeiian room for us at our house on Feeks Lane.

Mostly, though, we lived on the porches, even in rainy weather. A pineapple chandelier that I found at the Paris flea market hung over the table where we usually had meals, either with the boys or with friends; it was heaven to have

One of the fabrics we used in the house was Le Manach's Amalfi in the Ocean colorway, a blue-and-white checkerboard woven cotton. Unlike a print, the weave gave the fabric a subtle sheen.

dinner there, in a protected area, with the weathered shingle walls making a contrast with the white balloon-back chairs and gingham seats. The rest of the porches and the veranda were outfitted with white wicker furniture, potted ferns, and plants with red or pink flowers. It was pretty much my idea of paradise. ❧

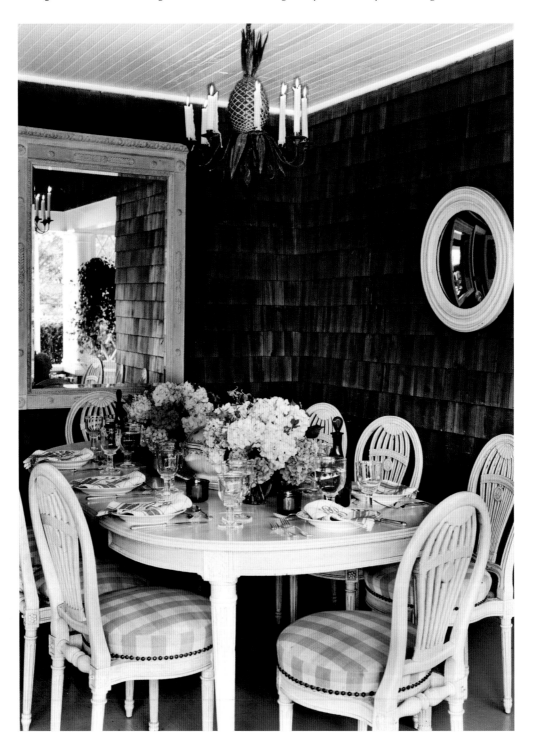

RIGHT "The porch was the heart of the house for me," says Alexis Bryan, my stepdaughter. "It was the decompression zone before you went inside." And where we had most meals.

OPPOSITE Painted chairs and a marbleized demilune stand on the entrance hall's checkerboard floor. The painted and giltwood mirror conjures the feeling of a Swedish manor house.

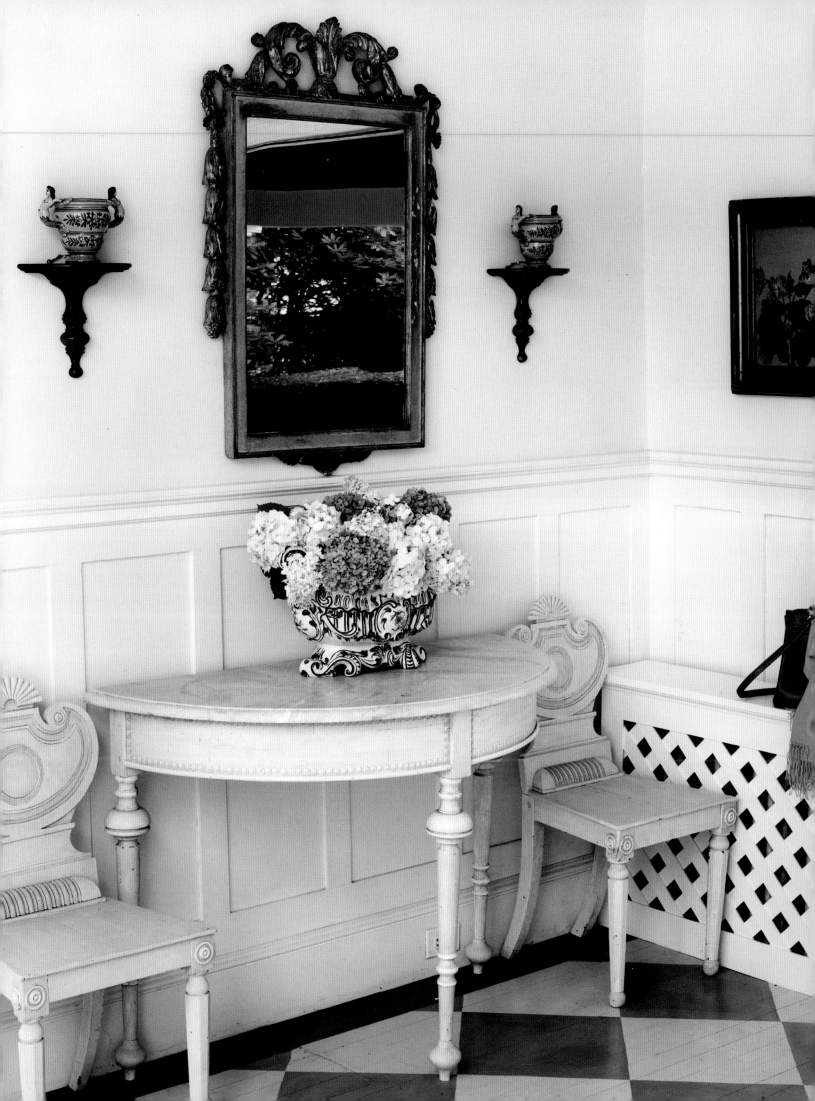

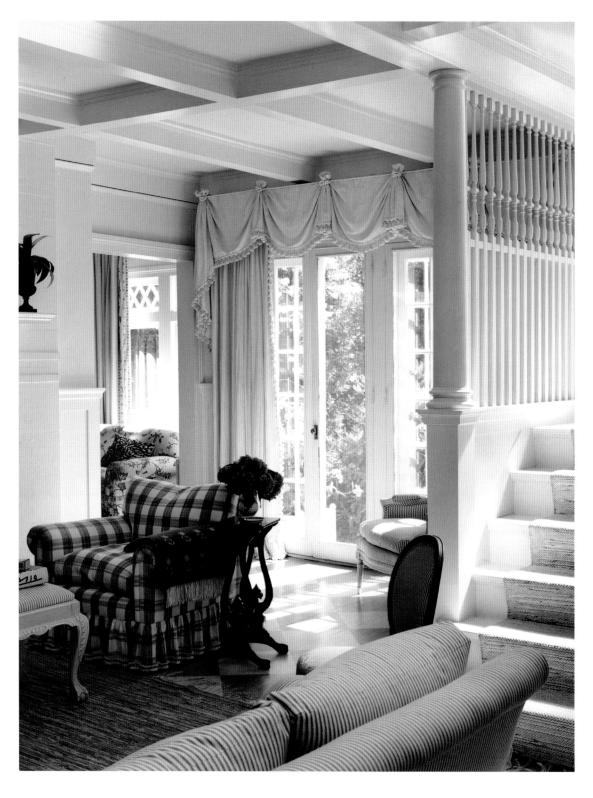

ABOVE *Mark draped the living room's French doors with a curtain treatment identical to the one in our Manhattan living room, but in a heavy cream fabric.*

OPPOSITE *Simple textiles casually combined—humble stripes, bold checks, and knubby rag rugs—are enduring elements of Swedish country style.*

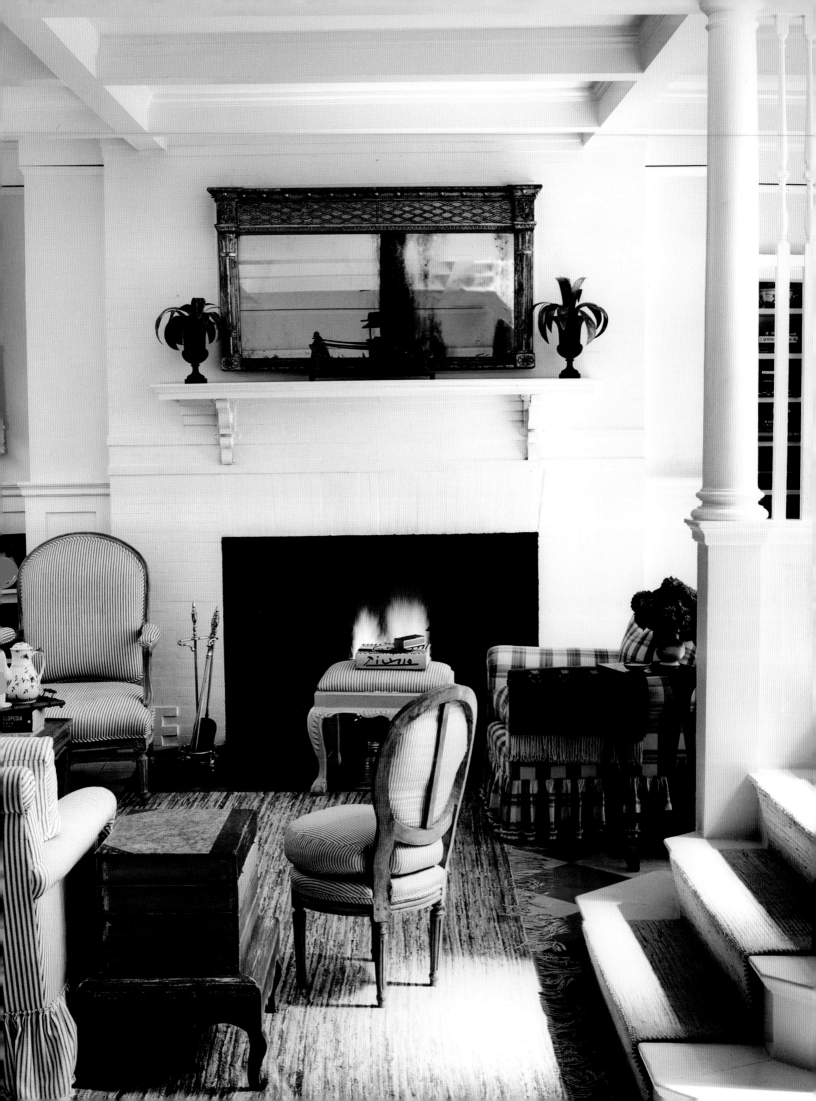

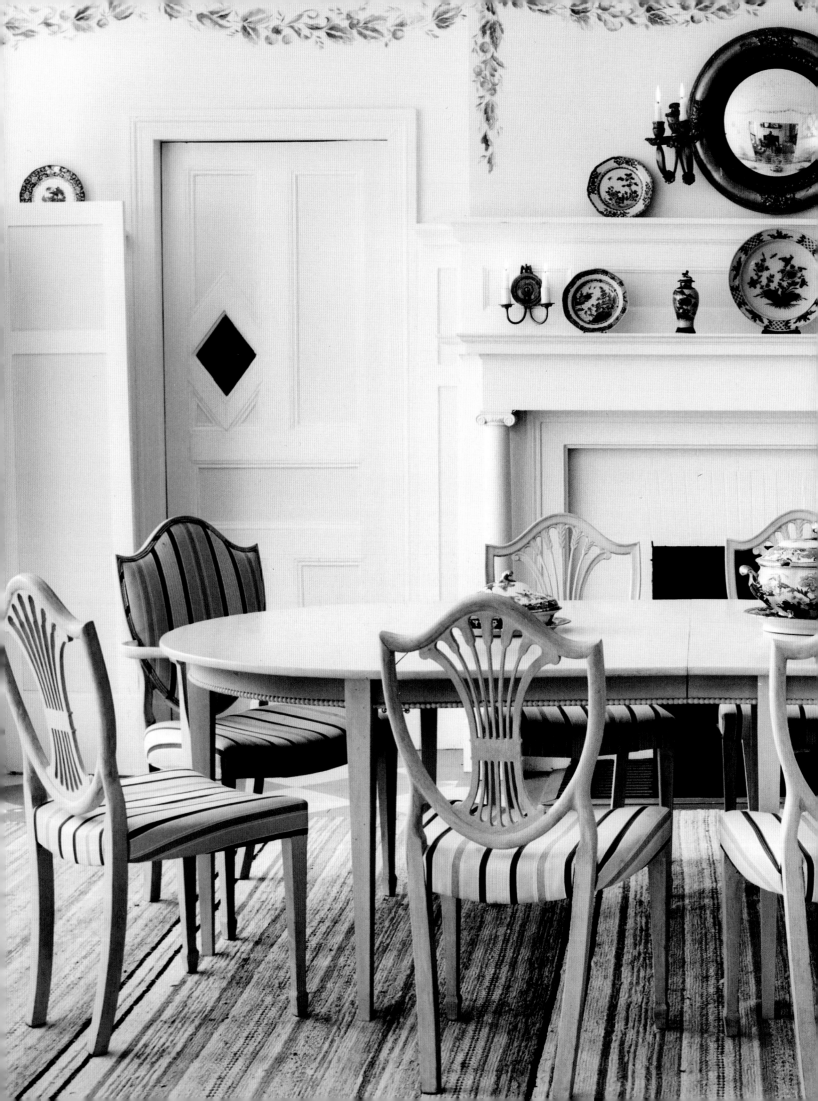

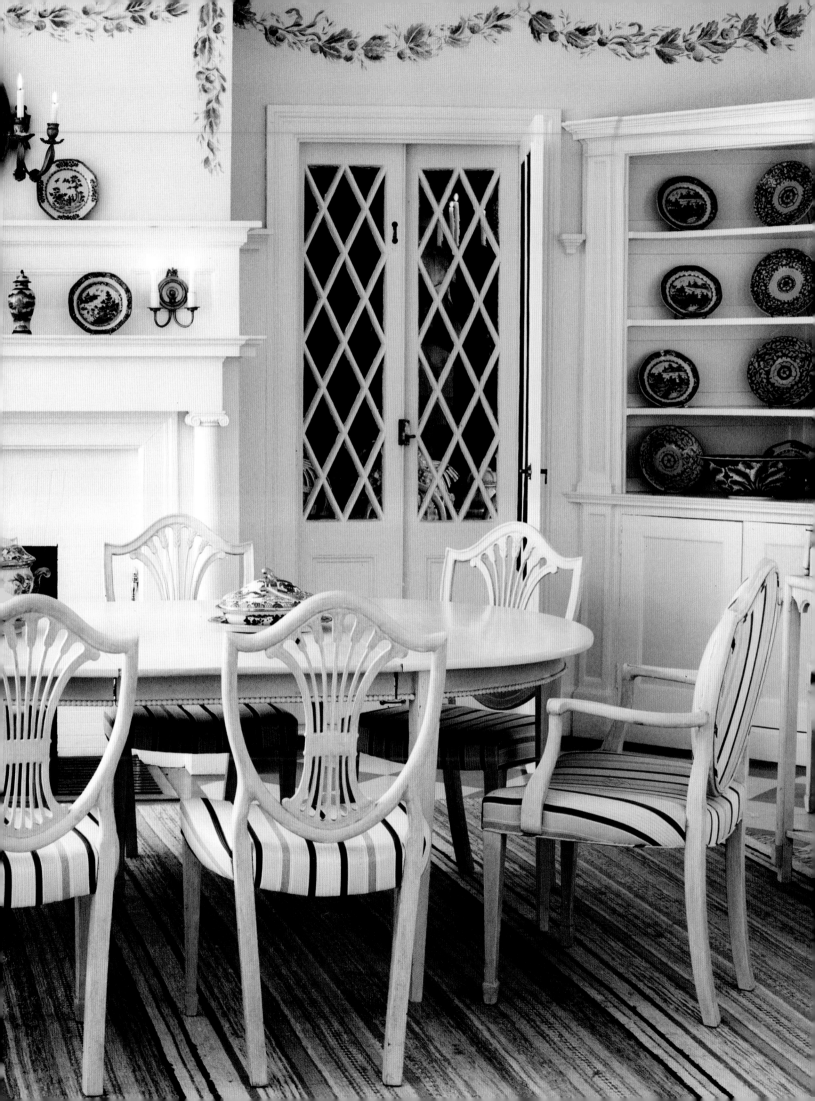

PRECEDING PAGES AND ABOVE *The blue-and-white dining room was bordered with garlands painted by artist Lucinda Abbe. We used a mixture of chairs in the dining room—shield-backs and balloon-backs, some with stripes, others with checks—but all whitewashed to work together.*

OPPOSITE *At the foot of the main staircase, we placed an antique Mora longcase clock made of waxed pine. A rag runner climbs the stairs.*

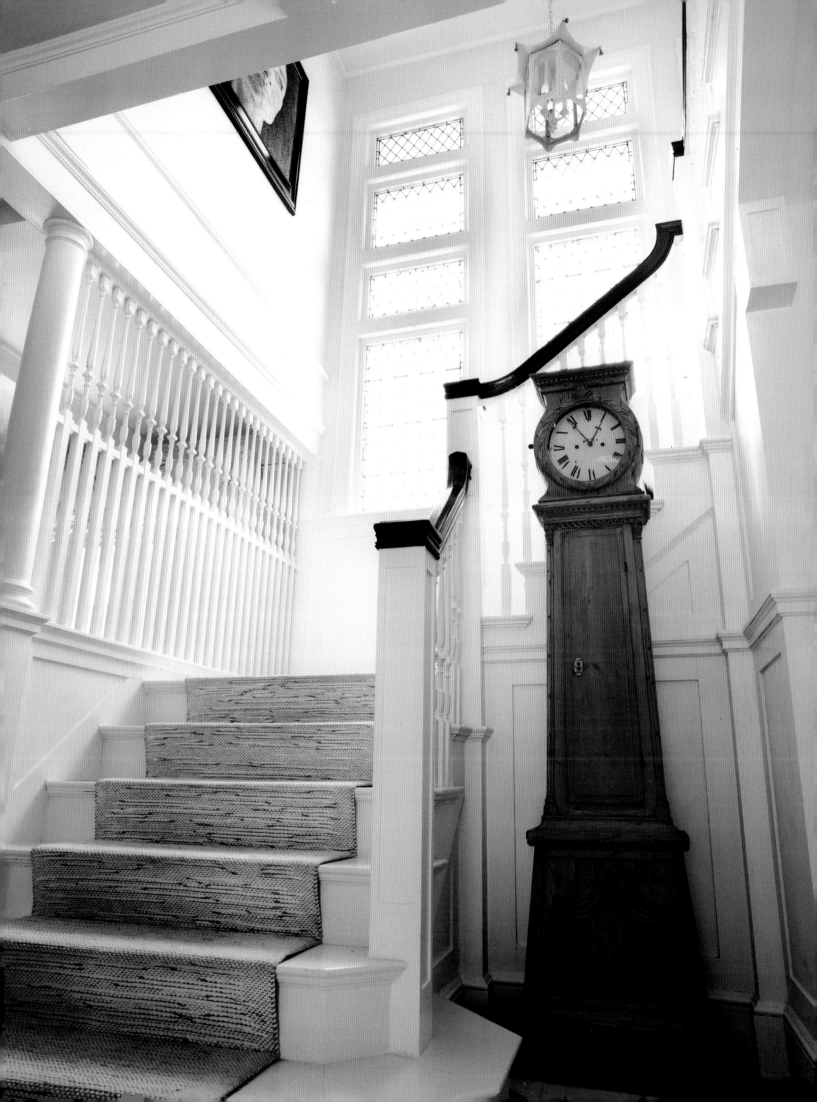

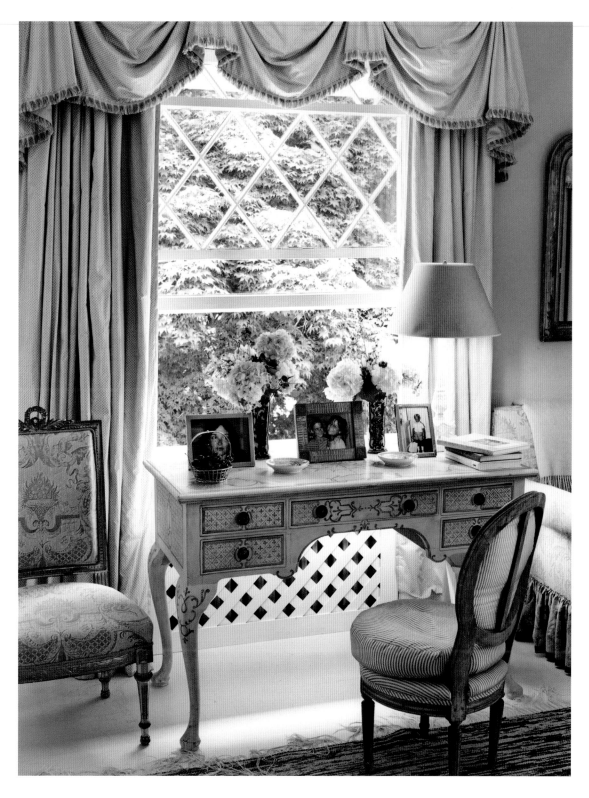

OPPOSITE *In our bedroom, an overmantel mirror with reverse-painted garlands recalls the dining room florals painted by Lucinda Abbe. The little landscape reminded me of Sweden.*

ABOVE *Painted decoration and a loosely marbleized top put a Scandinavian spin on a cabriole-legged desk, as does the mattress ticking applied to the French Provincial chair.*

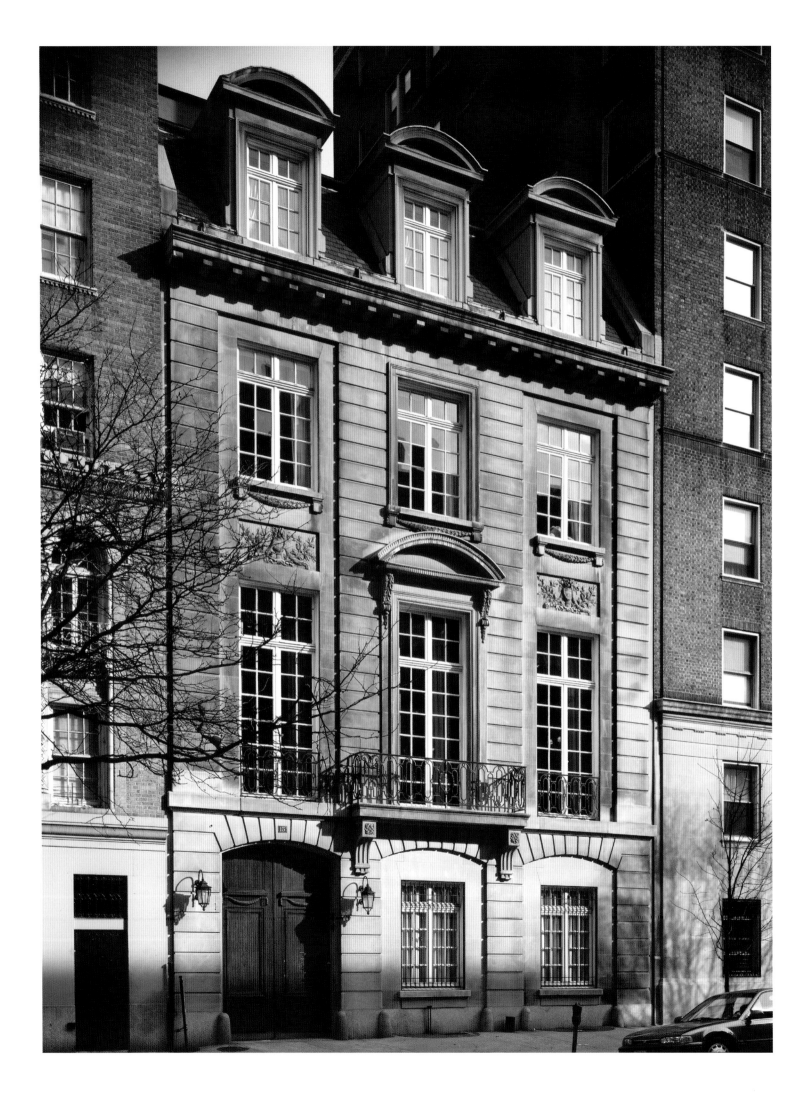

Mark Hampton was shocked at the idea when I told him that Shelby and I were going to rent Manhattan's Cartier mansion. "You can't live there," he admonished me. "You're not Jayne Wrightsman. You don't have eighteenth-century French furniture. Who do you think you are?" I might not have been Mrs. Wrightsman—society doyenne, collector, and philanthropist—but I wanted him to decorate that beautiful house. After some trepidation, he warmed to the idea, especially after I told him, "Yes, I can live there. We will make it beautiful."

It was easy to understand why he agreed: the house is one of architect Ogden Codman Jr.'s masterworks, a classical French mansion built in 1916 for the wealthy divorcée Lucy Drexel Dahlgren. Strangely, neither she nor her children spent much time living there. Dahlgren ended up renting it in the 1920s to the French jeweler Pierre Cartier, who lived there with his wife and children, and at some point, the house became a convent before being turned back into a private residence. Mark was right; its palatial atmosphere and twenty-odd rooms demanded that you live up to it. Friends thought we were crazy, but the kids loved all the space, because they could disappear, and I didn't always know where they were. It also had features that few other Manhattan residences possess. One was the elaborate pipe organ in the living room, which we hired a musician to play at Christmas parties. Another was the driveway.

"It was very odd to live in a house so big," my son Jack Bryan says of the Cartier mansion.
"After a year of living there, you'd say, 'I've never been in this room before' or 'I didn't know we had
this guest room.'"

The approach to the house was through wooden double doors on the left side of the building, which swung open to reveal a drive paved with cobblestones. Originally, a horse-drawn carriage would have dropped passengers off inside, at the front door, to the right of the drive. The vehicle would have made its way to the garage at the far end of the drive, where the horses were removed from their harnesses and put on an elevator that took them below ground to the stables. The floor of the garage had a lazy Susan mechanism, a turntable, so the carriage (or, later, a car) could be rotated to face the double doors. Once the horses had been brought back up from the stables and hitched to the carriage, the coachman would pick up the passengers at the front door. Then, the double doors would open to the street. It was a feat of engineering.

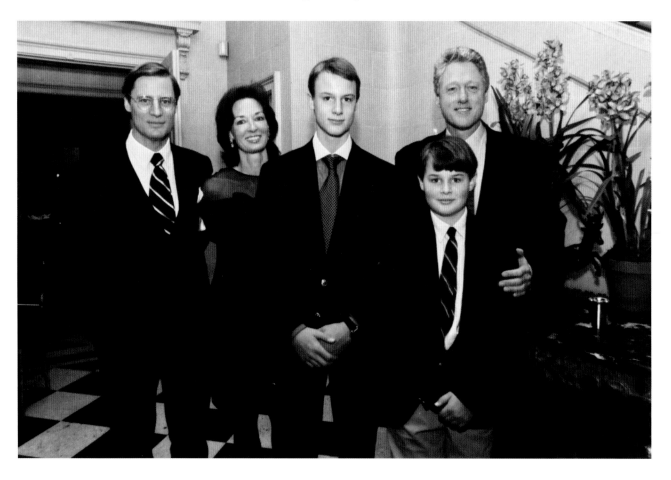

President Bill Clinton at the house with Shelby, me, and our sons, Jack and Austin, during a fundraising event.

The Cartier mansion had been designed for entertaining, so it was a perfect stage for Shelby's work as finance chair for the Democratic Senate Committee. We had numerous political events there, including a dinner for President Bill Clinton. Political dinners don't sound like much fun, but they actually are, and are very informative, different from the usual dinner. We were thrilled to open up

the house for dinners and cocktail parties, and Mark, Shelby, and I had a great time dressing it up.

The kind of furniture that complemented the house, mainly Régence, a style that I particularly love, wasn't very fashionable in the mid 1990s, and, luckily, it was priced accordingly. Some of the most perfect furnishings, which were going unloved at auction and gathering dust at shops, found a home with us. We went to many auctions in London, and recycled a lot of furniture from previous houses, too. Mark designed an elegant *lit à la polonaise* for the main bedroom—I still have the sketch—but we ended up just using the simple headboard we already had. Still, Shelby and I certainly didn't have enough furniture for a house with so many rooms, some of which had very specific shapes that had to be taken into consideration.

I was surprised when I found a Georgian octagonal table at Hyde Park Antiques, which was perfect for the octagonal dining room, where Codman had installed two fountains for rinsing wine glasses. The inner wall of the staircase was so high and vast that only a large tapestry—an art form that was unfashionable then and remains rather unfashionable now—would

Mark Hampton's sketch for the main bedroom's lit à la polonaise, *which we never had made, opting instead for the upholstered headboard from our previous town house.*

fill it. Eventually, we came across one depicting Zeus dramatically zooming across the sky in a chariot—sandals, armor, and headdress flashing. It was beautiful, but so difficult to transfer to later residences!

Not many people are in the market for a life-sized nineteenth-century portrait of a person who is not a relative, but Shelby and I were. The Cartier mansion was built in an era when portraits were essential elements of interior decoration—which is why we acquired an 1860s Franz Xaver Winterhalter painting of a French noblewoman for the library, among other paintings that we hung throughout the house. Though Winterhalter was Napoleon III's court portraitist, and famous for his portraits of Empress Eugénie, there was not a big demand for this very average-looking lady. One day, while passing Dalva Brothers, the legendary French furniture shop on East Fifty-seventh Street, my

eye caught sight of a beautiful Régence *canapé* in the second-story window. I began bargaining with Leon Dalva, the owner, and eventually, after many visits, many conversations with Shelby, and many negotiations, we bought that beauty! Upholstered in bronze silk brocade, it became the star of the living room, as we called Lucy Dahlgren's salon. I think Ogden Codman would have approved. ❦

RIGHT The entrance hall was of palatial proportions, so, like the Paris houses that inspired Codman, we furnished it simply, as a passage rather than as a room.

OPPOSITE An antique commode with chinoiserie scenes was the sole piece of furniture on the upper landing, again emphasizing its use as a passageway.

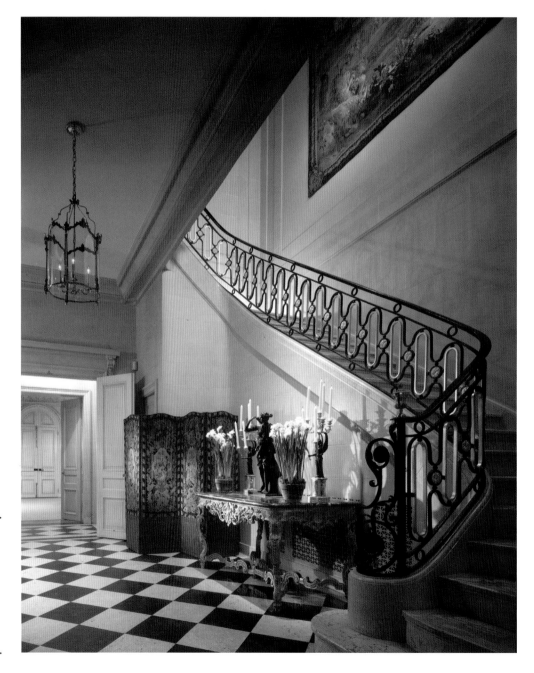

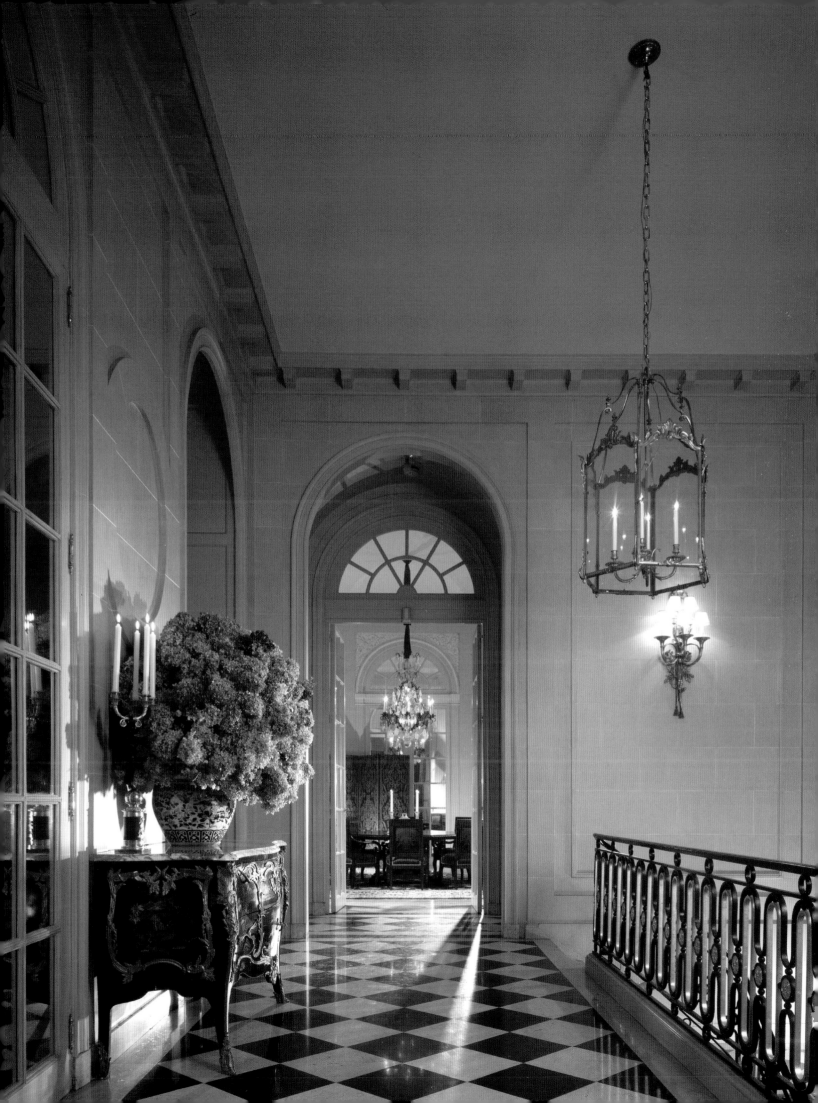

We found an octagonal table for the octagonal dining room and surrounded it with Empire chairs. The button-tufted armchair and sofa came from our East Seventy-first Street library.

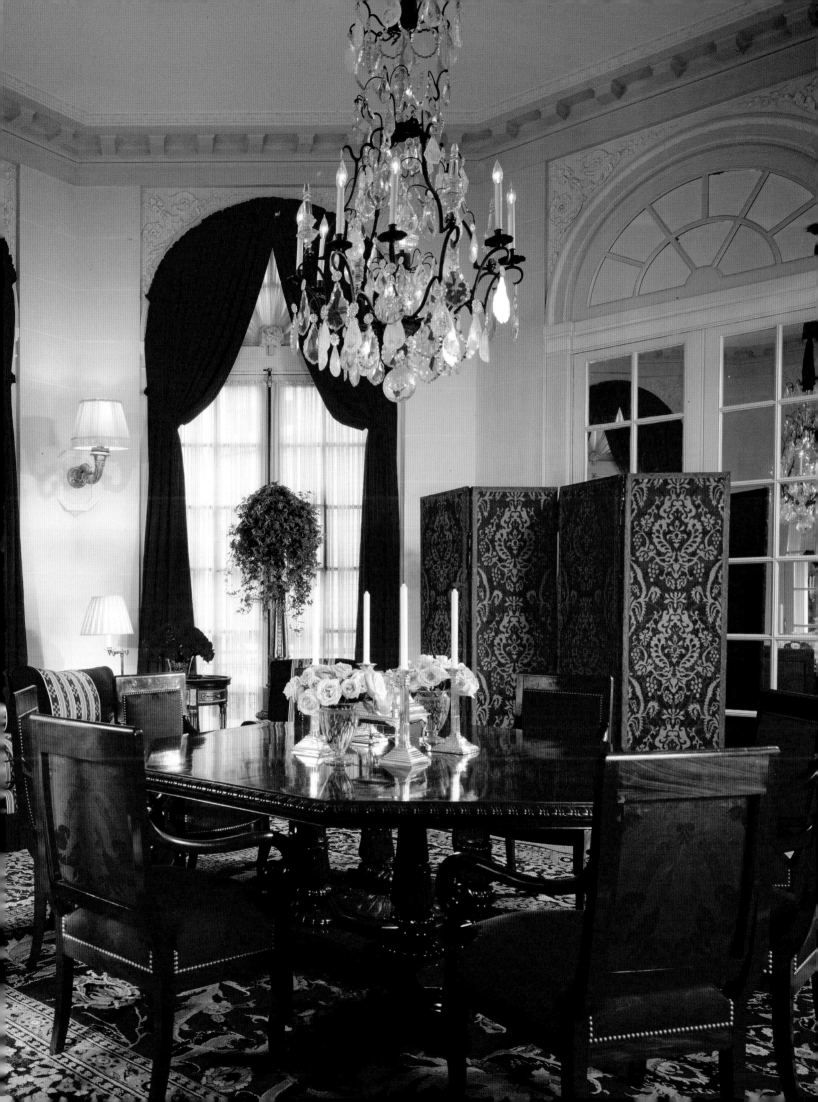

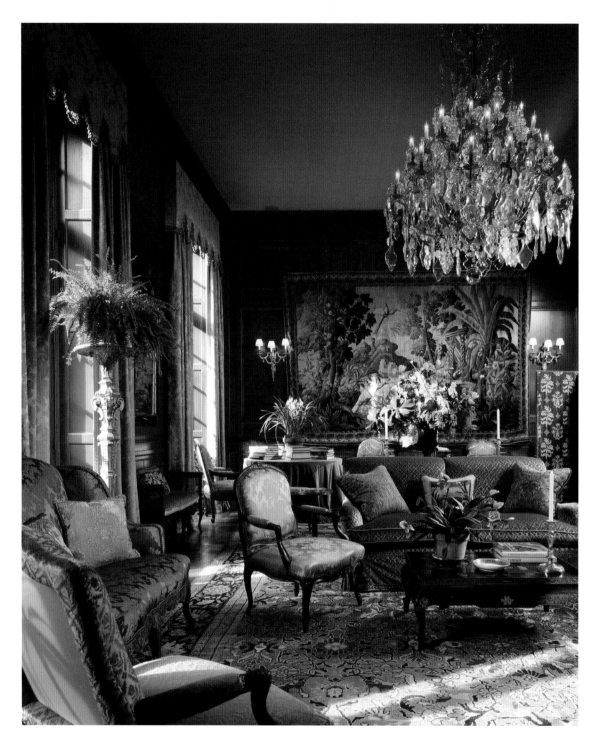

ABOVE *Large rooms need big works of art, so we selected a verdant antique tapestry to anchor one end of the living room. The colors for the upholstery, all figured fabrics, were taken from the Sultanabad carpet.*

OPPOSITE *A marble chimneypiece (the Régence clock came from our East Seventy-first Street living room) and inset mirror balanced the tapestry at the other end of the room. Fringed valances crowned the towering windows.*

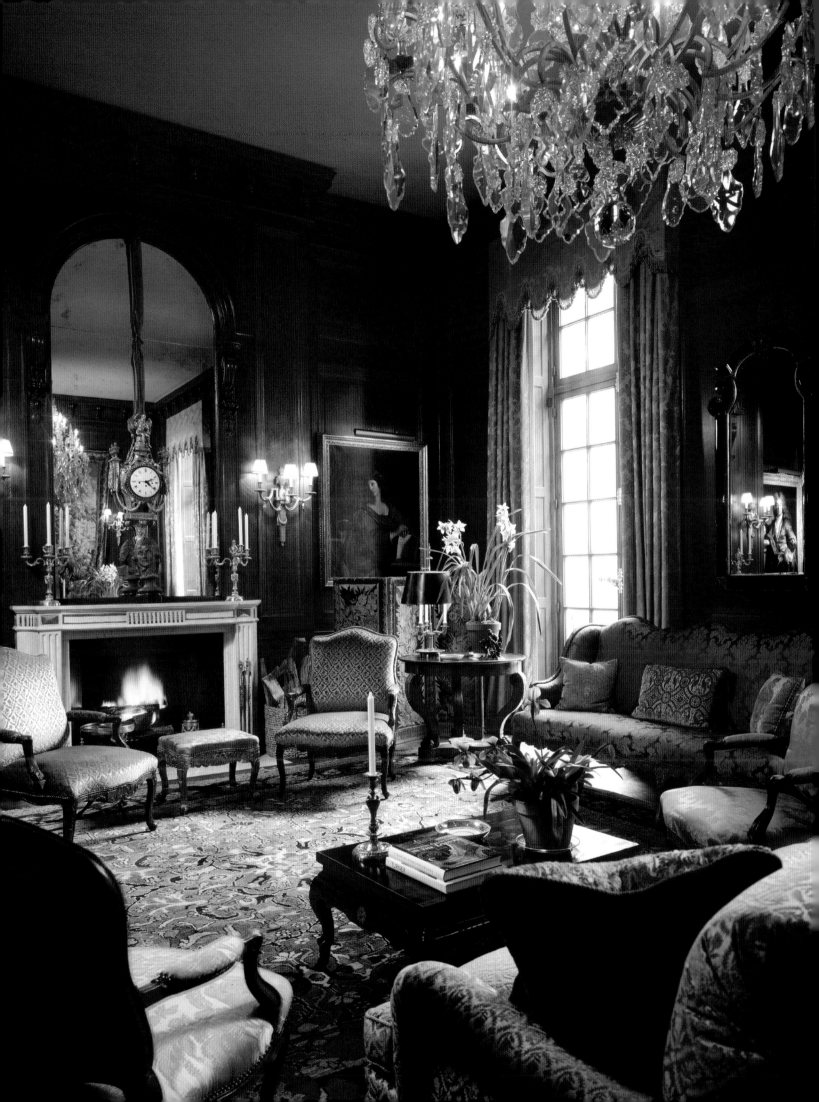

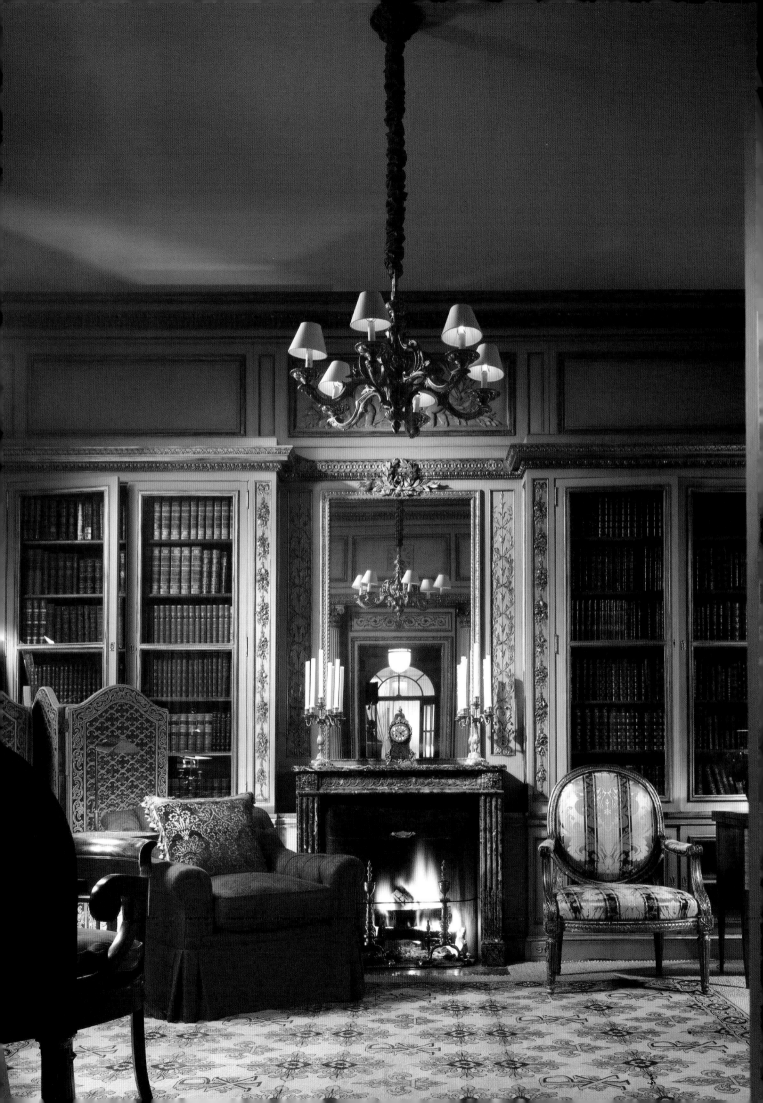

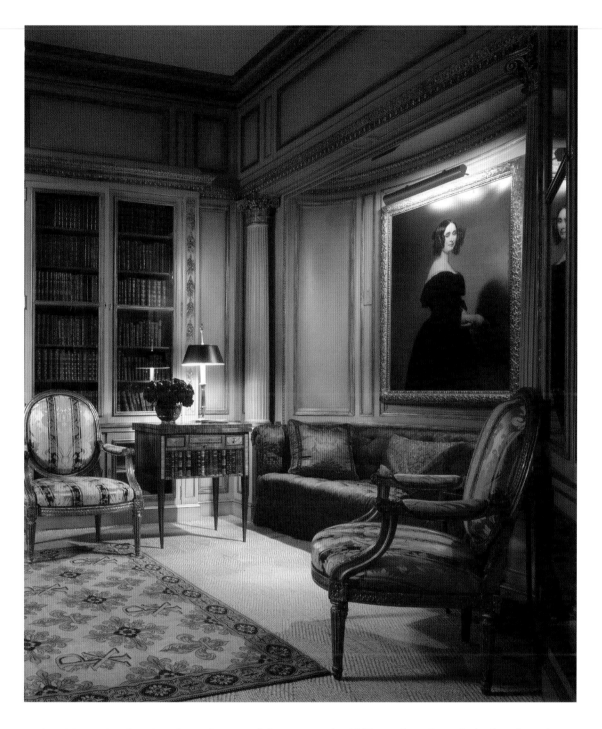

OPPOSITE *Our favorite color, red, accented the cream-and-gold library, from the ruched velvet sleeve that camouflaged the chandelier chain to the needlework carpet.*

ABOVE *A nineteenth-century Franz Xaver Winterhalter portrait was nestled into a curved alcove, above a scarlet sofa. The chairs are Louis XVI giltwood, dressed in striped damask.*

FOLLOWING PAGES *Though Mark had designed a lit à la polonaise for this bedroom, in the end we opted for a simpler upholstered headboard, which we brought from the East Seventy-first Street town house, along with other items in the Roses & Pansies fabric.*

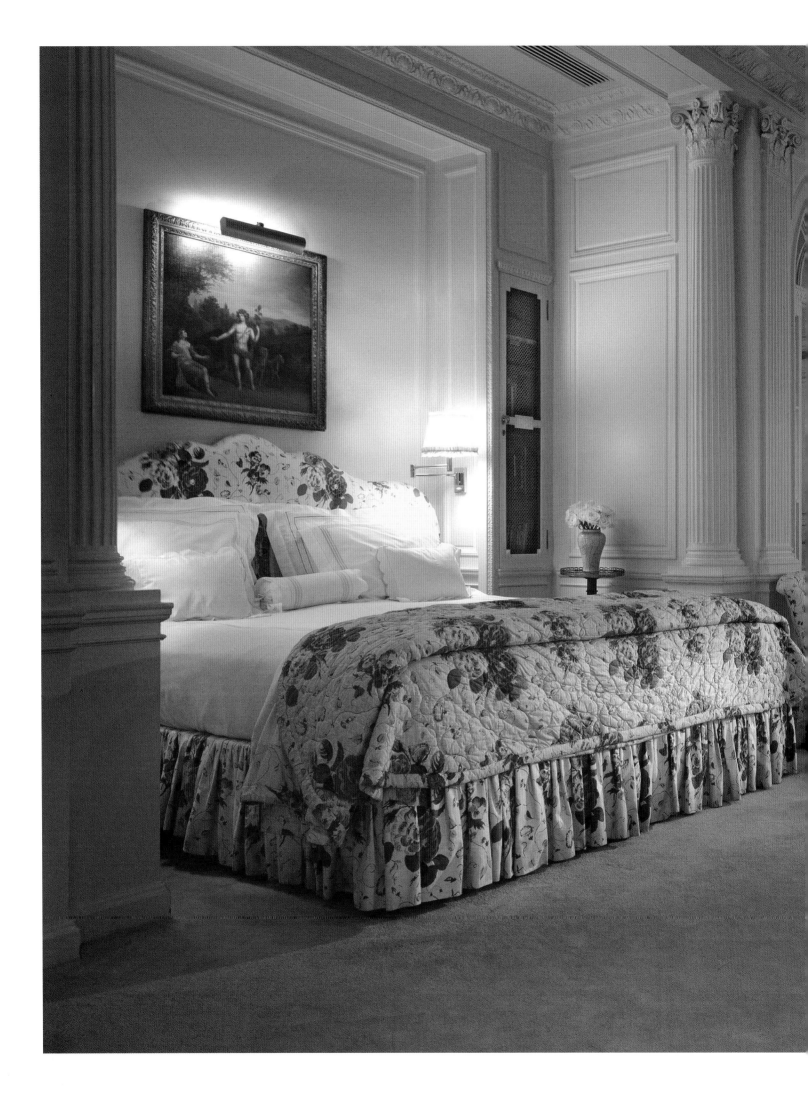

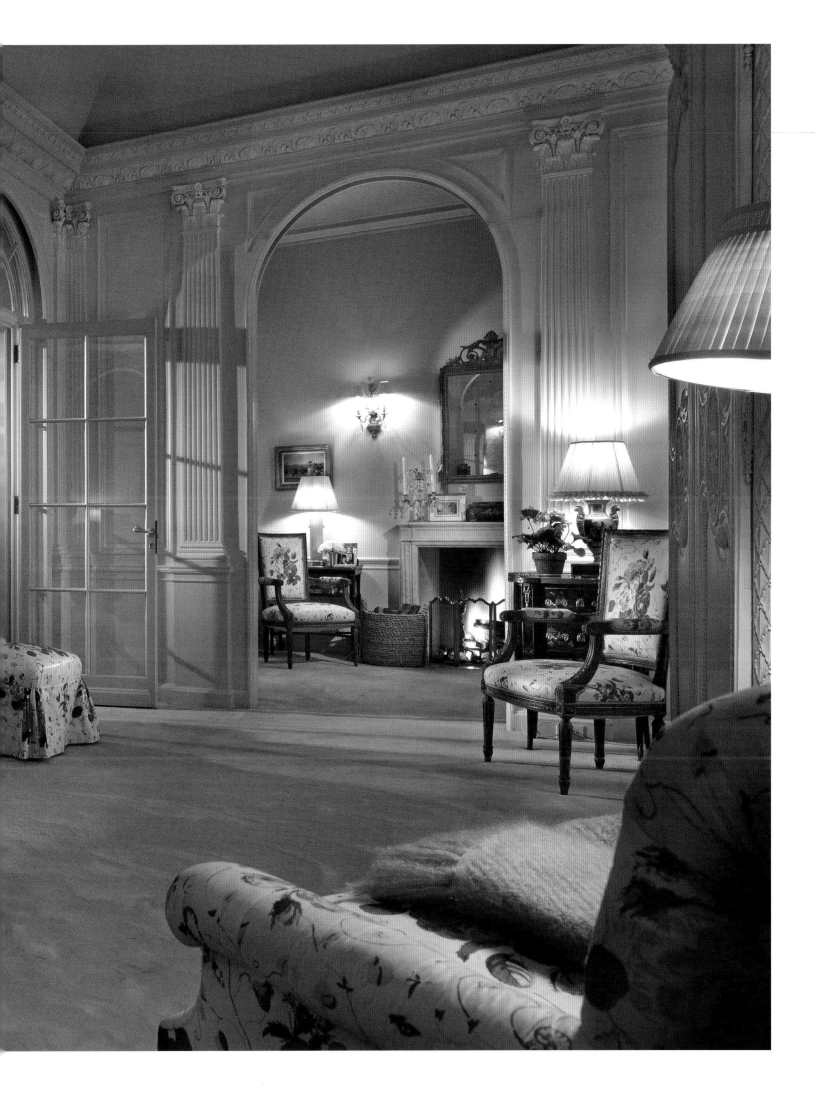

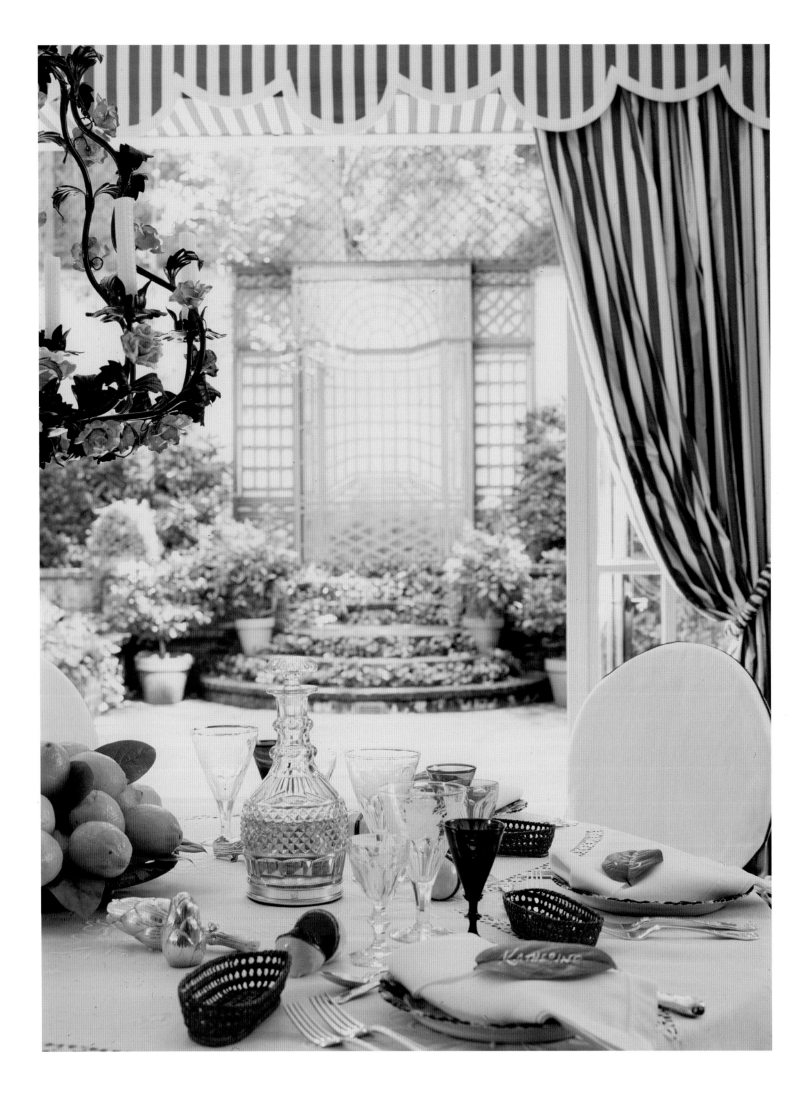

Classic Swedish style has a lot to recommend it: clarity, crispness, simplicity, and freshness. My East Hampton house had many Swedish references, from geometric painted floors to sunny rooms decorated in schemes of blue and white. It is an easy style to admire and emulate. When I moved into a nineteenth-century brownstone on East Seventy-first Street, after Shelby and I were divorced—coincidentally, it was right next door to the house that Mark Hampton decorated for us—Susan Gutfreund, a good friend and another lover of Swedish style, stepped in to help me put it together. It was a great house for entertaining, too, with three rooms side by side on the main level, and, on the ground floor, a garden room adjacent to the dining room.

Susan's Fifth Avenue apartment had been one of my favorite places to visit for years, a duplex that was very luxurious but also very comfortable and full of interesting objects and art. She had worked on it with Thierry Despont and Henri Samuel, who created the romantic chinoiserie-style winter garden overlooking Central Park. Samuel also decorated her beautiful hôtel-particulier apartment in Paris, where couturier Hubert de Givenchy and his partner, fashion designer Philippe Venet, were her downstairs neighbors and close friends. Those seminal experiences led Susan to eventually take up decorating herself, and we both were looking forward to a promising partnership.

Tenting the dining room gave the space a plein air atmosphere, amplified when the doors were opened—and often left ajar all day—to the garden.

She and I would be using many of the furnishings that had been in various other houses of mine, among them the Cartier mansion, the house on Feeks Lane in Locust Valley, and my previous residence next door on Seventy-first Street. But the new house offered a completely different atmosphere than its neighbor. Though it faced north, it had lots of southern light, so we both felt that it needed a more relaxed, less formal hand than the city residences where I had lived before. Also, while the neighborhood was a place I loved, and the furniture, art, and objects had been with me for years, I was embarking on a new chapter in my life, creating a home for me and my children, one of whom was still at home.

In addition to great taste and boundless enthusiasm, Susan has real inquisitiveness and an eye for a bargain. She doesn't shop at all the places that typical decorators do. At IKEA—yes, IKEA—she discovered a blue-and-white floral-print cotton and proposed it for the walls and curtains of the long living room, a space that was encircled by a stately parade of Ionic pilasters. The room would basically be one pattern, a French decorating tradition known as *en suite*, and I loved the idea. The fabric was tremendously charming, the sort of material you could imagine coming across in a Swedish country house, even a palace, where it relaxes the stately architecture and formal furnishings. The Seventy-first Street house featured a lot of the former, and I owned a lot of the latter, so the fabric brought everything down to earth.

Susan Gutfreund found a now-discontinued IKEA floral to dress the walls of the living room. The glamorous effect belied the low cost of the fabric.

Loosening up the house was extremely important to me, because I was ready to stop living as formally as I had in the past. Susan and I selected materials with a humble hand and a summery sensibility. Grass cloth covered the walls of the library, and raffia matting was laid across its parquet floor instead of a traditional carpet. A boldly striped Rose Cumming fabric, the sort of stripe you see used for old-fashioned awnings in the South of France, tented the dining room, with a tabbed valance that was attached with Velcro so it could be pulled off and cleaned. Leaning against one wall was a large portrait of an Indian nobleman; the placement

felt right for some reason, more casual. Since the dining room accessed the walled and trellised garden, we added a chandelier and sconces that were decorated with porcelain flowers, and we carpeted the floor with a wonderful diamond-patterned emerald felt. Instead of a proper room, the space felt like a fantasy, as if it were a party tent that had been erected outside. As a result, every meal had the feeling of a special event.

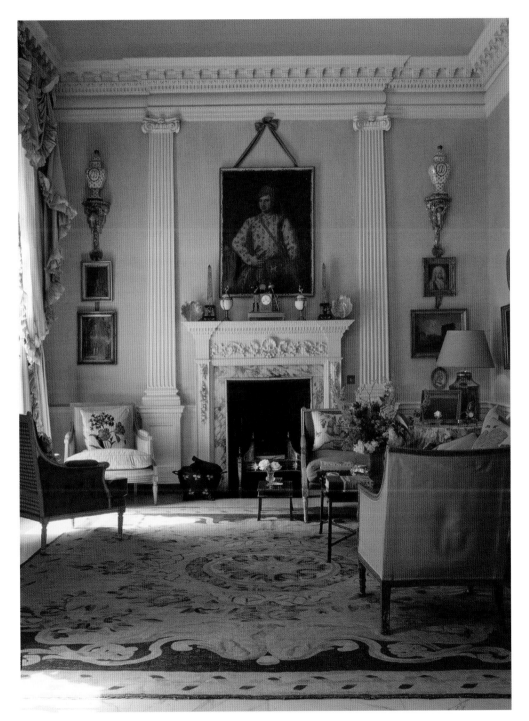

John Fowler famously decorated Evangeline Bruce's London drawing room, which I first discovered in the March 1991 issue of Architectural Digest *and which has influenced me for years. Above the fireplace is an Anglo-Indian portrait that I purchased and propped in the dining room (see pages 114–115).*

After a few years, all my sons were grown and on their own, so I decided to sell the house. The buyer was Charlotte Moss, another terrific decorator, and she and her husband still live there. She did such a phenomenal job of making my rooms her own—and beautifully so—that I enjoy going back to visit. ❦

RIGHT A detail of a chinoiserie lacquer screen, which features multiple garden scenes populated with musicians, courtiers, and pagodas.

OPPOSITE A carved wooden deer reclines beneath an antique Italian table in the entrance hall. The Empire candelabras came downtown from the Cartier mansion.

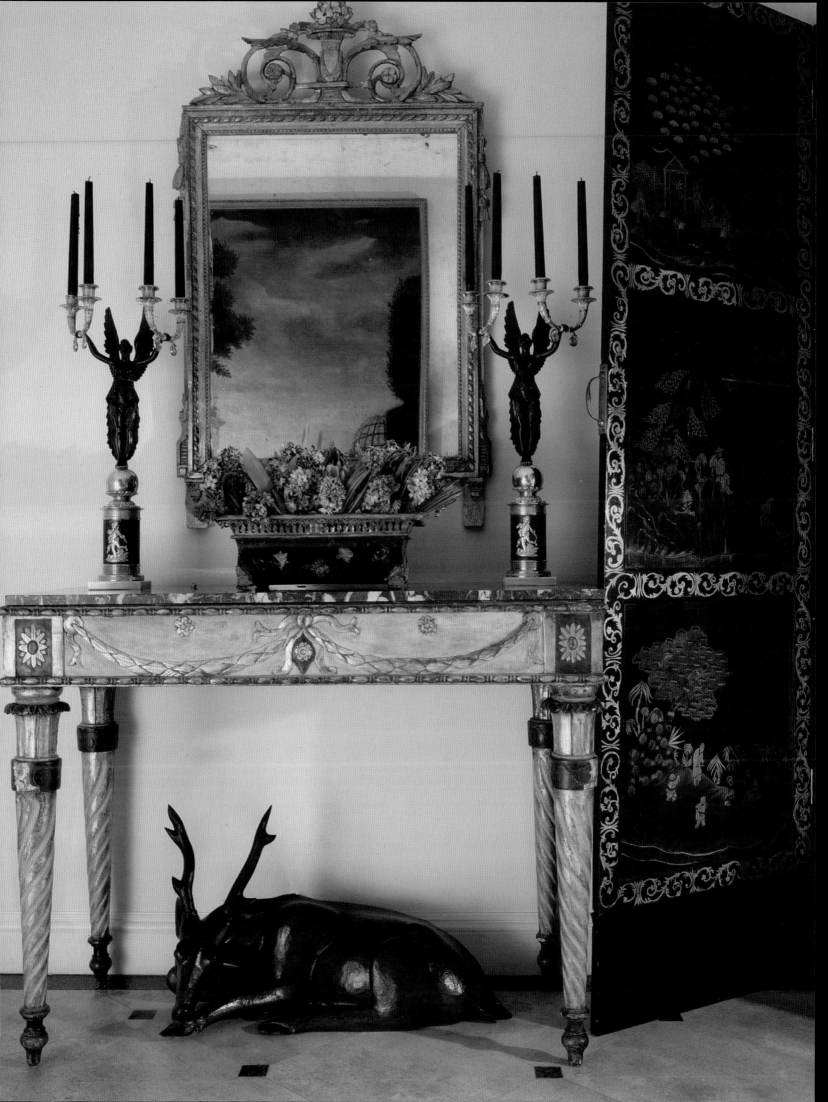

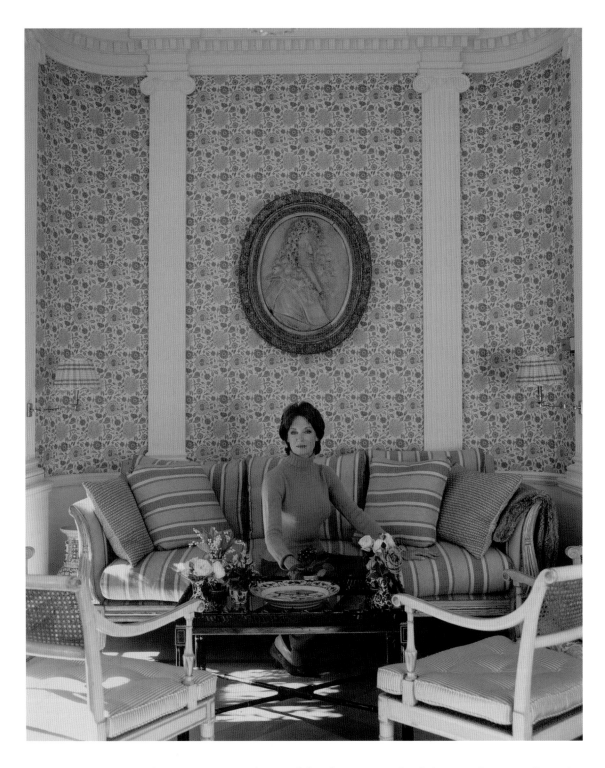

PRECEDING PAGES *The IKEA print gave the second-floor living room a Swedish air, as if it were a Gustavian pavilion in the countryside. Blue and white dominated the decor, from the painted floor to mattress-ticking cushions to garden seats.*

ABOVE AND OPPOSITE *We placed a long sofa in the living room's bowed recess, cushioning it with a simple but bold stripe. The portrait medallion is of a French monarch, flanked by ruffled lampshades with a cottage-like charm. Embracing the room's height led to some eye-catching ideas, such as stacking gilt-bronze sconces on either side of the fireplace.*

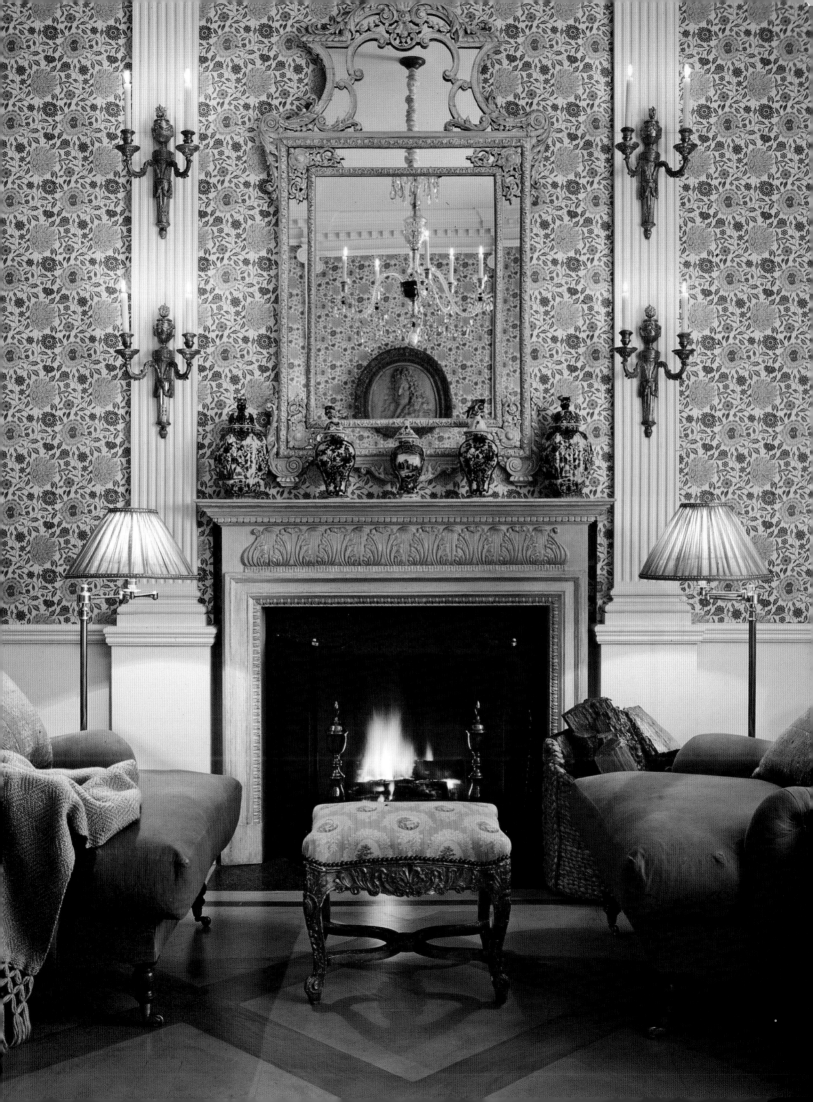

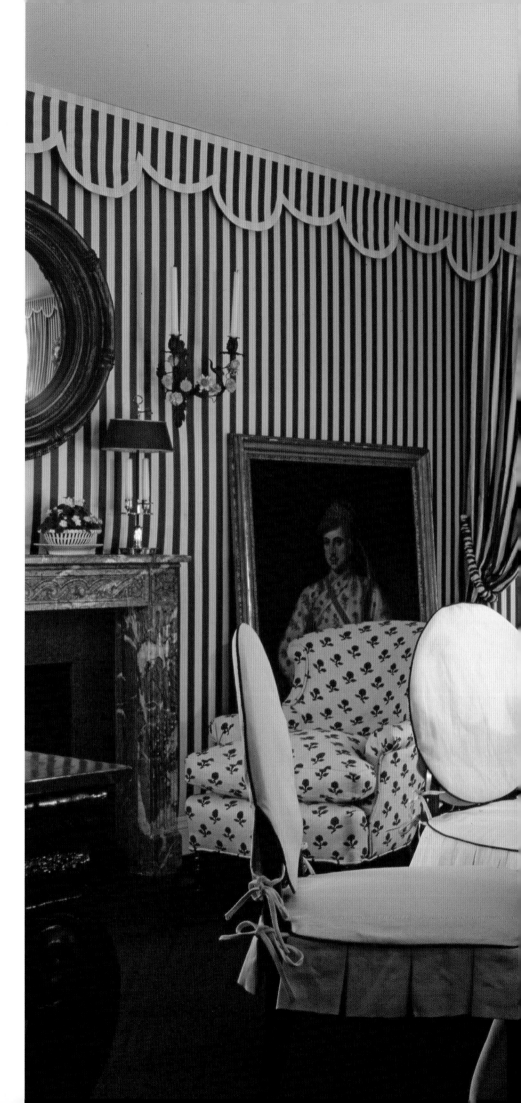

RIGHT A bit Napoleonic and a bit Côte d'Azur, the tented dining room—we used a Rose Cumming stripe—was relaxed rather than formal, a feeling underscored by the casual propping of Evangeline Bruce's antique portrait (see page 107) against one wall.

FOLLOWING PAGES The library was calmingly neutral, all browns and beiges, with touches of red. The walls were covered in grass cloth, the curtains were made of raw silk from India, and raffia matting served as a carpet.

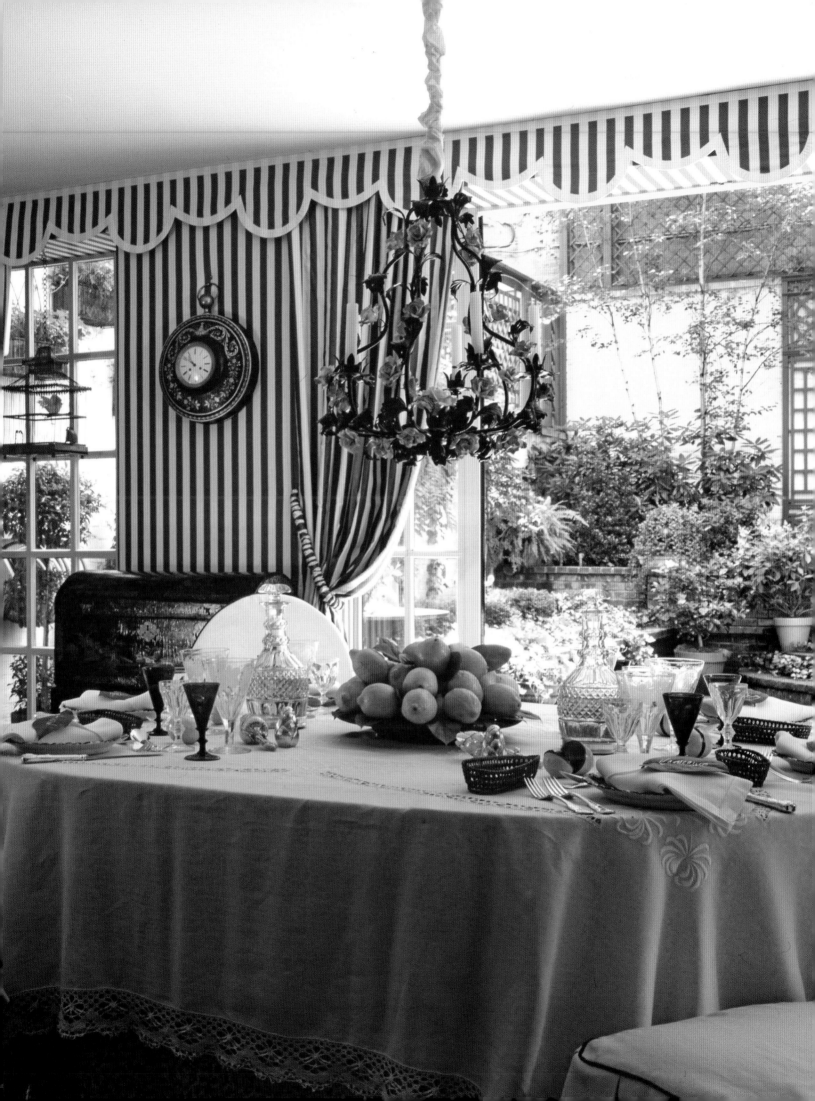

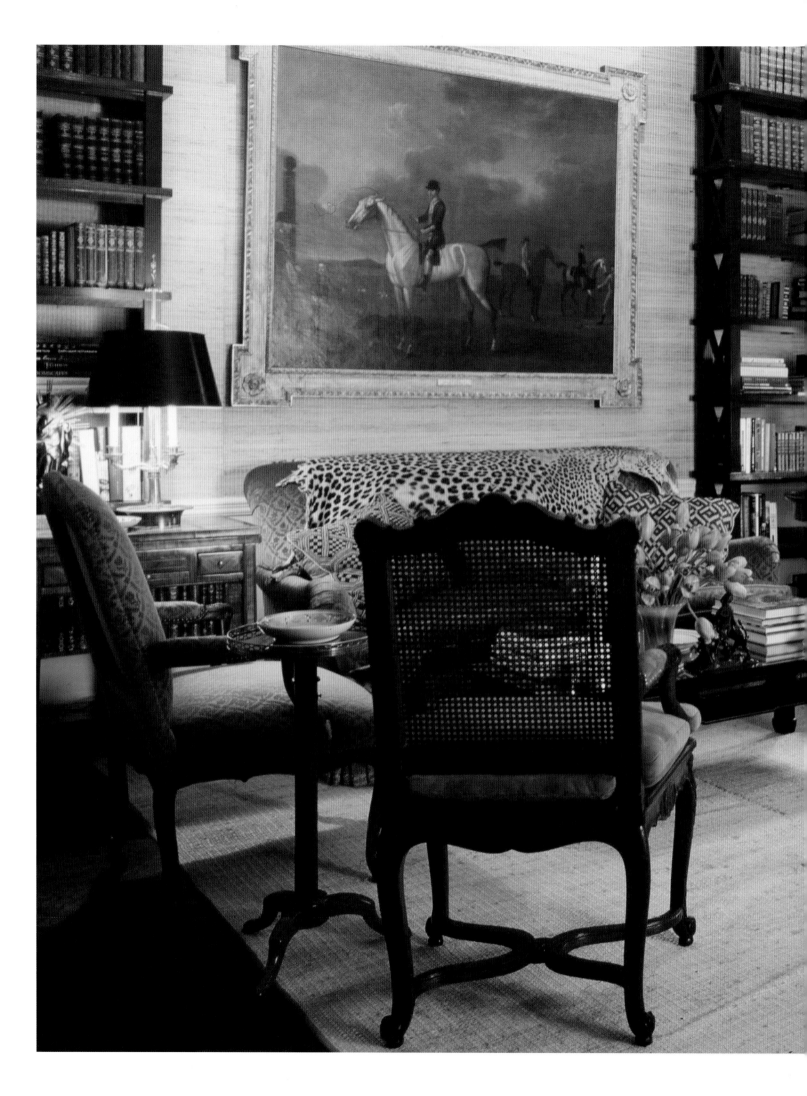

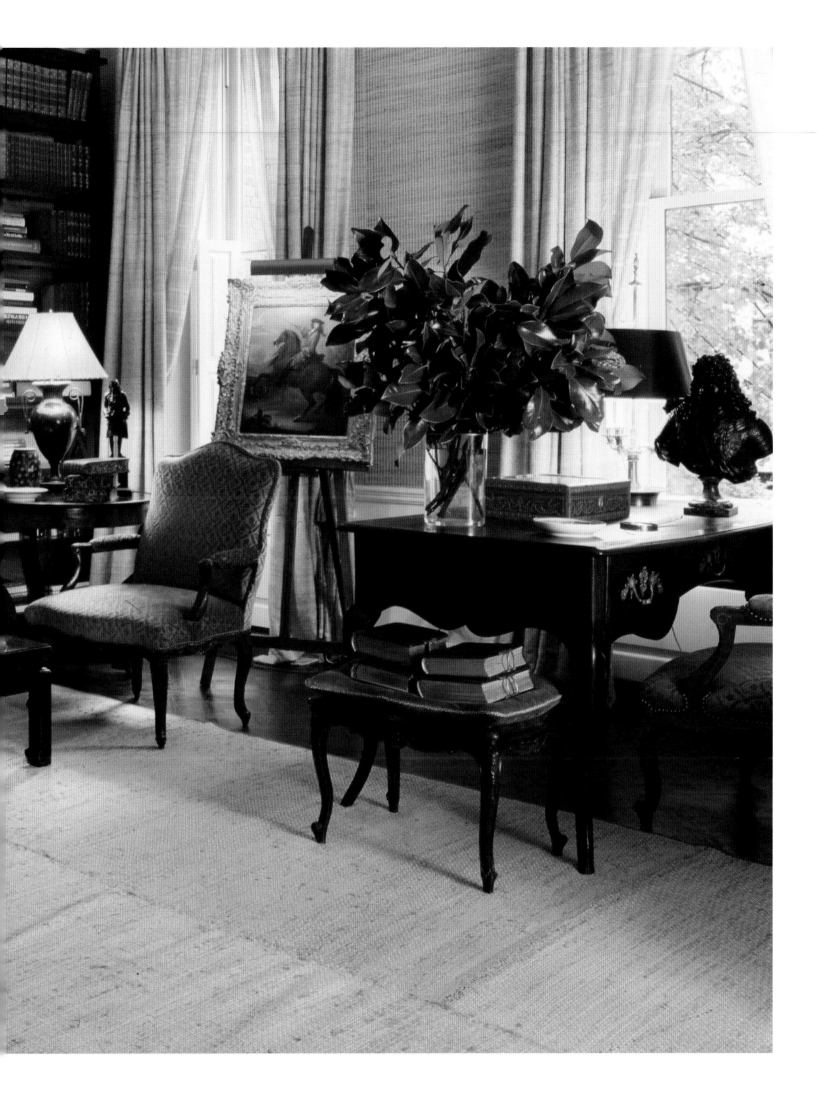

ABOVE *In the library, a portrait by Nicolas de Largillière hangs above an early eighteenth-century English table made of gilded gesso.*

OPPOSITE *A corner of my bedroom, where the dressing table mirror was draped, eighteenth-century fashion, in a length of lace.*

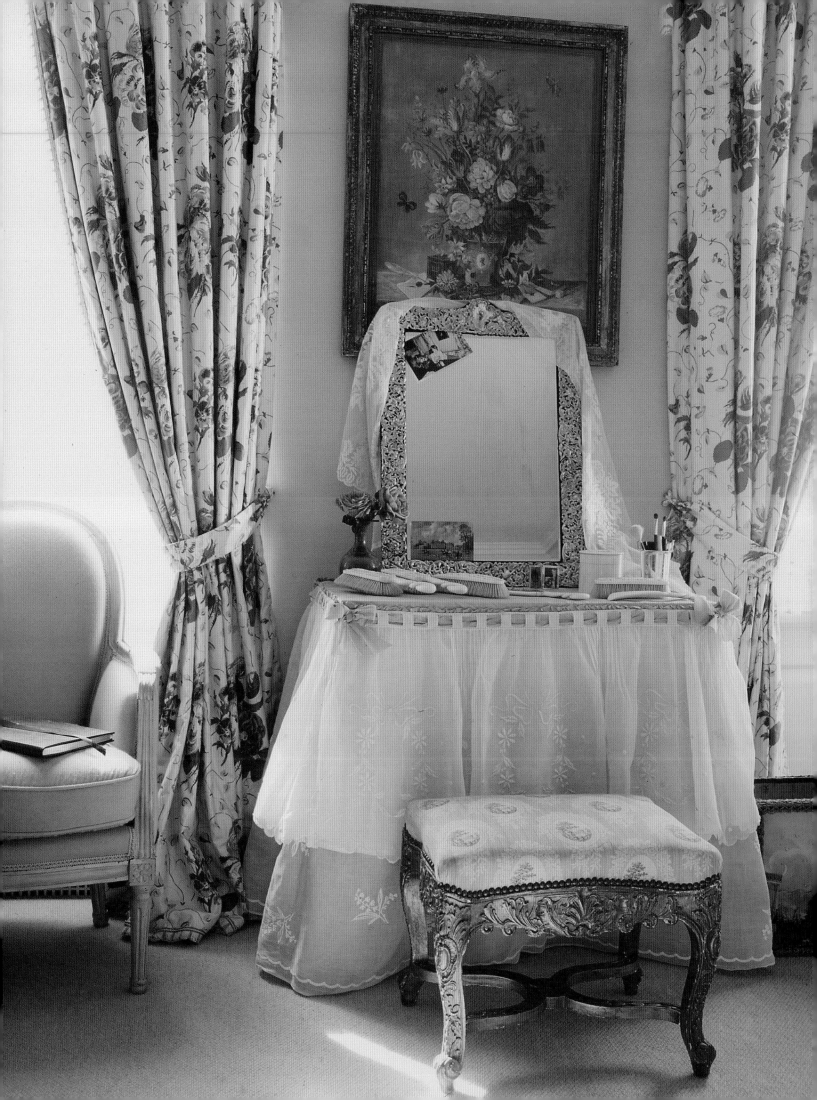

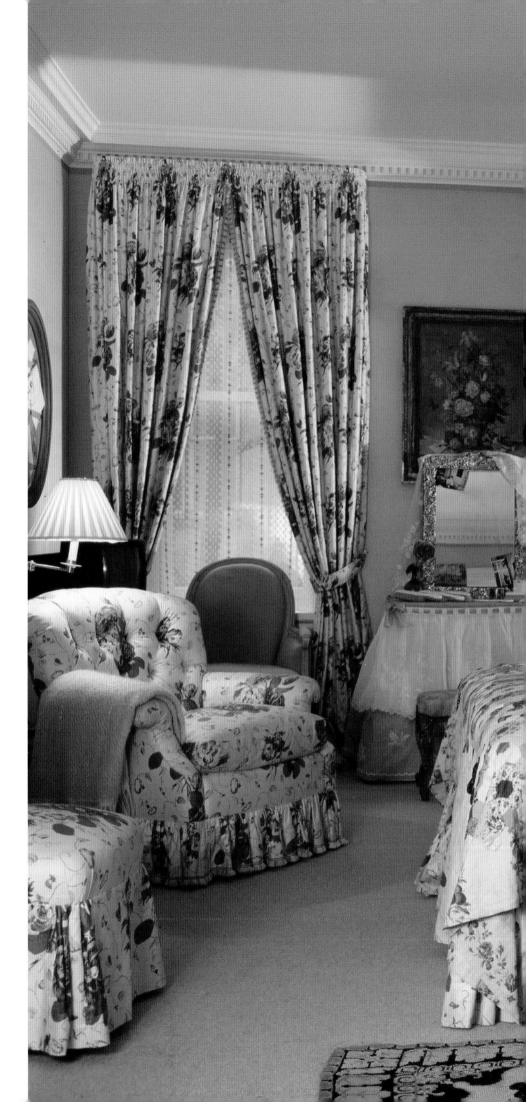

Susan and I managed to use many of the contents of the bedroom from my previous house, even though this room was smaller in scale than the primary bedroom at the Cartier mansion. A patchwork quilt loosens up the Colefax and Fowler floral.

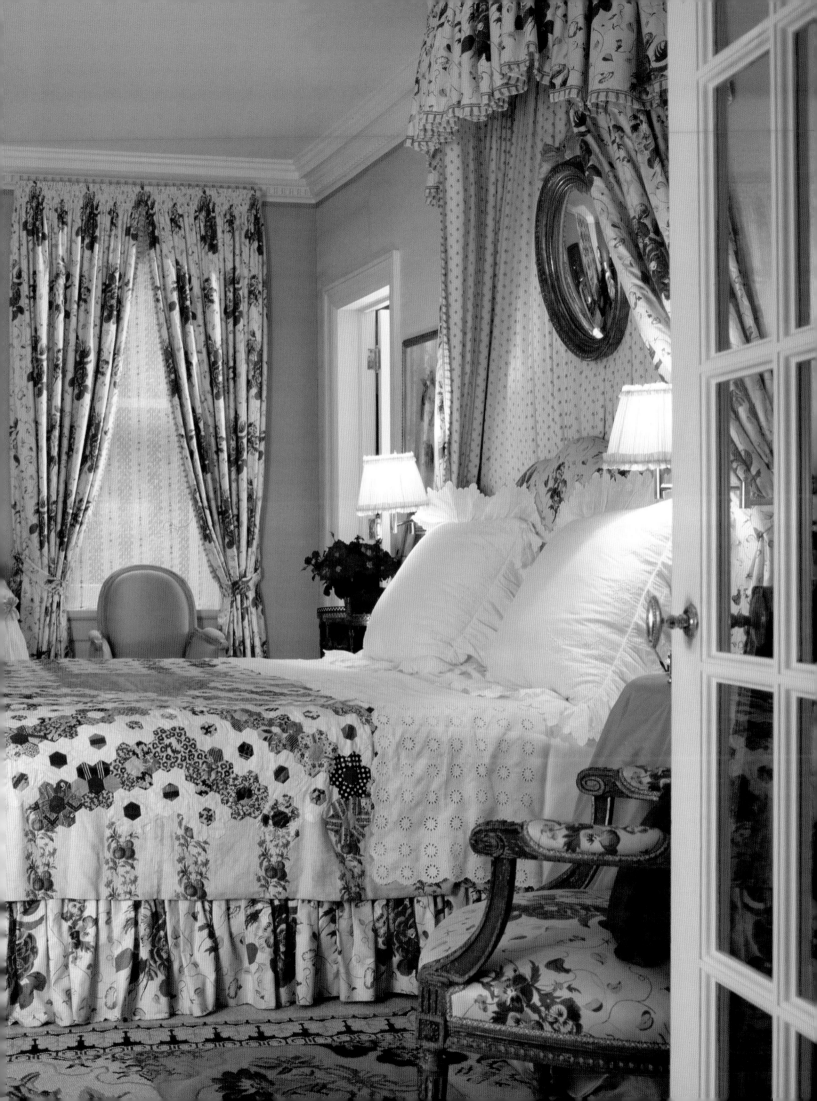

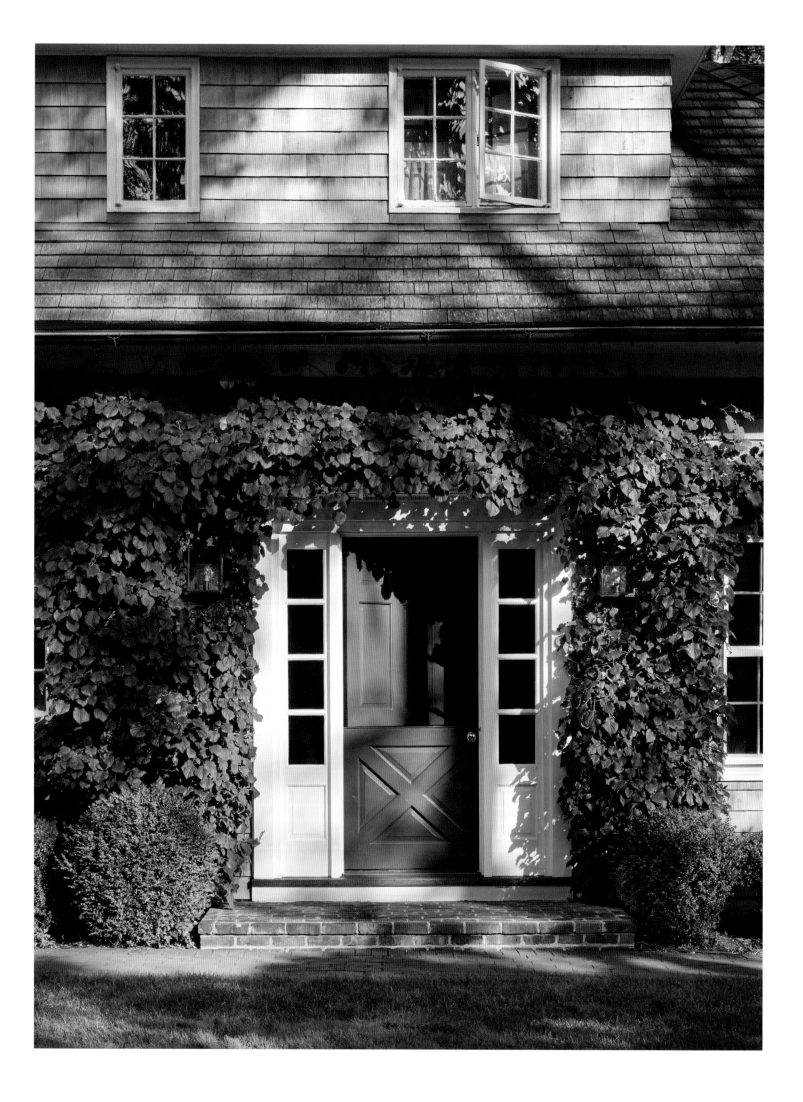

BAITING HOLLOW ROAD

East Hampton | *2003–present*

Regrets in life are inevitable, and for me, they are often related to a residence. There's always the one that got away. The house on Lily Pond Lane in East Hampton, which was my home for so many years, is the one place I wish I'd never sold. For a long time, I didn't think I'd find another that would please me as much or offer the same sense of welcome and security. I kept looking, admittedly without a great deal of enthusiasm. The trouble was simple: I was a bit spoiled. I wanted exactly the same house, with precisely the same landscape, in precisely the same location. Instead, about three minutes away, I discovered an entirely different but utterly captivating house, smaller but charming, much more of a cottage. It is where I now spend weekends and family holidays.

Living in a renovated barn has always been a dream of mine, perhaps related in some way to the rambling log house that my parents had near Kansas City and where I spent my teenage years. I never have moved into a barn, but my present home comes closest. Once a carriage house on an old estate, it had been moved to its present site from the top of a nearby hill. The architecture gives it the appearance of an illustration from a children's storybook: part Arts and Crafts, part Colonial Revival, with a Dutch door, a shingled exterior, and a picturesque roofline. Dan Lufkin, a co-founder of the investment firm Donaldson, Lufkin & Jenrette, had owned the house for a period of time, and he sympathetically enlarged it, making it more livable. Still, despite the increased square footage, it feels intimate. The property may be barely an acre, but it seems so much more

To my mind, the friendliest front doors are Dutch doors, especially on a house in the country. I've trained vines around mine, so the entrance—the upper half often ajar—draws your attention as you approach for the first time.

expansive. Mature trees and dense undergrowth give the impression that the house is nestled in a forest, though the actual vegetation is only about thirty feet deep. Since the rear of the house doesn't get an enormous amount of direct sunlight, I created a shade garden, inspired by one that I had once seen in Maine.

If the house on Lily Pond Lane told me and Mark Hampton that its rooms wanted to be Swedish in effect, the new retreat in East Hampton suggested the English countryside. Waxed and polished woodwork, mostly pine, is in abundance, from the beamed and paneled entrance hall downstairs to the beadboard in my bedroom upstairs. I would be decorating the place myself, but needed some advice, so I nervously called Albert Hadley, the great decorator who made up half of the famous firm of Parish Hadley and whom I had always admired. Figuring out what color to paint the living room was proving more difficult than I imagined—too many possibilities—so Albert, in his generous way, said he'd come out

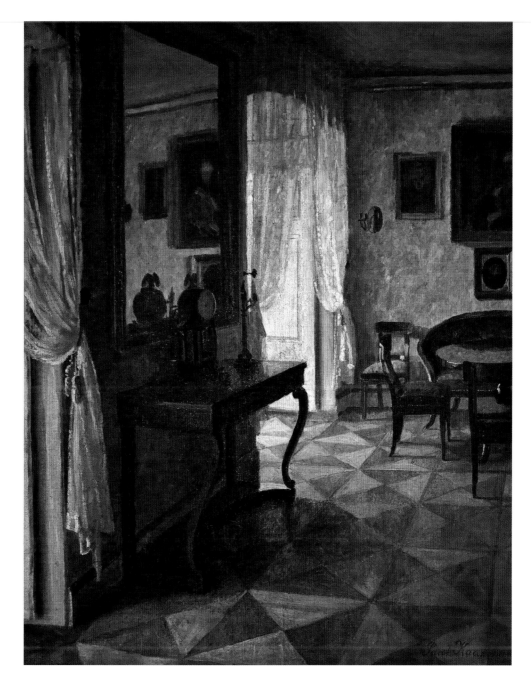

OPPOSITE A fairy-tale cottage in appearance, my house was actually a carriage house for a neighboring estate and later enlarged to become a more proper home.

LEFT Albert Hadley's eagle eye spotted the perfect yellow for my living room in a nineteenth-century painting I have.

to take a look; he loved exploring houses and offering insights, even if they weren't his own projects. "That's the color you want: yellow," he said, gesturing to the background of a Scandinavian painting that I hadn't hung yet. Who was I to argue with the man people called the dean of American interior design? Yellow the living room walls would be, and yellow they remain, a soft but sunny foil to the room's darker wood accents.

One of my longtime friends is Robert Lighton, the founder of the late, great clothing and furnishings company British Khaki, and his taste has influenced

me a great deal. Inspired by Raj-era furnishings made in India and other colonial spots in the nineteenth century, his designs are simple but also romantic, and they work wonderfully here. They are a bit like the furniture you imagine that Karen Blixen used at her famous farm in Africa—some beautiful tribal masks that I've set on tables and shelves heighten that allusion. Being made of mahogany or teak, the tones complement the dark-honey-color woodwork. White and cream-color upholstery, on the other hand, keeps the atmosphere feeling easy and relaxed. So does the entrance hall, which I use as a dining room. Once you open the front door and see the table and chairs, it feels like you're just minutes away from a cozy gathering.

Given that the house had been originally built to store carriages and tack, it seemed natural to incorporate animals—representative rather than real—into the rooms, such as a painting of monkeys on horseback. In a corner of the living room stands an elephant made of wood that I bought online, thinking that it was small, but which turned out to be as big as a golden retriever when it arrived. There are antlers, too, and a beautiful T'ang horse that had been in the collection of Evangeline Bruce. The house and its rooms have an English atmosphere, to my mind: relaxed, a bit quirky, and classic. 🐾

RIGHT A vintage cast-iron cow's head is mounted on the exterior of the shingled house, a reminder of the building's agrarian past.

OPPOSITE AND FOLLOWING PAGES The paneled entrance hall is used as a multipurpose space, largely for dining, though the table is also the perfect place to study or write letters or play board games.

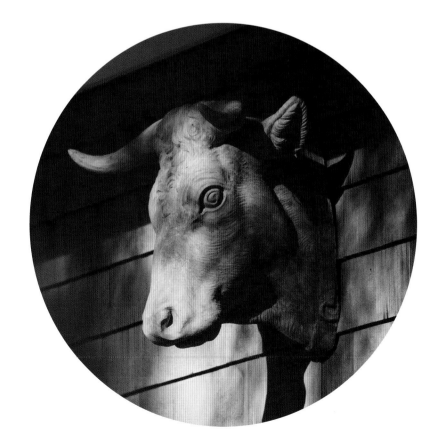

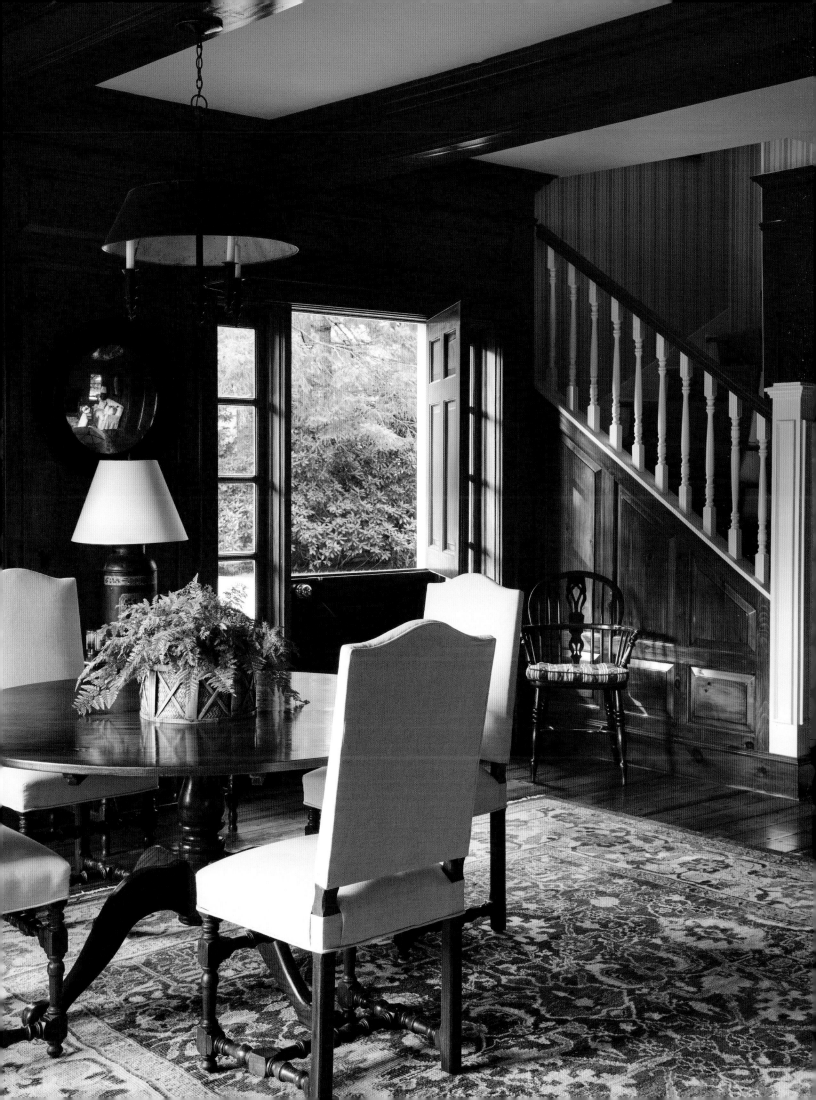

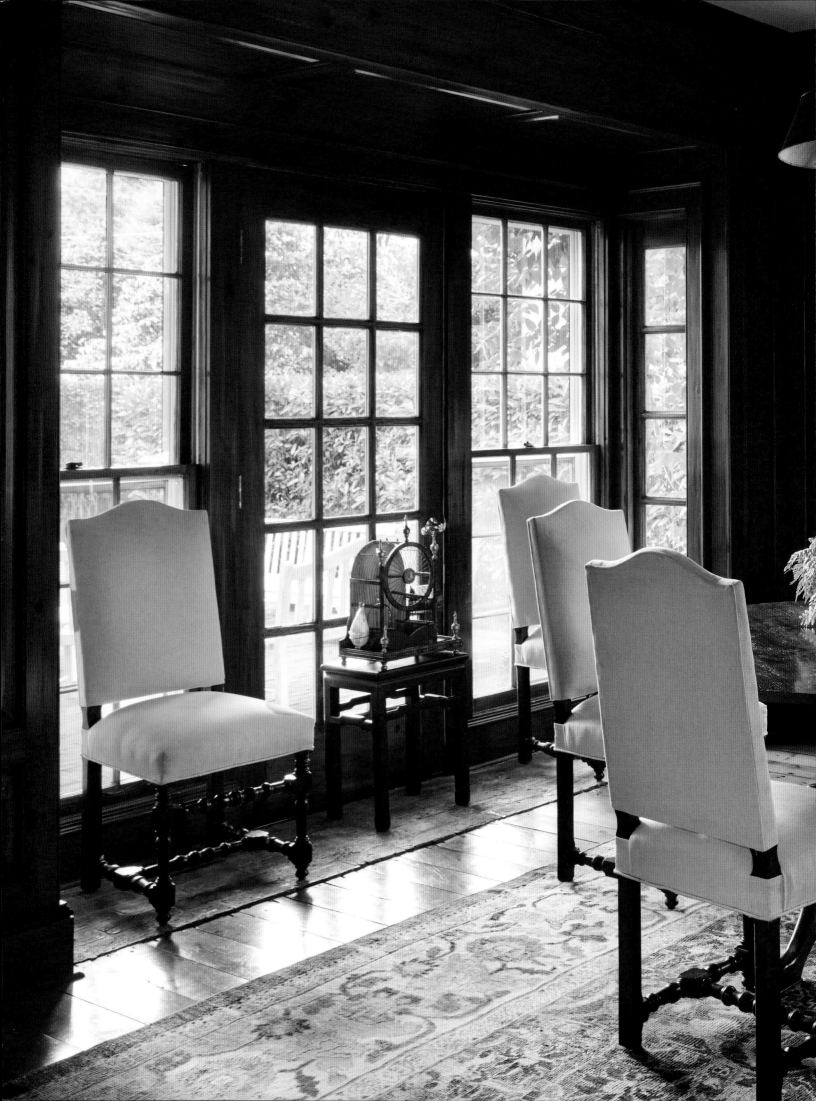

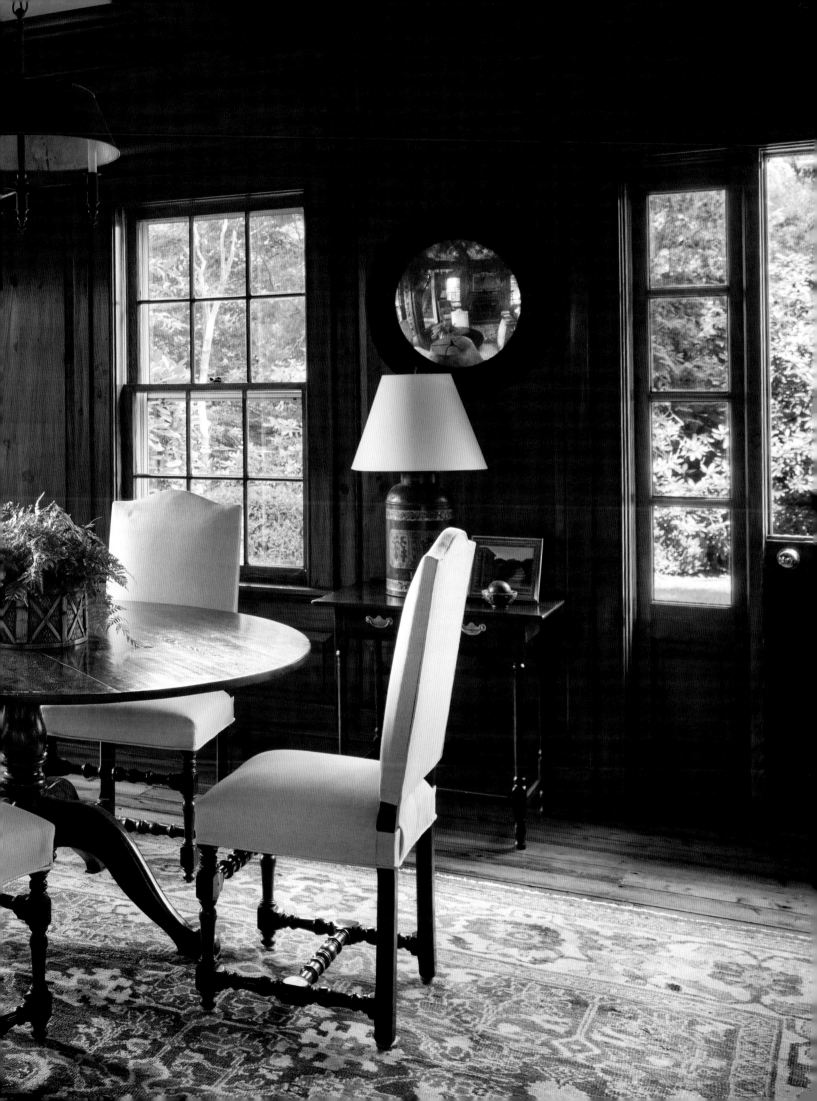

ABOVE Wood furniture of various styles and eras seamlessly blends with the pine paneling. Crisp cream-colored upholstery keeps darkness at bay, as does a stylized floral print on the pillows. My portrait by Sébastien de Ganay has followed me to several residences.

OPPOSITE An antique painting of monkeys riding horses, once owned by Evangeline Bruce, ensures that the carriage-house past is always present, as does the bronze dog sculpture.

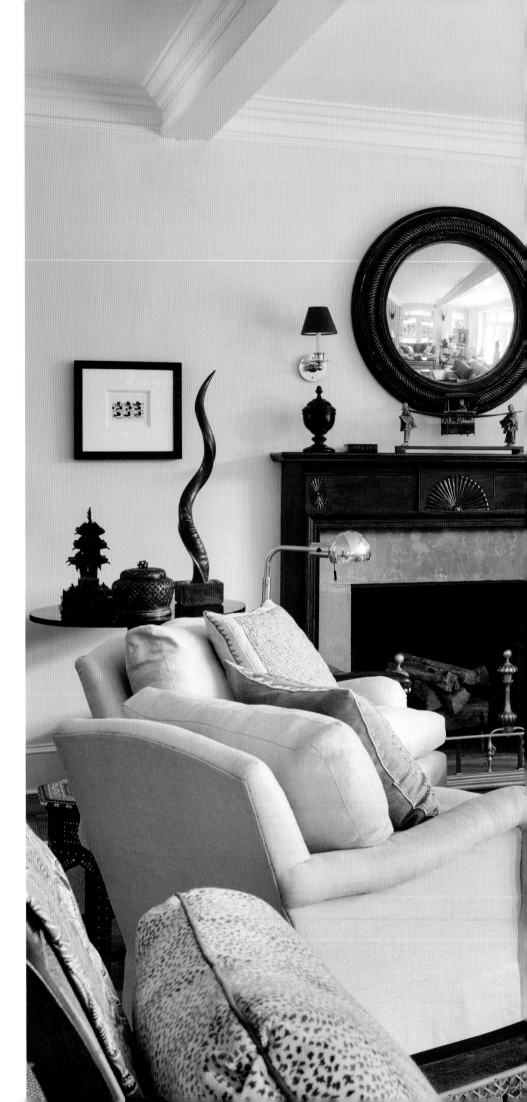

RIGHT "There's Asian, there's Turkish, there's Roman, Greek, and Etruscan stuff, and yet it all feels harmonious, like it belongs there," my son Jack Bryan explains of the living room. Albert Hadley, the dean of American decorating, chose the calming yellow color for the walls.

FOLLOWING PAGES The wooden armchairs in the living room were made by Robert Lighton, the founder of British Khaki. Faux fur is layered on the sofa, and African carvings stand on a side table.

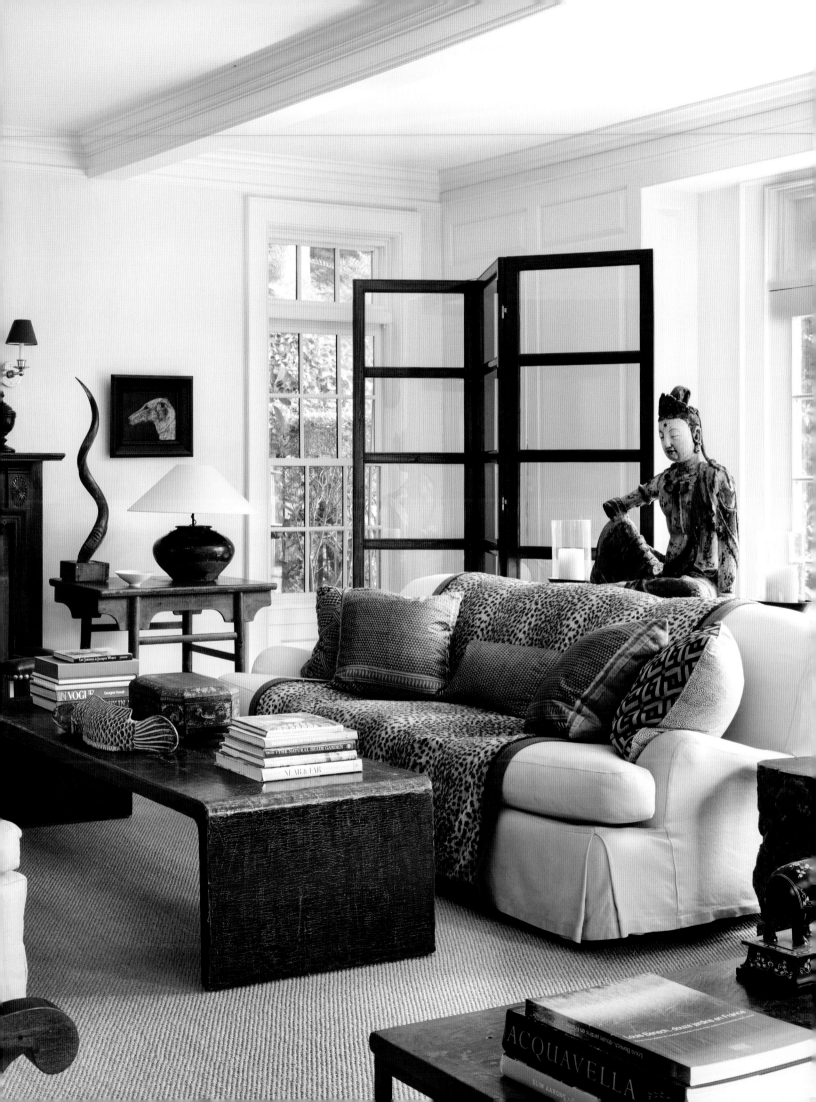

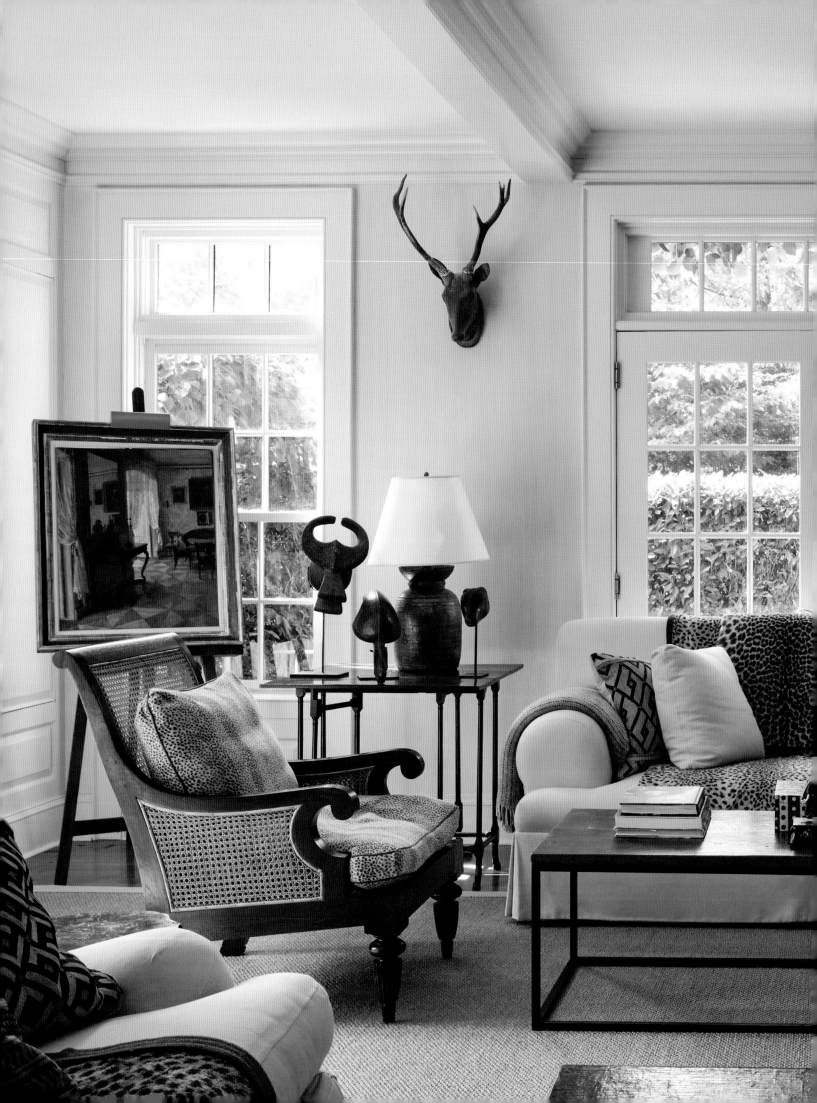

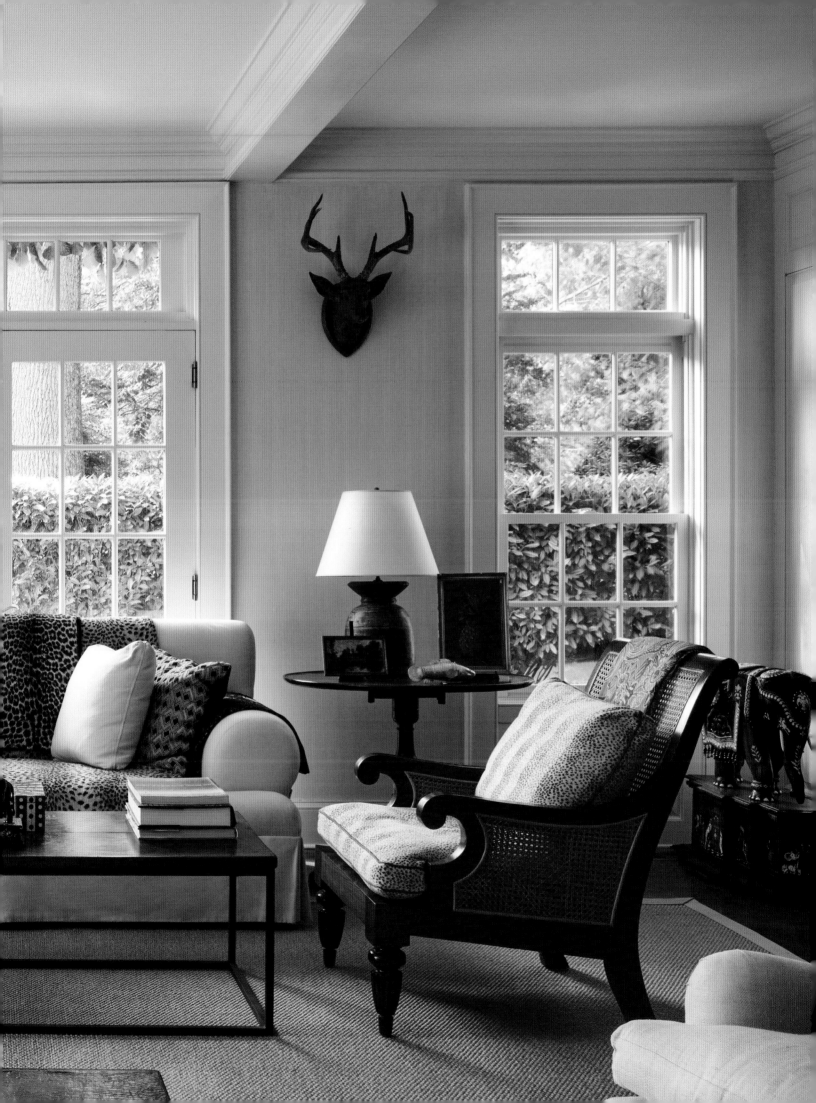

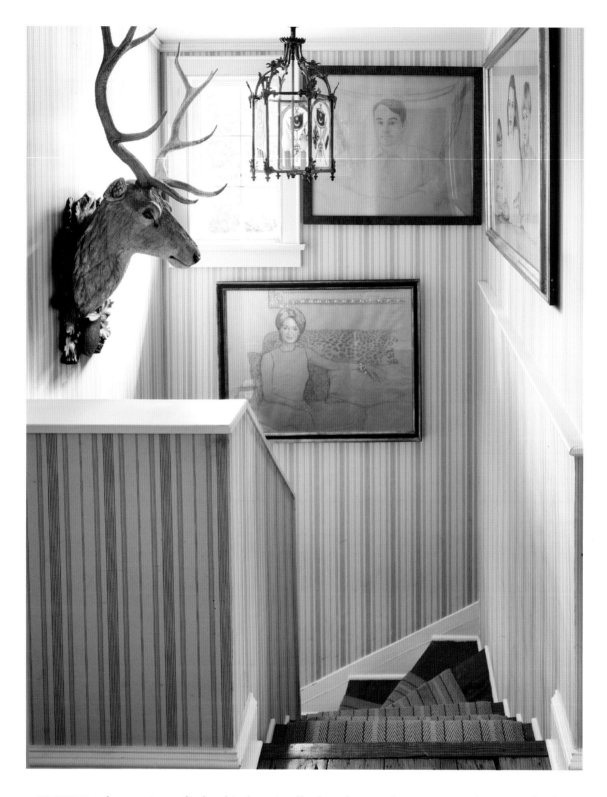

ABOVE Family portraits are displayed in the stairwell, where they seem less pretentious than over a fireplace. The German deer head is a carved and painted trophy.

OPPOSITE An English portrait of a child is tucked in an alcove in my bedroom, alongside a British Khaki sofa.

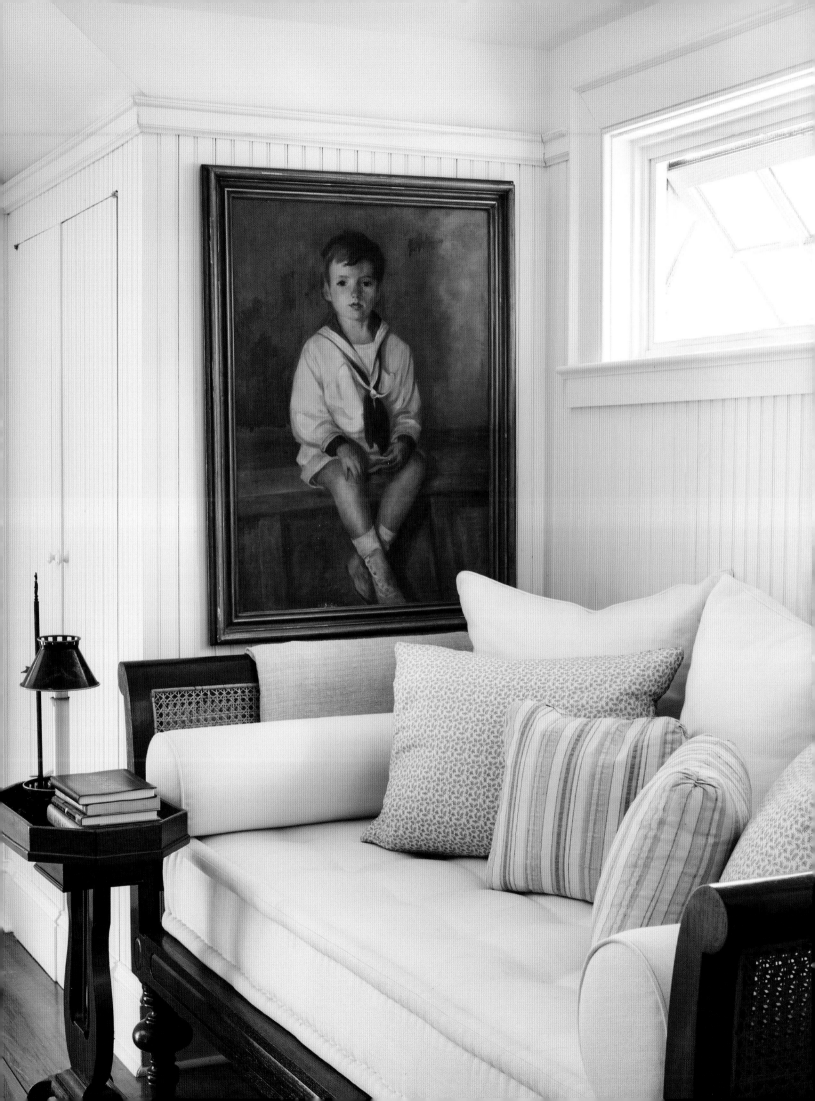

LEFT *Another example of a canopy bed being a room inside a room. My Caribbean-style British Khaki bed is a bit like an island, with the rest of the space and its furnishings just beyond the curtained margins.*

FOLLOWING PAGES *Garden hats populate a striped corner with Chinese prints (left). A gate enticingly frames a stand of hydrangeas (right).*

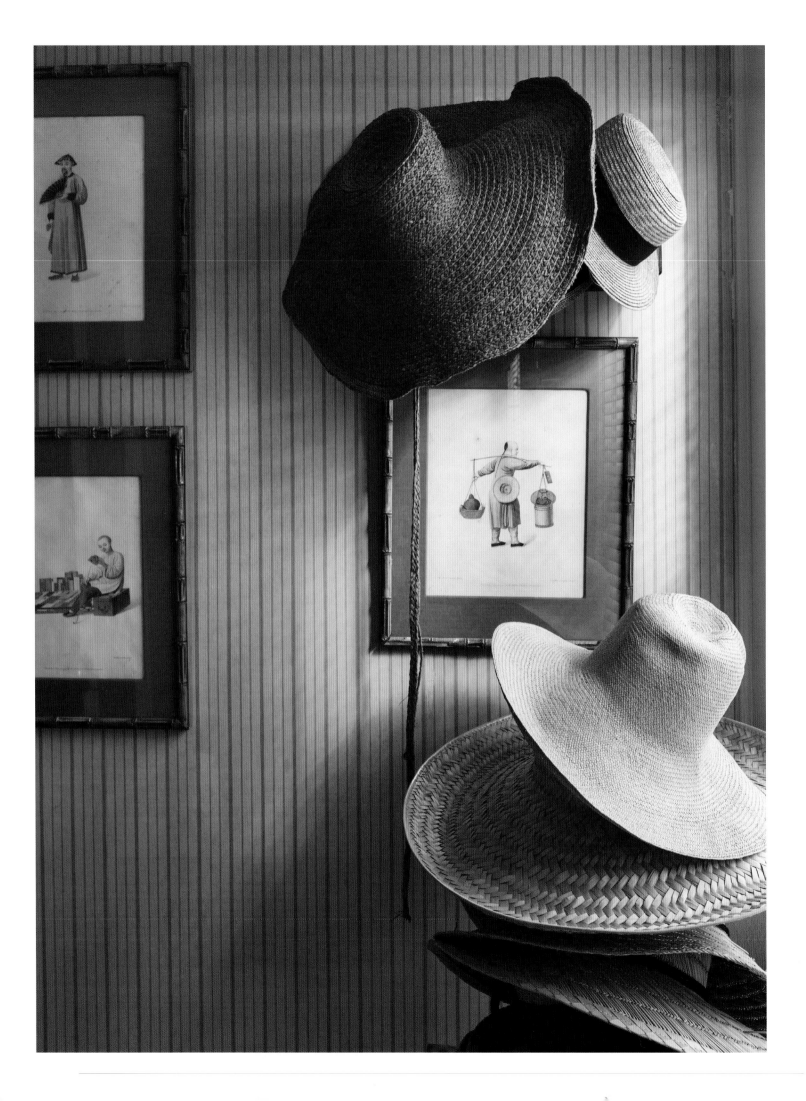

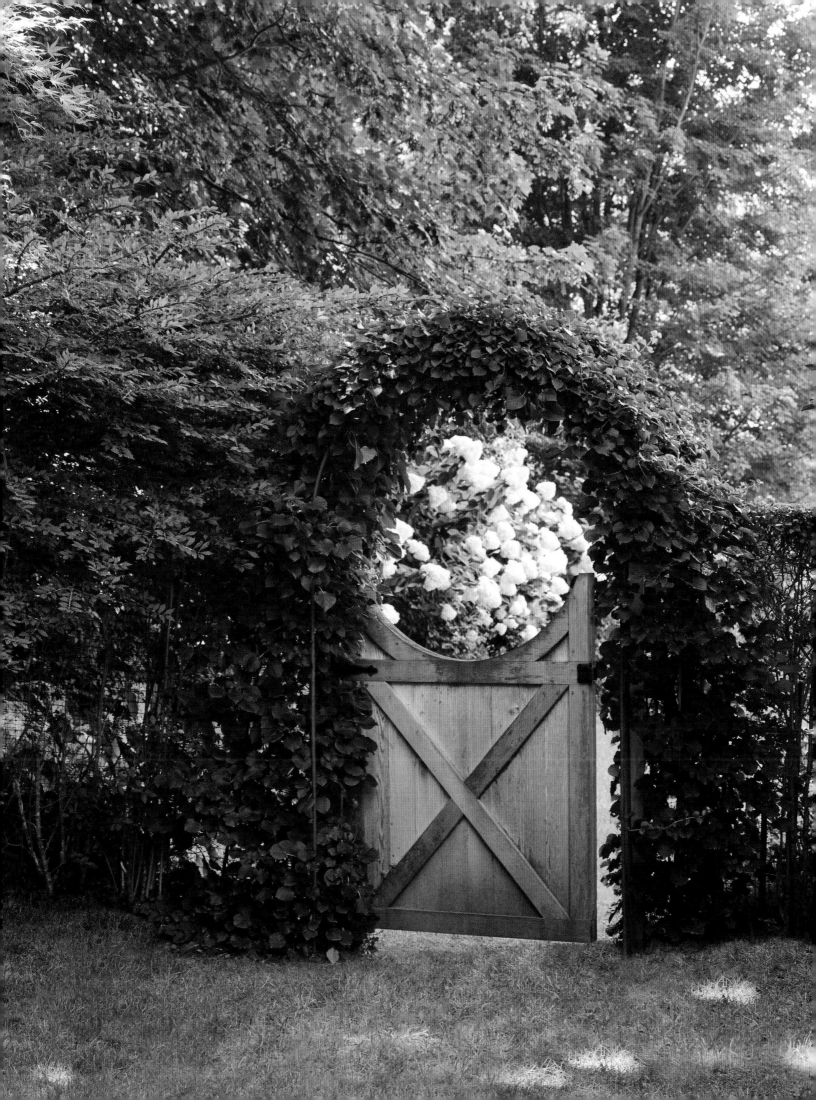

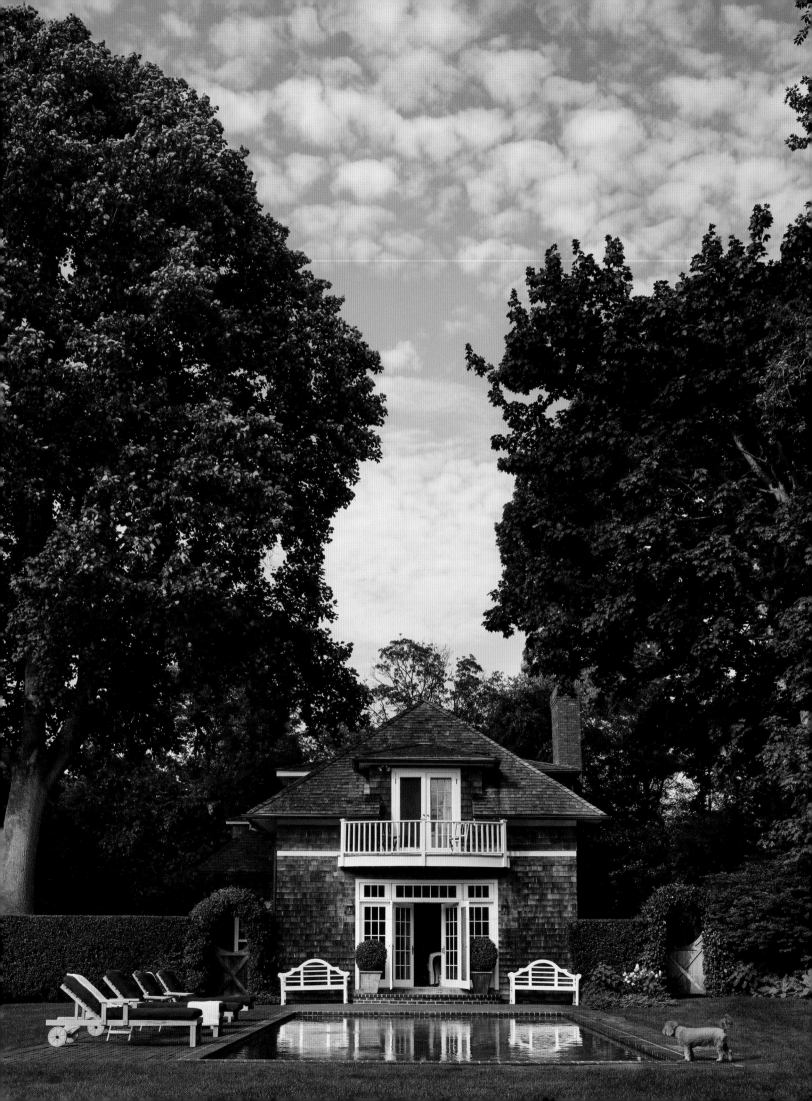

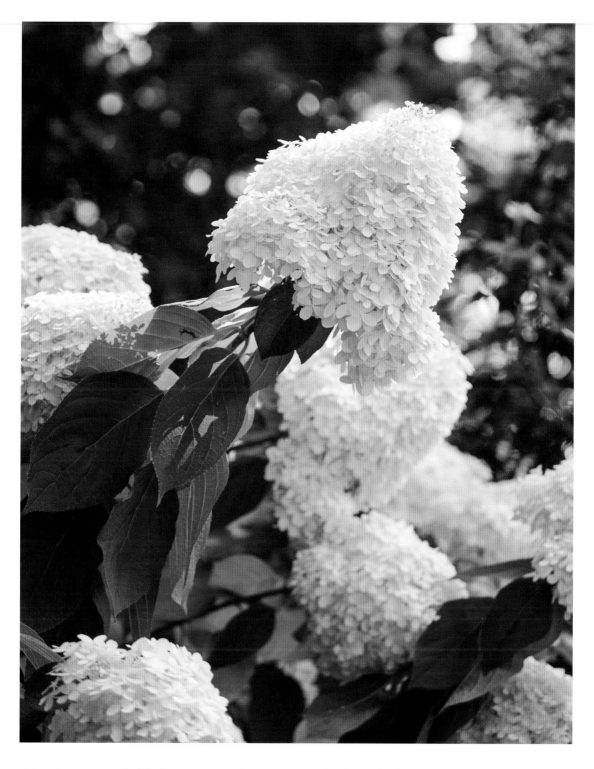

OPPOSITE *One end of the house opens to the swimming pool. It's a modestly designed feature, edged with brick coping, about as simple a pool as I can imagine or need.*

ABOVE *Few flowers are so easy to grow or more firmly associated with American summers—or Long Island—than hydrangeas, so I've planted them everywhere.*

FOLLOWING PAGES *A classic Lutyens bench provides a focal point at the end of a lawn, framed by hydrangeas and backed with a bed of pachysandra.*

ABOVE Designed for dining, lounging, and entertaining, the brick terraces—at the front and rear of the house—double the square footage during warm months.

OPPOSITE A casual luncheon table, with lacy raffia place mats, printed cotton napkins, and Herend's Chinese Bouquet porcelain.

FOLLOWING PAGES The back terrace charmingly follows the irregular footprint of the house and is bordered by a low wall topped with stone. Hurricane lanterns illuminate the area when dusk falls, and the trelliswork panel in the distance came from the garden of my second house on East Seventy-first Street.

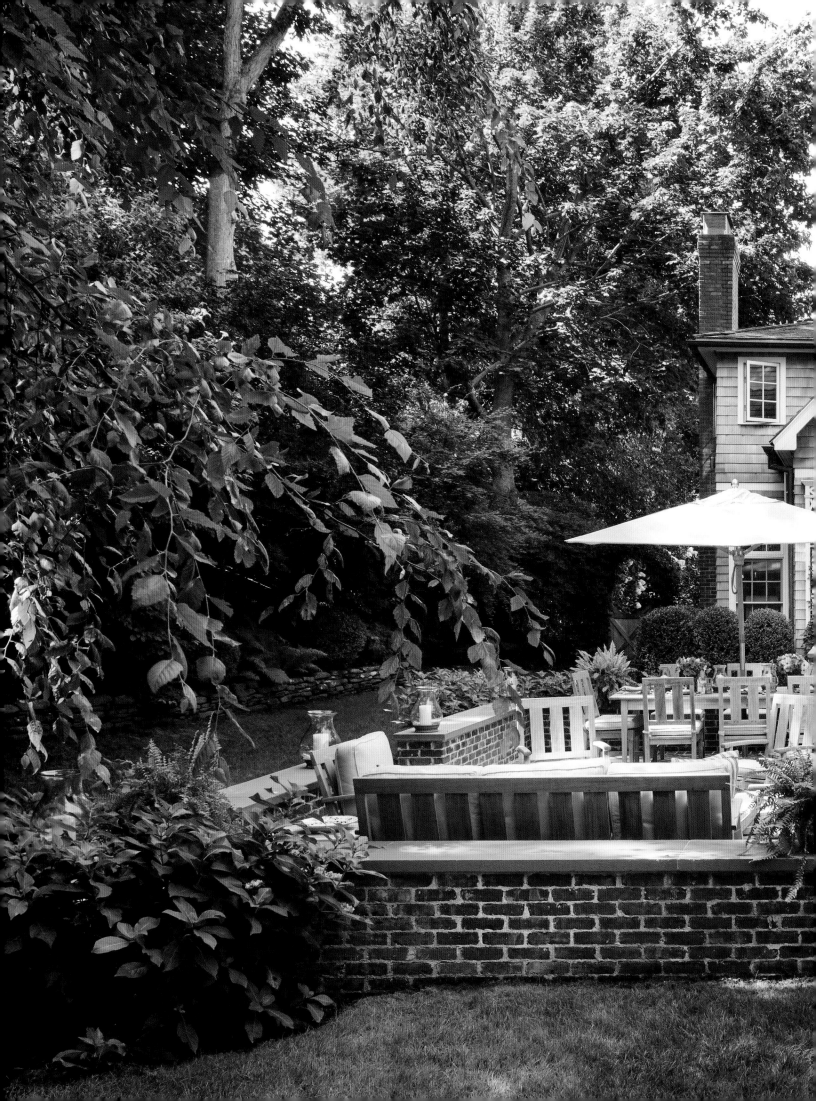

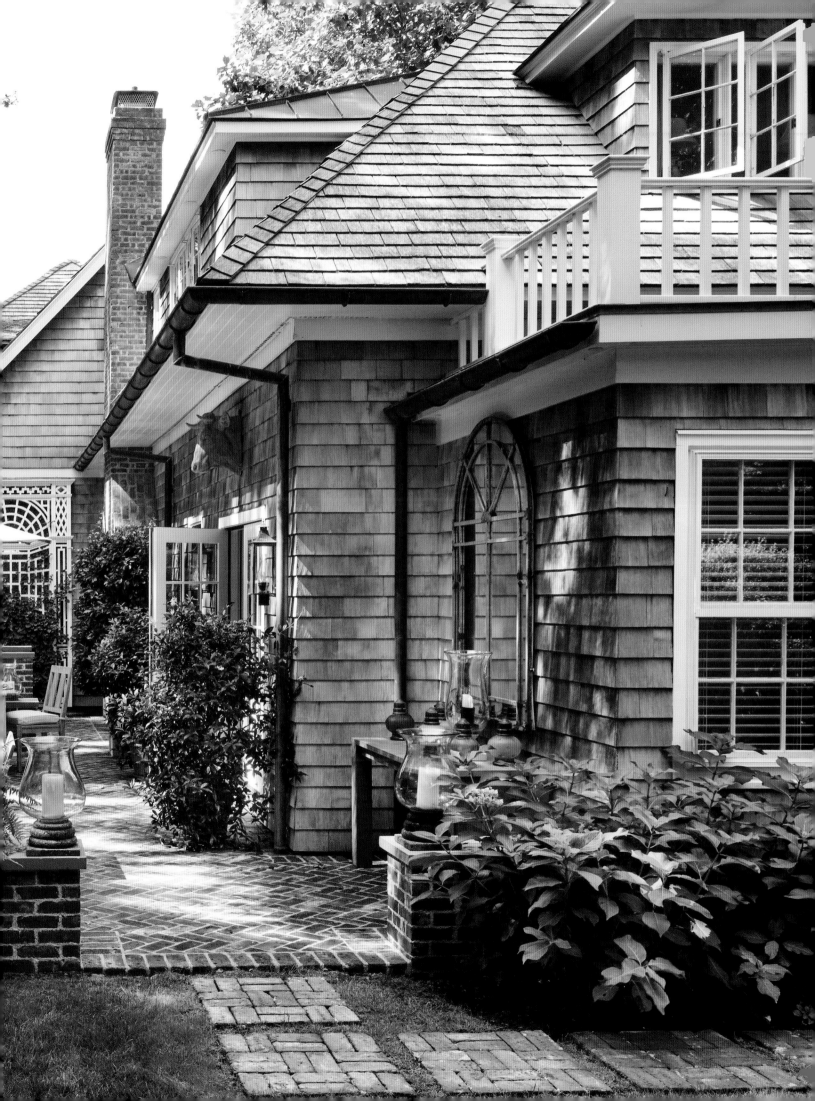

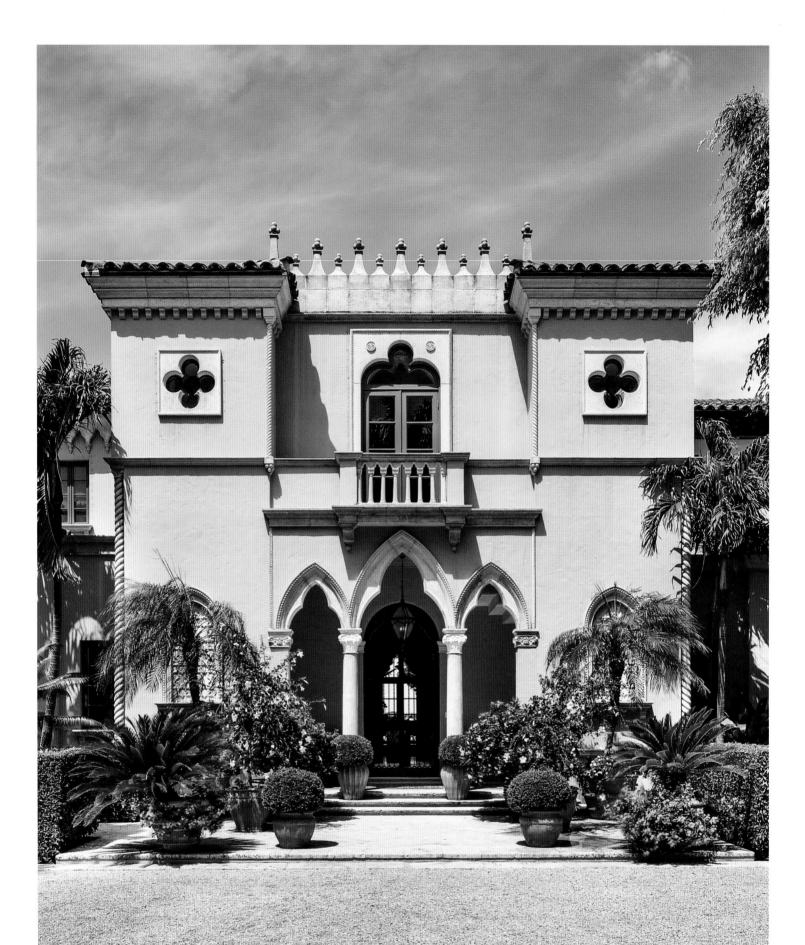

SOUTH OCEAN BOULEVARD

Palm Beach | *2011–2015*

When Damon Mezzacappa and I married, a new house came into my life: a palazzo in Palm Beach that Damon had commissioned from architect Jeffery W. Smith in the late 1990s. Wrapped with pointed arches, shady colonnades, and broad terraces—and painted a very pretty pink—it was a formidable example of the Venetian Gothic style, one of the vernaculars that had been popularized in South Florida in the early twentieth century, when Palm Beach had established itself as a resort community. With the house, known as Villa Venezia, came existing decor, some of which was created circa 2000 for Damon and his late wife by the admired decorator Bunny Williams. As beautiful as the interiors were, I wondered how I was going to find my footing in rooms furnished for an earlier time in my husband's life. The answer was: thoughtfully and respectfully. Luckily, Damon agreed that changes had to be made. The house was now ours and had to reflect that.

Smith modeled Villa Venezia after the Doge's Palace, and the richly conceived rooms reflected the architecture: dark coffered ceilings, moody jewel tones, and elaborate golden torchères. I wanted to lighten things up, and Susan Gutfreund came down from Manhattan to help me. One major step was to move Damon's handsome old master paintings in the living room to the groin-vaulted corridor that cut through the center of the house. That decision transformed the latter space from a passage into a dedicated gallery for the gilt-framed works that my husband had been collecting for decades, along with works by Giorgio Vasari and other luminaries. Guests could stop and admire the canvases as they made their

Potted plants accent the entrance to the Palm Beach house I redecorated with Susan Gutfreund. It was designed by architect Jeffery W. Smith, who was inspired by 1920s Palm Beach houses in the Venetian Gothic style.

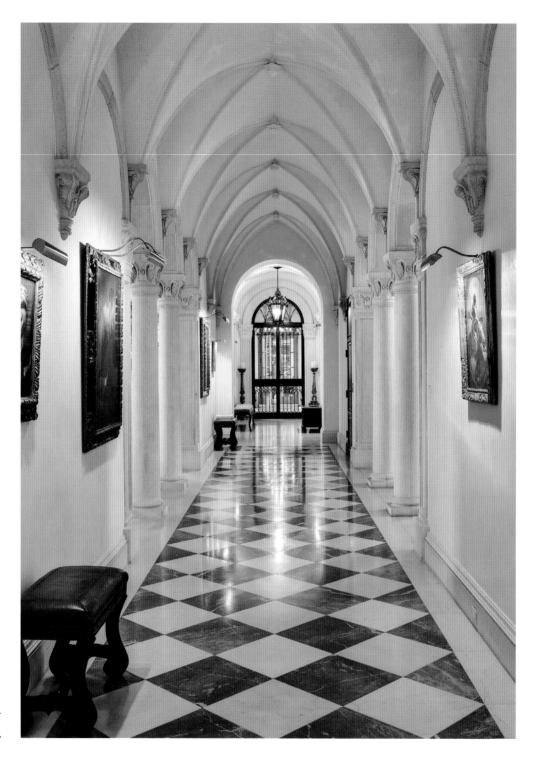

I turned the central corridor into a gallery for my husband Damon Mezzacappa's wonderful collection of old master paintings.

way from the front of the house to the rear terraces. Also, the paintings' relocation gave me an opportunity to create a much more relaxing, welcoming living room.

The room's carved ceiling was soon picked out in ivory-white, cream lacquer soothed the ochre walls, and the brown-and-white terrazzo floor was softened by two big neutral checkerboard carpets woven in Guatemala by textile master

Mitchell Denburg. Susan and I recovered much of the existing upholstered furniture—sofas, armchairs, wing chairs—in nougat colors and discreet patterns, such as tone-on-tone stripes. The only bright notes came from a collection of abstract paintings, including a wonderful 1950s Joan Mitchell, each one an energetic contrast to the subdued old masters that had preceded them. Over one sofa we hung a larger-than-life Lucian Freud portrait of Brigadier Andrew Parker Bowles, the former husband of Queen Camilla, in full uniform with masses of medals but seated in a big leather chair, his jacket unbuttoned and looking very laid back. Another of Damon's enthusiasms was for the work of Chinese artist

Xu Weixin, which we saw at a gallery in Paris after our wedding. Not long after, he purchased a huge Xu portrait of a coal miner in a hardhat to hang in the soaring two-story entrance hall.

Just as in the living room, Susan and I used as much existing furniture as possible throughout the main house. It seemed not only more sensible and cost-conscious, but also more thoughtful; I didn't want to erase Damon's past, just to combine my taste with his. The rattan furniture in the sunny breakfast room was dressed up in a leafy Braquenié pattern that echoed the room's potted palms and orchids. We also brought in a few Syrian octagonal occasional tables and fun lamps in the shape of elongated pineapples. The iron furniture on the adjacent terraces was simply recovered, in broad awning stripes in coconut-brown and cream.

The tropical setting, as well as the fantasy architecture, led me to select Braquenié's La Rivière Enchantée, in the Brun colorway, for the breakfast room.

The dining room had been painted turquoise years before, but because the color didn't provide enough contrast, I thought the views of the lawn, palm trees, and Lake Worth Lagoon seemed to lose their brilliance. Susan came up with the idea of creating a burlap wallcovering in two shades of red and stenciled with a Fortuny-like damask pattern, which features sprays of pineapples. We slipcovered the elaborate Italian chairs to match, with a red-striped fabric tied on with ribbons, which undercut their formality. We added a room-size carpet, too, also in red, a Mitchell Denburg herringbone weave. There was so much red, in fact,

that the green-and-blue views came into much sharper focus, like a painting when it is paired with the right frame. When it came to the guesthouse, though, Susan and I both agreed that every room was spectacular; we couldn't improve it in any way. Sometimes, I've learned over the years, leaving well enough alone is the best decision you can make.🐾

RIGHT For an exterior wall, I commissioned street artist Faith47 to paint a crouching tiger, as if it were emerging from the undergrowth.

OPPOSITE In the entrance hall, a Xu Weixin portrait of a Chinese coal miner makes a memorable counterpoint to the Venetian Gothic architecture. It's a surprising marriage of styles, but it works.

FOLLOWING PAGES Columned screens separate the main rooms from the central corridor. Two of Damon's old master paintings flank the entrance to the living room.

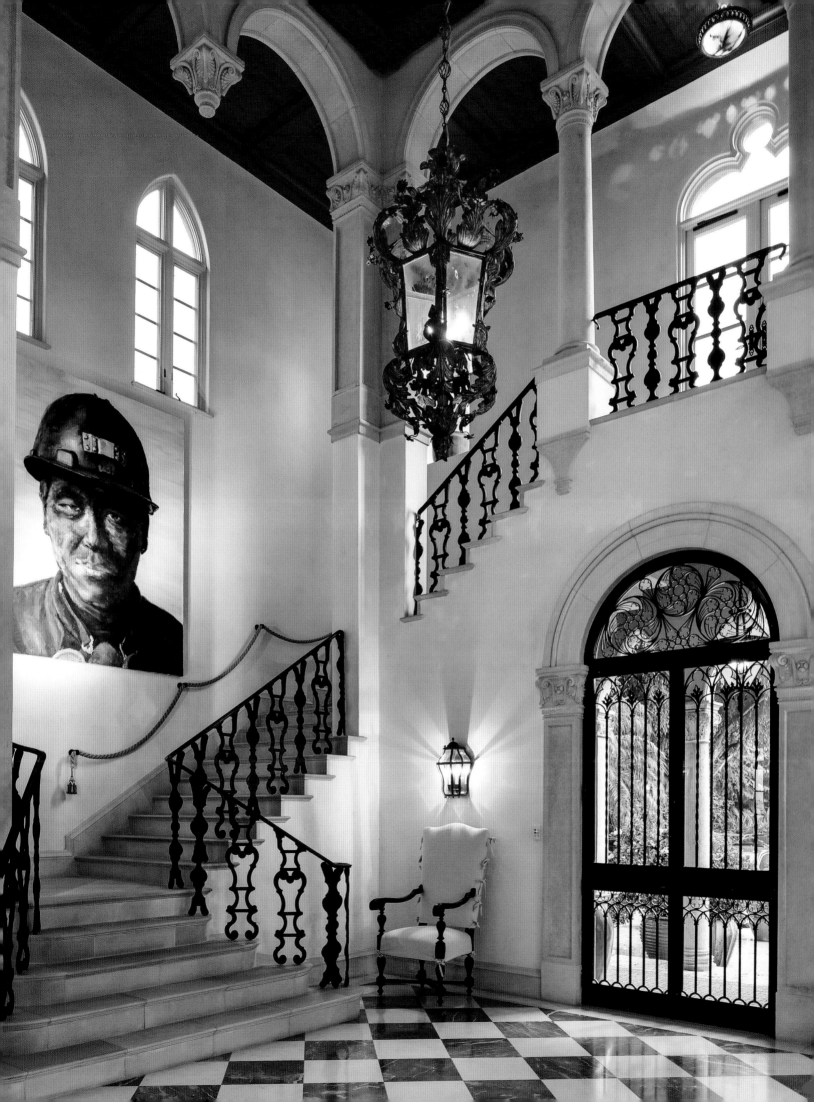

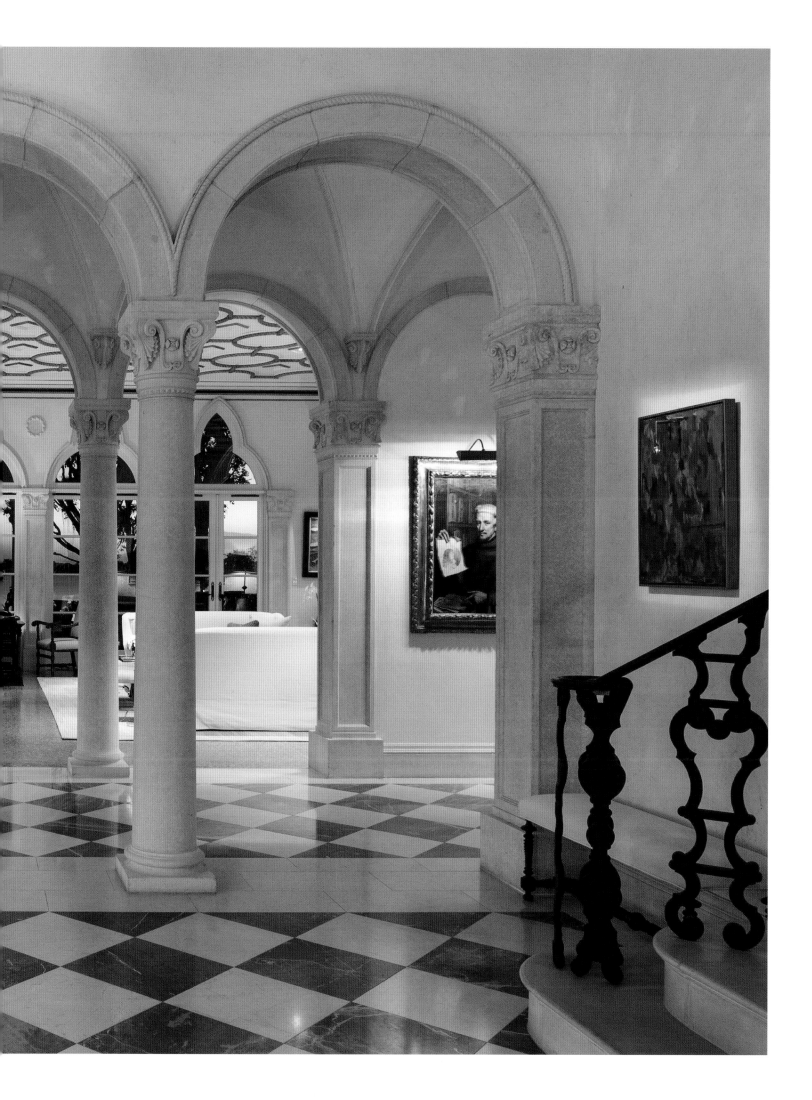

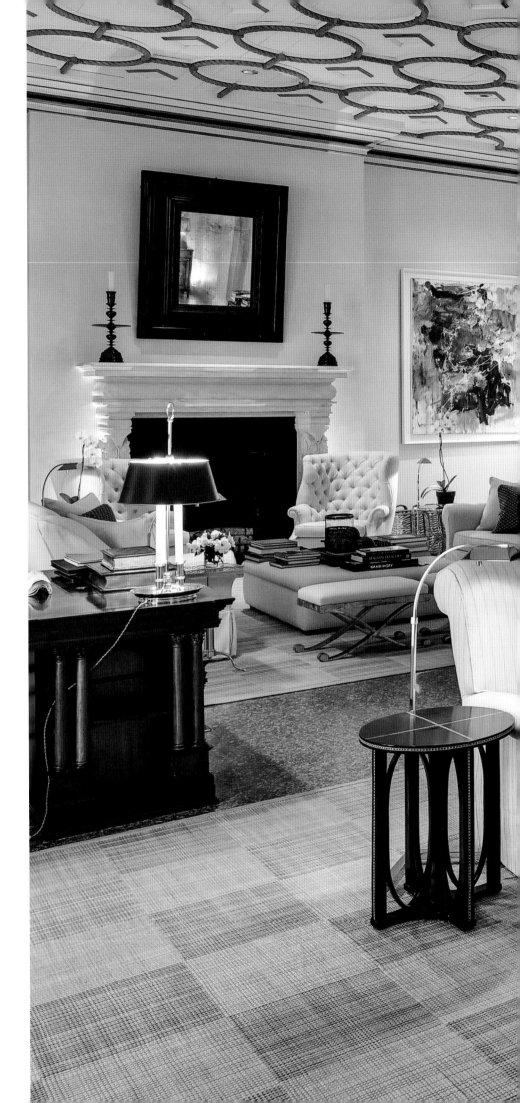

RIGHT Damon and I hung modern and contemporary artworks in the living room, including ones by Joan Mitchell and Howard Hodgkin. We also lightened the palette with pale ochre walls, ivory and beige upholstery, and a few graphic wooden elements.

FOLLOWING PAGES Susan and I lightened the coffered ceiling, painting it a soft shade of white and picking out the twisted-rope detailing in the color of natural hemp.

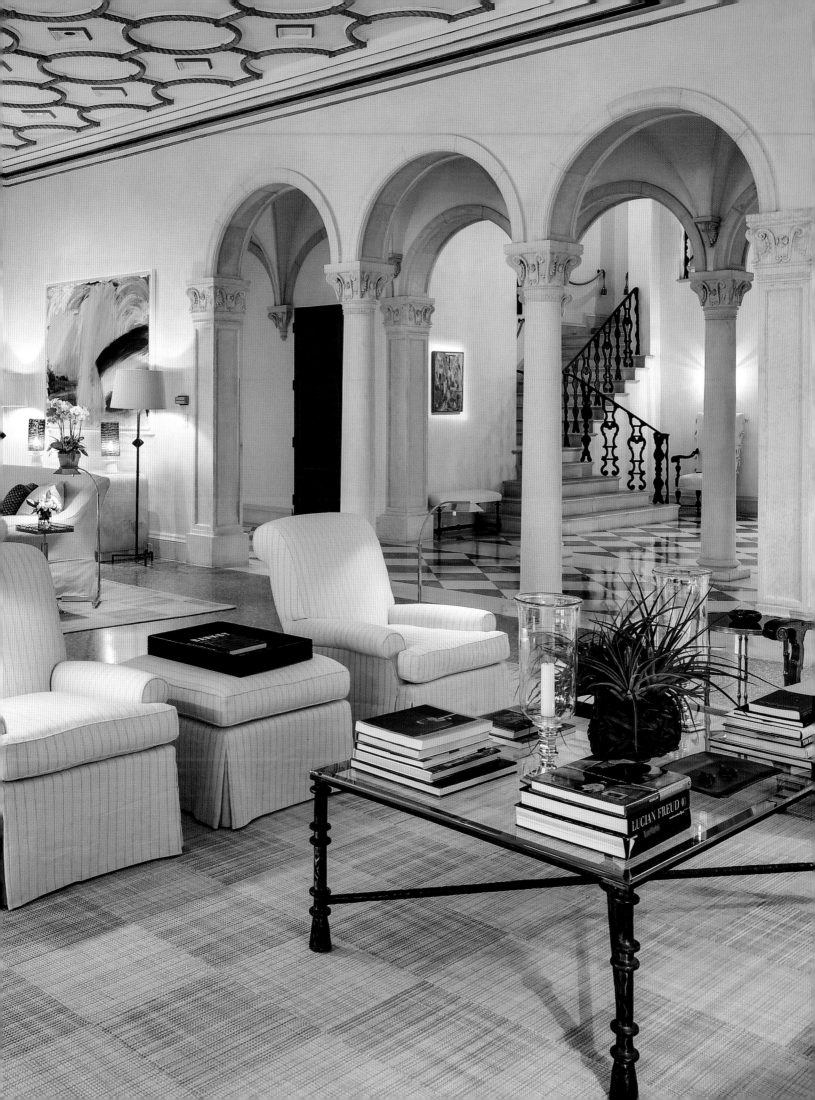

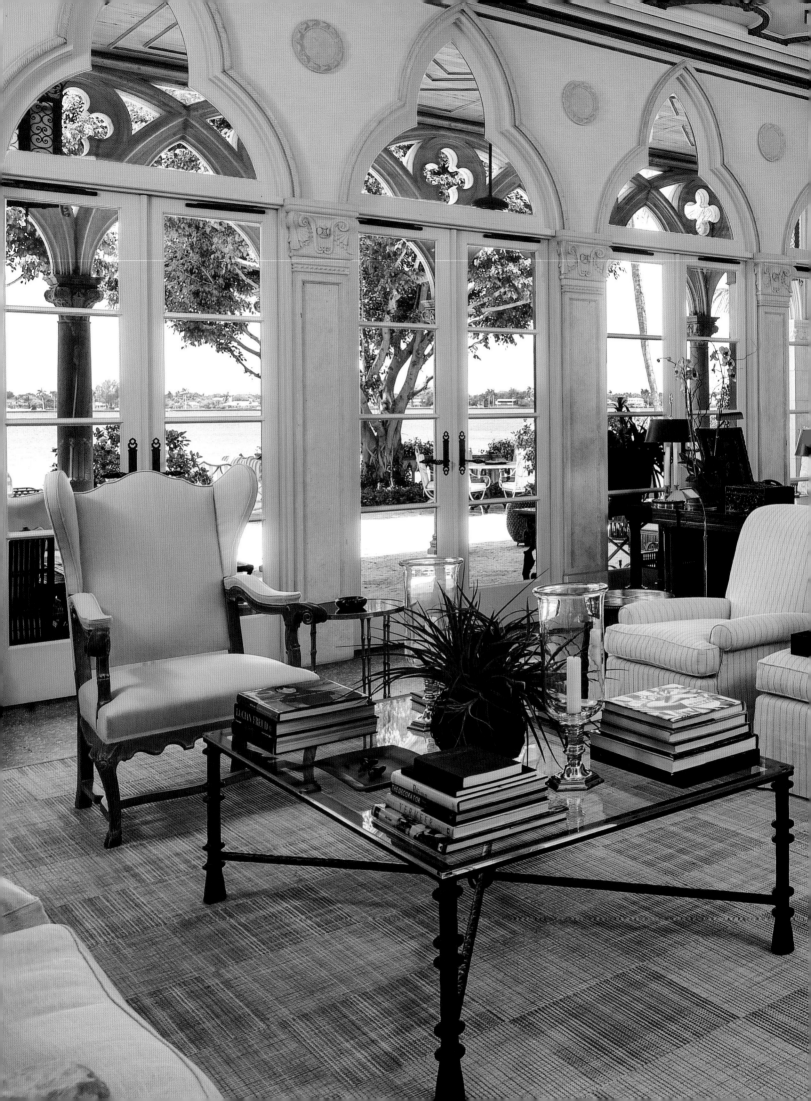

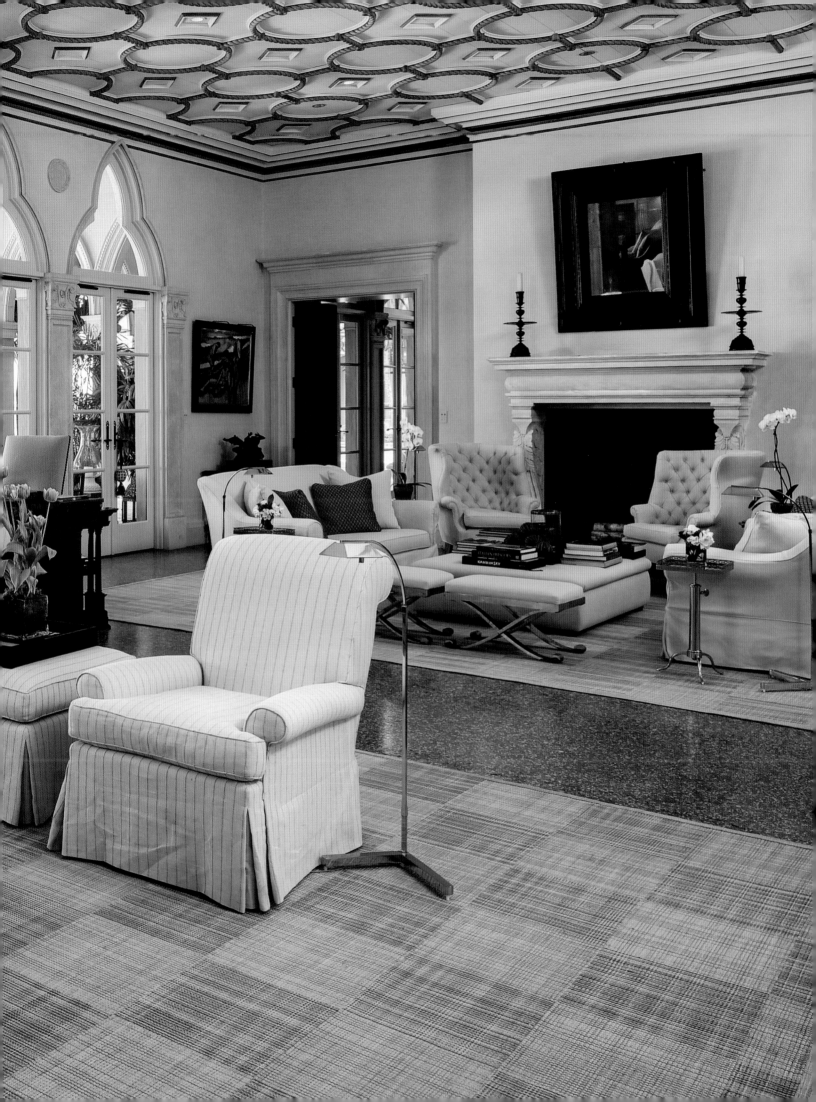

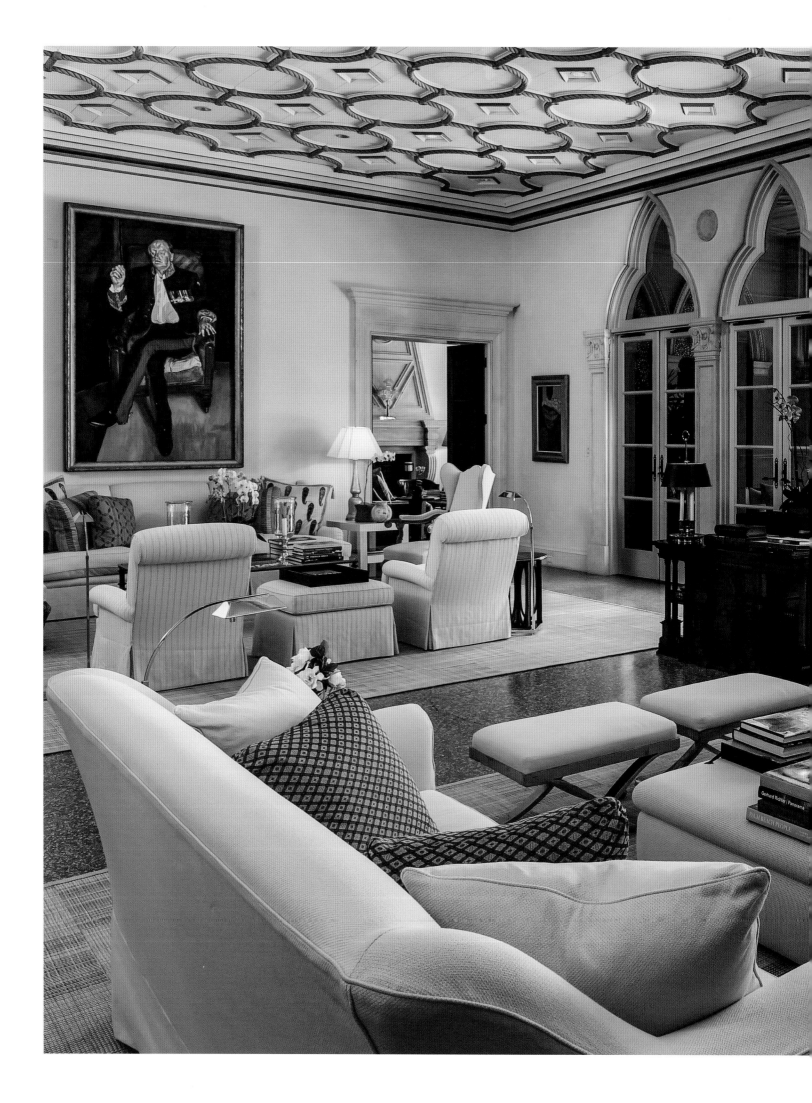

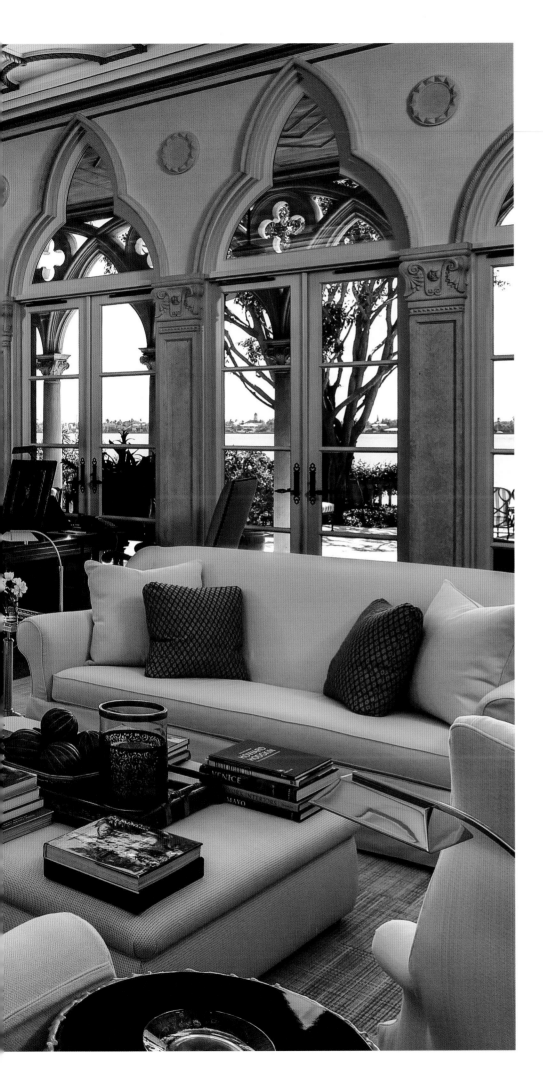

LEFT Anchoring a seating area was one of Damon's prize works of art, Lucian Freud's The Brigadier, a 2004 portrait of Andrew Parker Bowles. Two big checkerboard carpets by textile master Mitchell Denburg softened the terrazzo floor.

FOLLOWING PAGES The library retained most of the decoration of Bunny Williams, with blue curtains linking the room to the bay and sky seen through the windows.

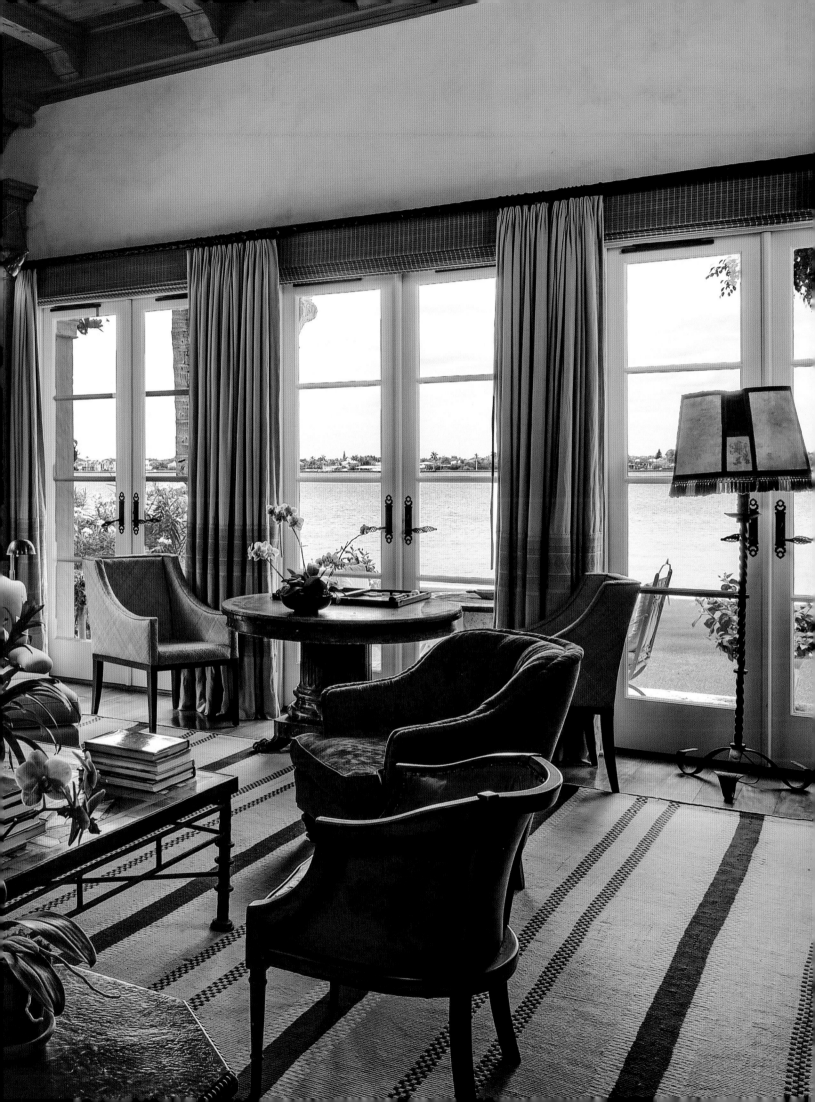

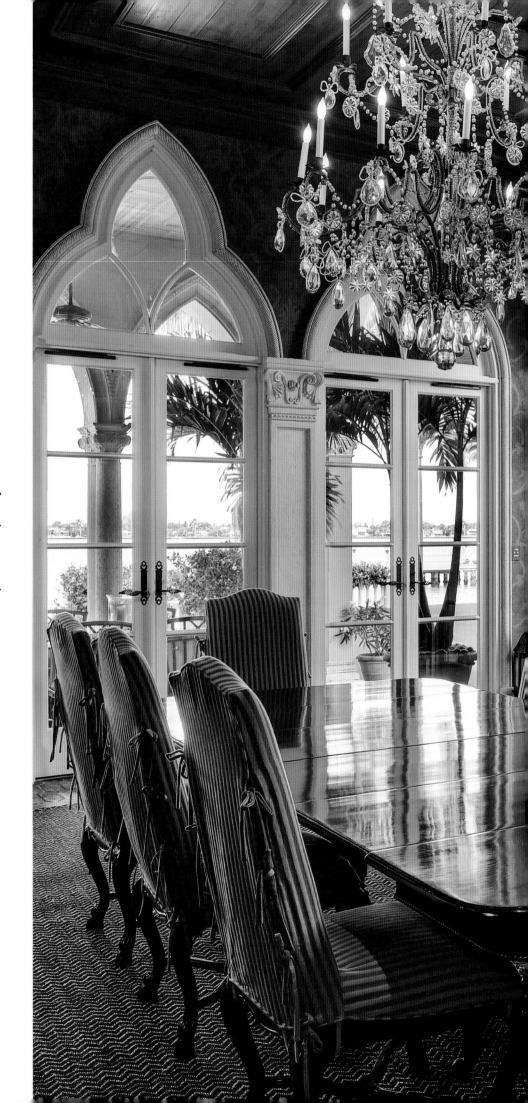

*Originally painted turquoise blue,
the dining room embraced a ruddy palette after
Susan and I began working together.
We introduced a Mitchell Denburg
wallcovering—a Fortuny-inspired pattern
stenciled onto burlap—and chairs slipcovered
with a coordinating stripe.*

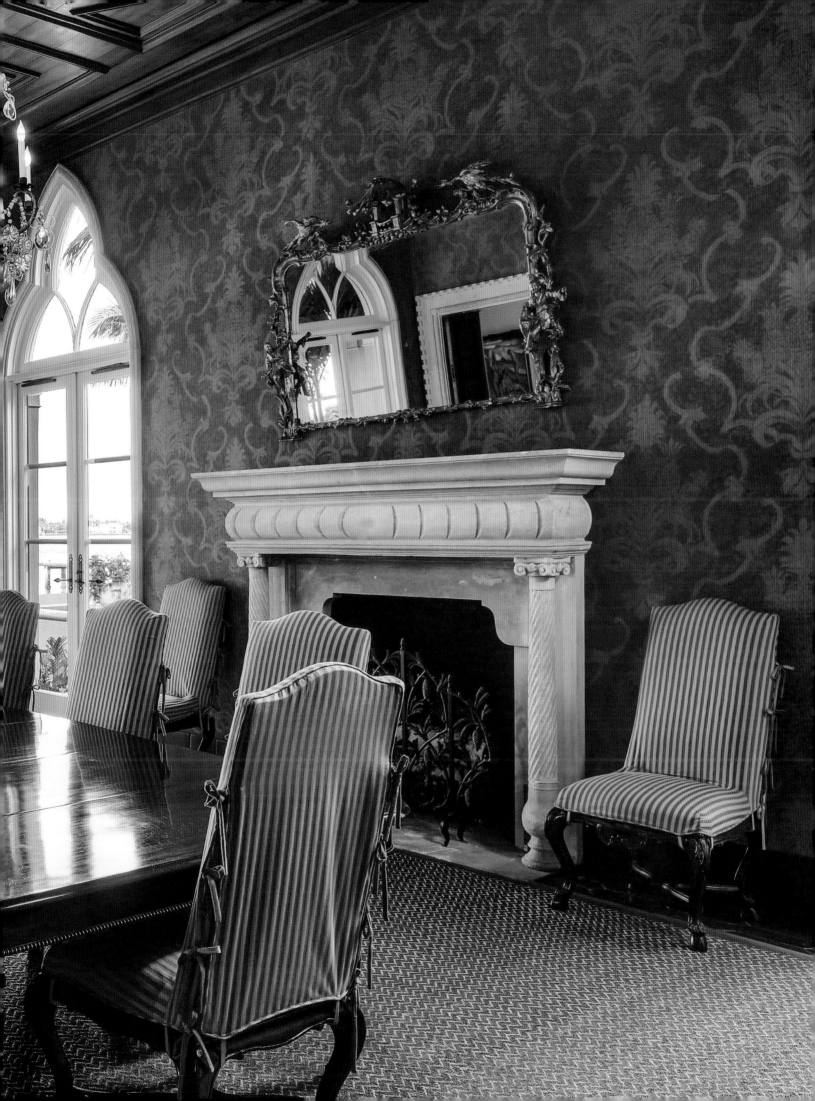

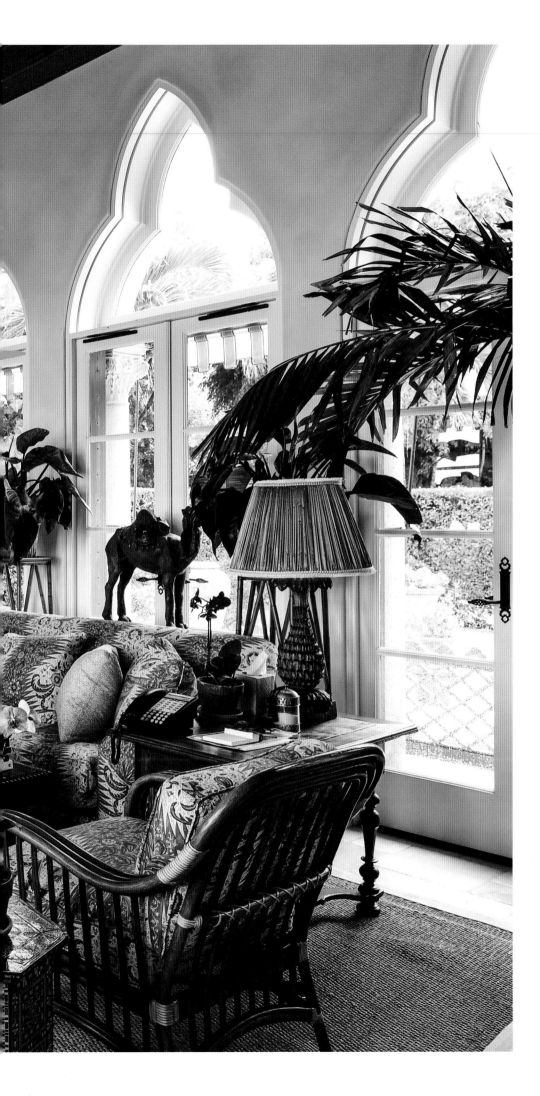

The breakfast room had French
doors on three sides, one series opening to
the pool. I rearranged the existing furniture,
added some British Khaki chairs and a
round table, and reupholstered everything in
Braquenié's La Rivière Enchantée.

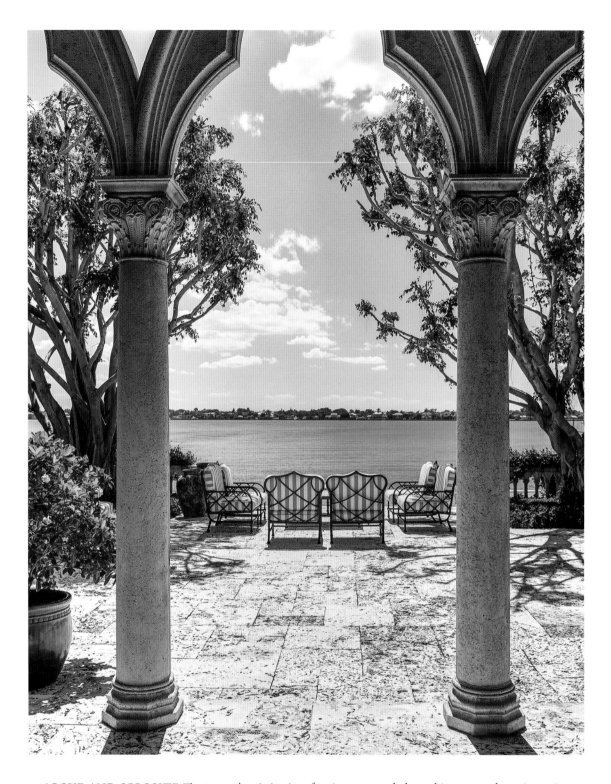

ABOVE AND OPPOSITE *The terrace's existing iron furniture was upholstered in a neutral awning stripe, the colorway keyed to the stone around it. Architect Jeffery W. Smith's romantic, rambling architecture incorporated numerous contemplative areas, spaces simply meant for visual pleasure. One was a small courtyard centered on a carved stone fountain. Delfino Garcia was the head gardener for this lush paradise.*

FOLLOWING PAGES *A stone-paved loggia, one of several transitional spaces in the house, overlooks Lake Worth Lagoon. The arched screen echoes the open loggias at the fourteenth-century Doge's Palace in Venice.*

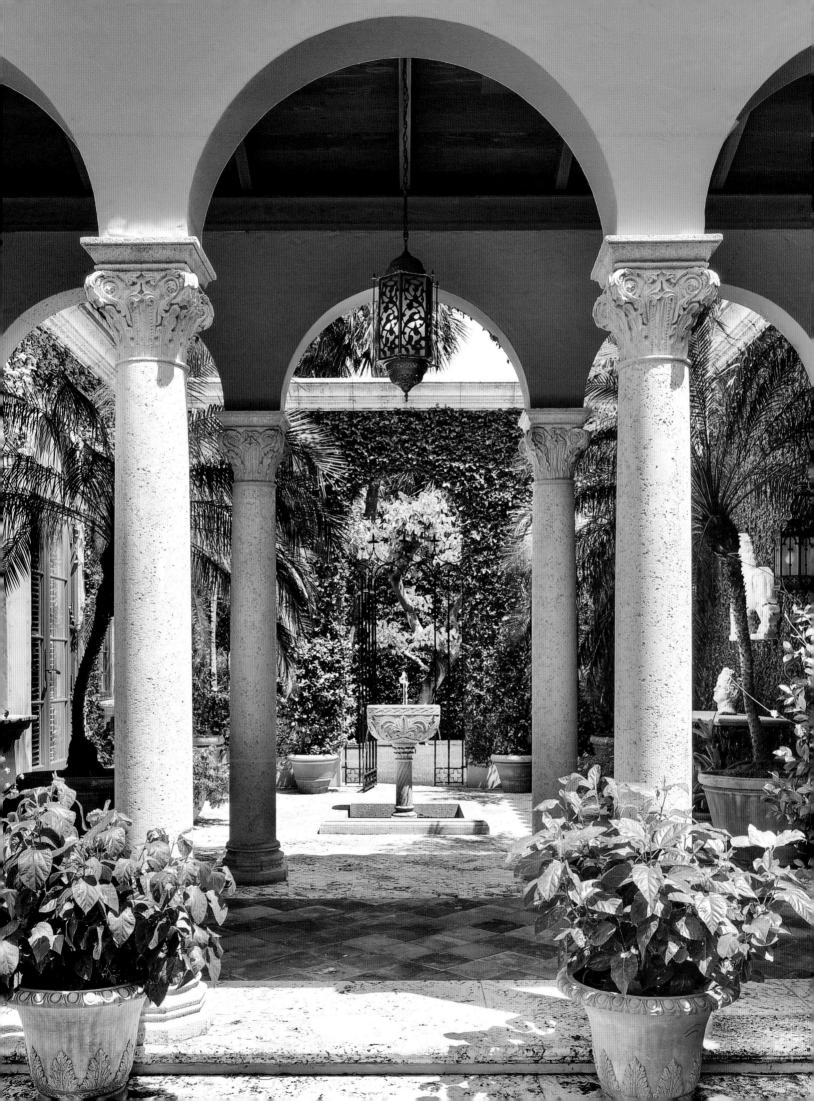

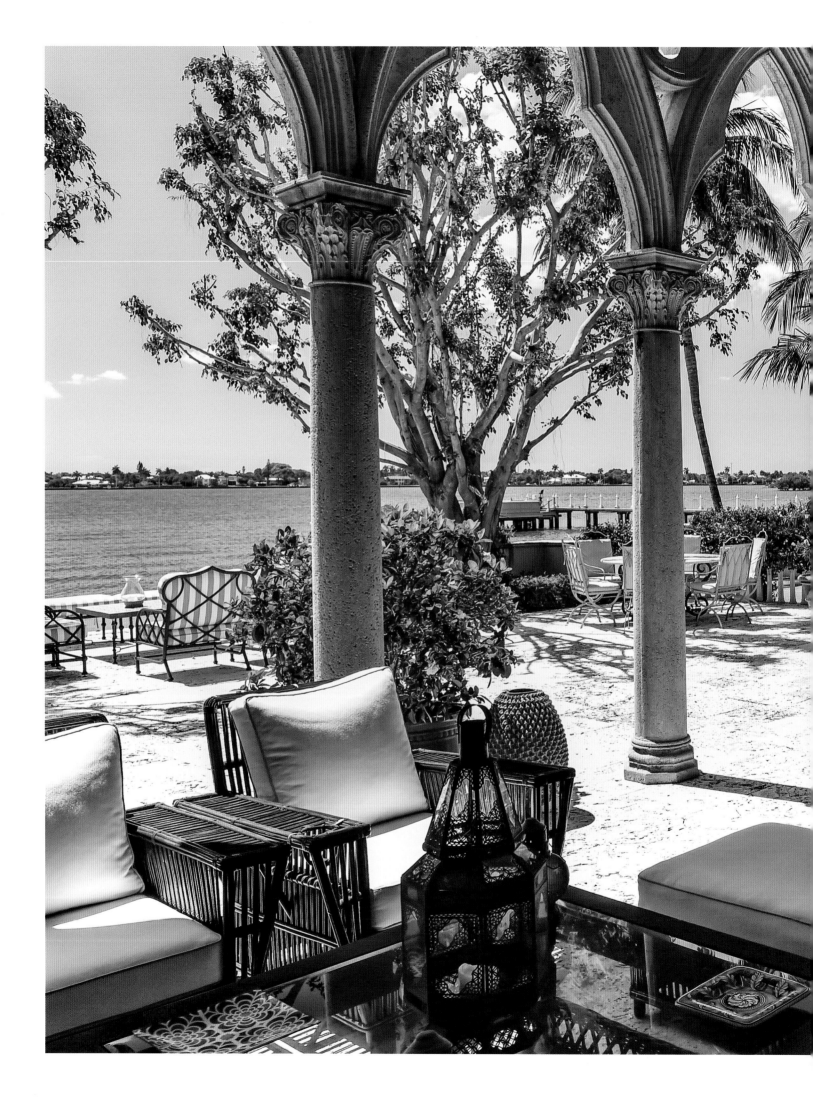

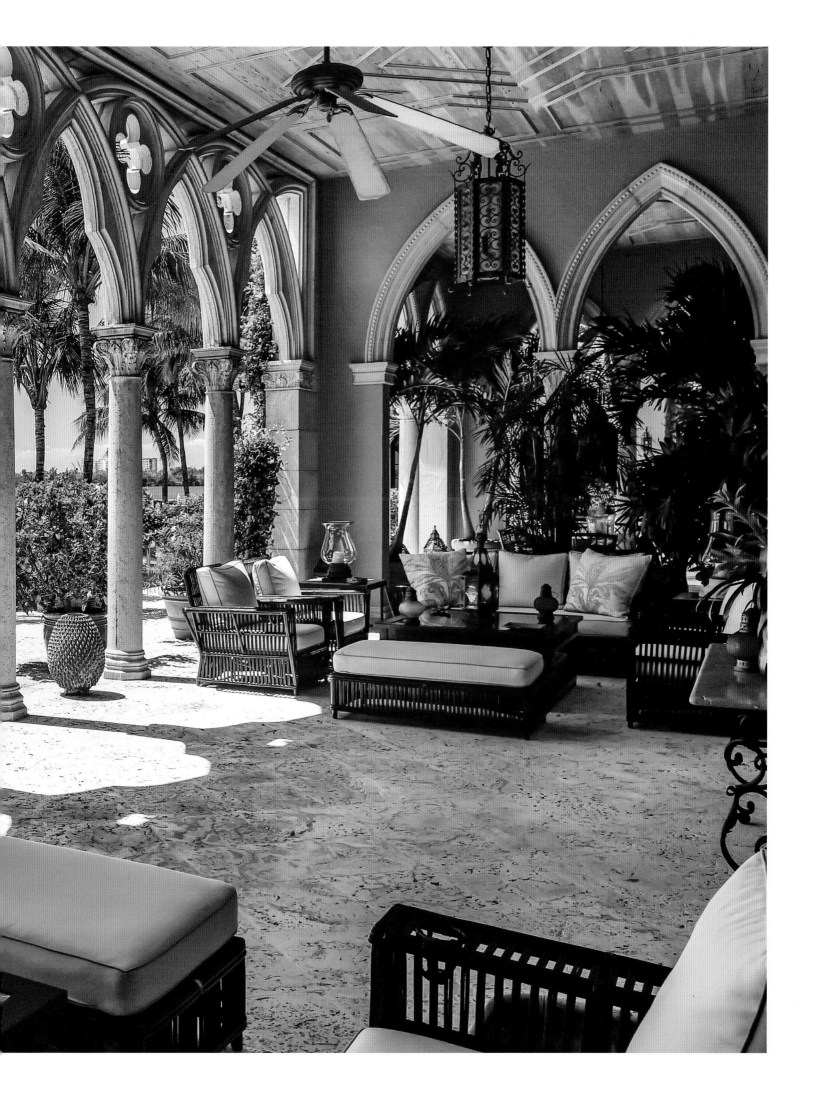

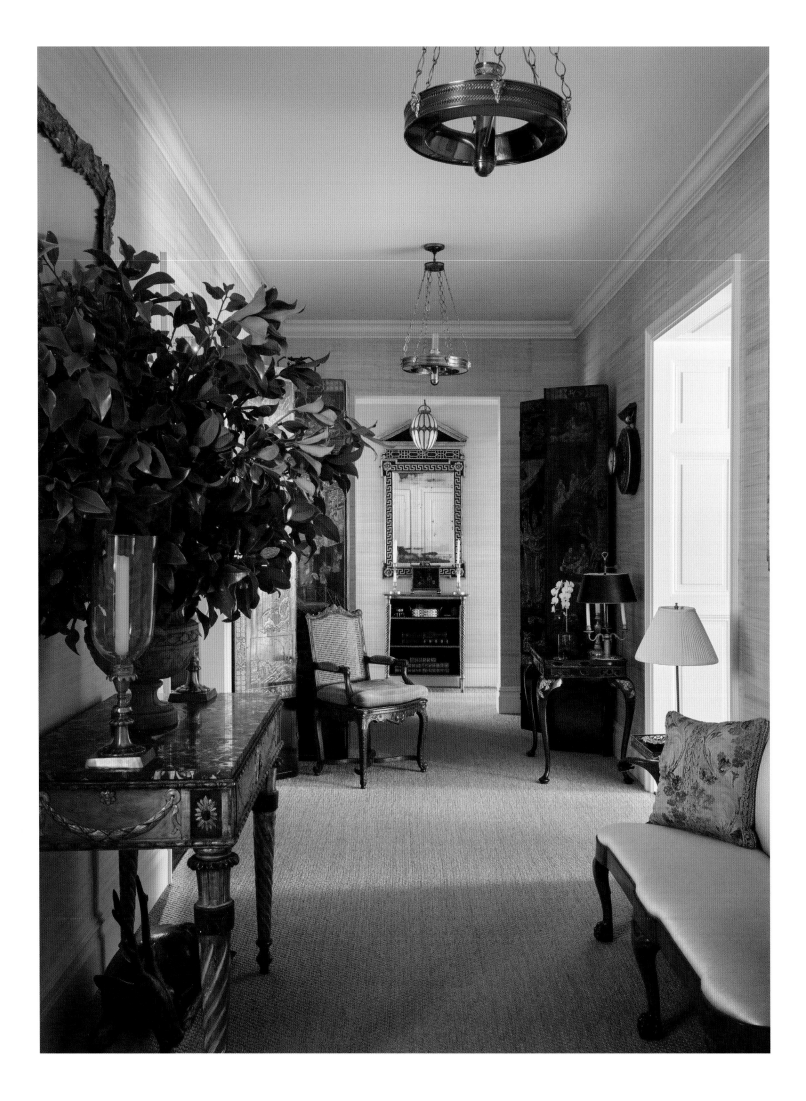

PARK AVENUE

New York | *2012–present*

L iving in the same house or apartment more than once rarely happens to anyone. I certainly never thought I would, but today I do live in an apartment I once owned. Actually, it's not precisely the same one, but it is an exact copy: it is located in the same Park Avenue building, in the same line, just on a lower floor. Everything's a match otherwise: the layout of the rooms, the placement of the windows and doors, even the architectural details. It has real elegance, which is the main reason that I was attracted to the building in the first place—and for the second time, too.

J. E. R. Carpenter, who designed the building in 1916, was one of Manhattan's great architects and developers in the first couple of decades of the twentieth century, with dozens of the most beautiful apartment houses in the city to his credit. He attended the École des Beaux-Arts in Paris and then was employed in the offices of McKim, Mead & White, so his eye for proportion and scale was as exacting as his belief in balance and harmony. My apartment had actually been much larger back in 1916. The original apartments were huge, with one per floor, though mine and many others were reduced to their present size when a very sympathetic architect renovated the building several decades ago. Mine is bi- sected by a wide central hall, with a big living room on one side, a smaller dining room and the kitchen on the other, and two bedrooms and a library at the end of the passage. The layout is efficient, but Carpenter's classicism and his skillful approach to proportions suggest that I am living in a jewel-box of a house rather than an apartment, even with the reduced square footage.

An antique Chinese lacquer screen, separated into two sections and set asymmetrically, breaks up the length of the Park Avenue entrance hall, as does the angled presence of a Régence chair. It's a simple idea that seems to reshape the architecture.

The decoration I live with now is almost the same as it was when I lived in the matching apartment several floors above, largely because I kept everything that my friend Susan Gutfreund and I had used there and would use again. Furniture, works of art, and carpets had been in storage for years. So when another apartment in the same building came onto the market, years after I had lived there but right after I had sold my second town house on East Seventy-first Street, it seemed like a good idea to send a moving van to the storage facility and pick it

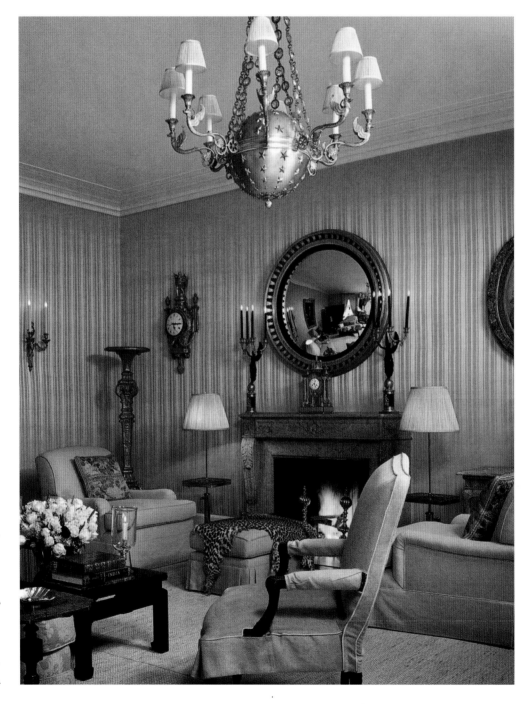

A woven silk stripe by Antico Setificio Fiorentino covered the walls of my present apartment's earlier incarnation; same line, higher floor. The palette is Italianate, all yellow, ochre, green, and a stony beige. The wall clock and the candelabras have followed me from house to house since the 1980s.

all up. Susan and I both agreed that the previous decorative scheme had been perfect, so we just replicated it. I think we ended up buying only one additional piece of furniture.

Some of the paintings and furniture had once belonged to Evangeline Bruce, the biographer and hostess, whose husband, David, had served as U.S. ambassador to France, the United Kingdom, and Germany. Mrs. Bruce's style has influenced so many people: the relaxed way she furnished a traditional room (often with the help of John Fowler), the way she dressed (chic but also nonchalant), and her idiosyncratic sense of style (such as placing stalks of parsley or heads of broccoli, instead of conventional flowers, in beautiful silver biscuit tins). After her death, Shelby and I bought her early nineteenth-century house in Washington, D.C.'s Georgetown district and many of its contents. A nineteenth-century portrait of a maharajah that the Bruces had at their set in London's historic Albany complex in Piccadilly now surveys my living room, and an antique view of an eccentric topiary garden is mounted above a settee in the main hall. Some of the large Dutch landscapes that had belonged to her were too tall for my rooms, so I convinced my neighbors to allow me to hang them in the common hall. They even agreed to let me paint that passage the same terra-cotta pink that Mrs. Bruce had selected for her Georgetown ballroom, which she used as a large drawing room. Mark Hampton had been helping Shelby and me to decorate the Bruces' house—one reason I saved so many of their treasures—but when our marriage ended, I decided not to move in. The house was far too big for a single person. But I still have some of the sketches that Mark did for us (see page 27).

In my current Manhattan apartment, a few small aesthetic changes were made to the decoration that Susan and I reincarnated. In my old living room, for instance, we covered the walls with striped silk damask in a goldenrod-

For both my Park Avenue dining rooms (current one on pages 188 and 189), Susan and I selected a custom-made colorway of Samarkand by Le Manach, a Persian-style printed cotton.

yellow—the idea was to make the room seem sunnier—but this time around we just painted the walls the same shade to get the same effect. But everything else is as it was before, from the very finely woven seagrass carpeting by Cogolin to the cork wallcovering in the library. Even the antique Austrian cartel clock in the dining room is hung in the same spot. It's proof that you really can go home again—and that if a decorating scheme works perfectly the first time, there's no reason to change it.

RIGHT An antique landscape—entirely make-believe—graced the ballroom of hostess Evangeline Bruce's Georgetown house, which we owned for a few years.

OPPOSITE The same painting now is mounted on a wall of my Park Avenue apartment, one of several items that were once part of the Bruce estate. They always remind me of her great taste and its influence on me.

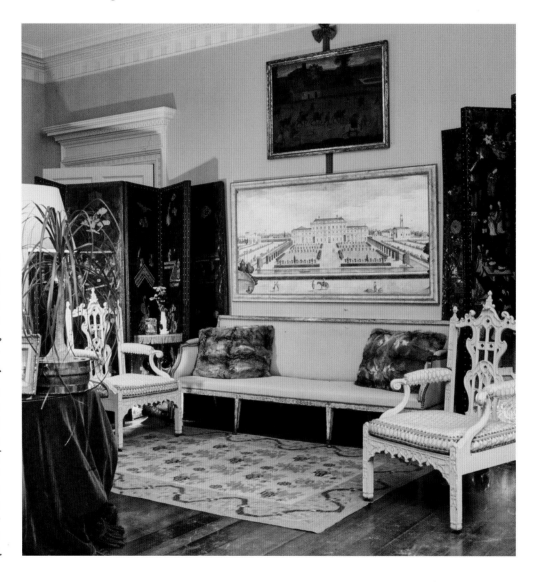

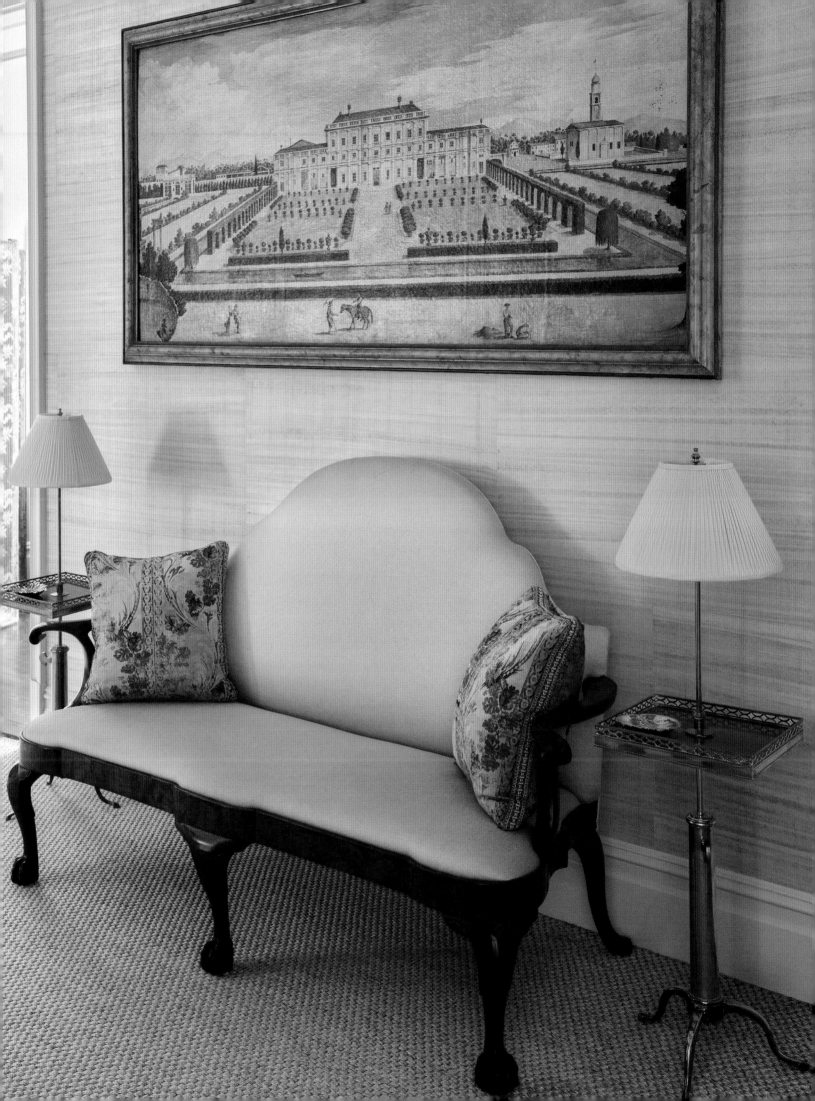

RIGHT *When Susan Gutfreund came to help me with my present apartment, we decided to glaze the walls with a painted stripe, rather than to use a silk similar to what we used before. It just seemed fresher than fabric, simpler. The furniture placement, however, remains the same as the previous living room.*

FOLLOWING PAGES *Another Bruce treasure of mine is a 1738 portrait of an Englishman in Indian costume, which hangs above a nineteenth-century sofa in the living room. The formality of the space is something that I'm working on relaxing as time goes by, with graphic modern art and a patchwork table cover that is actually a nineteenth-century Japanese priest's robe.*

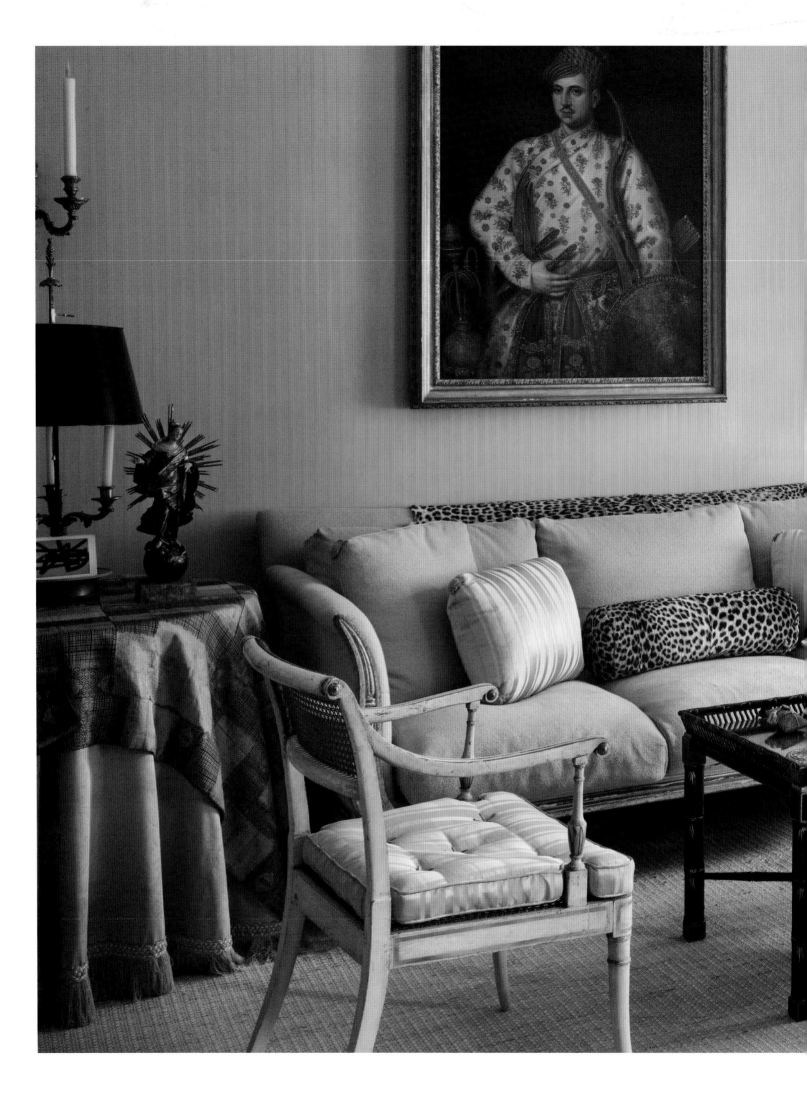

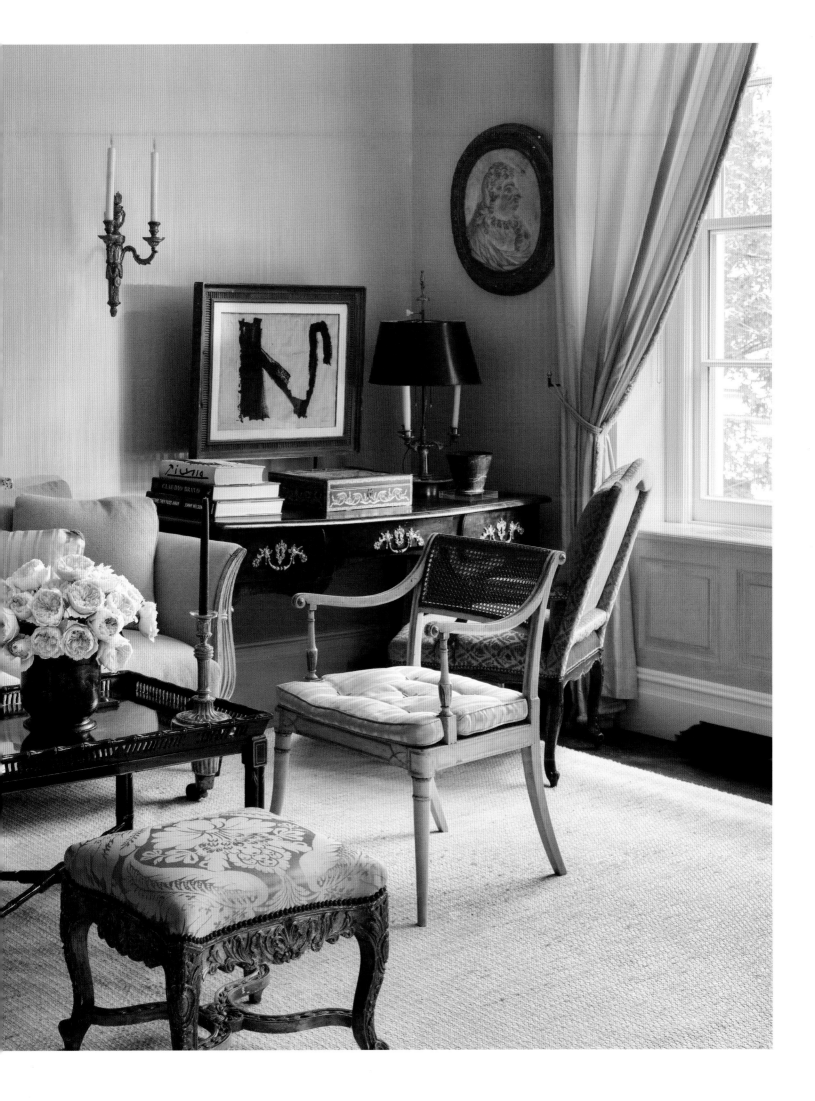

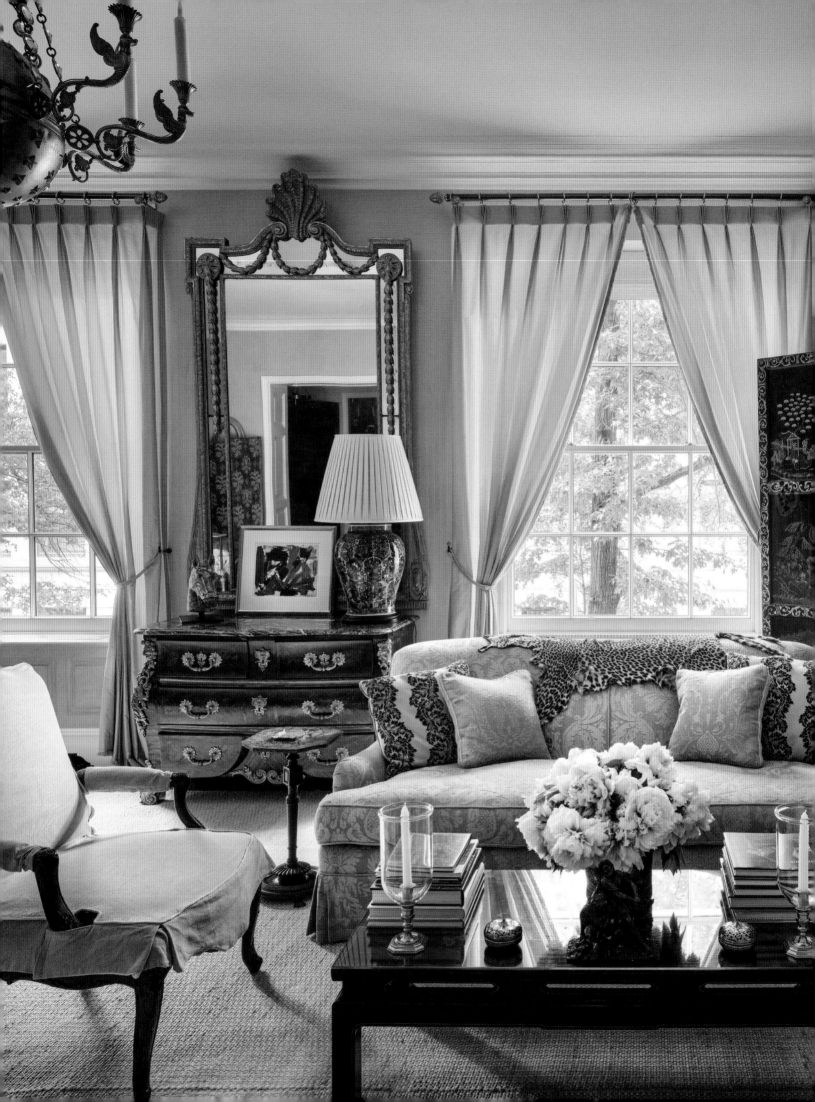

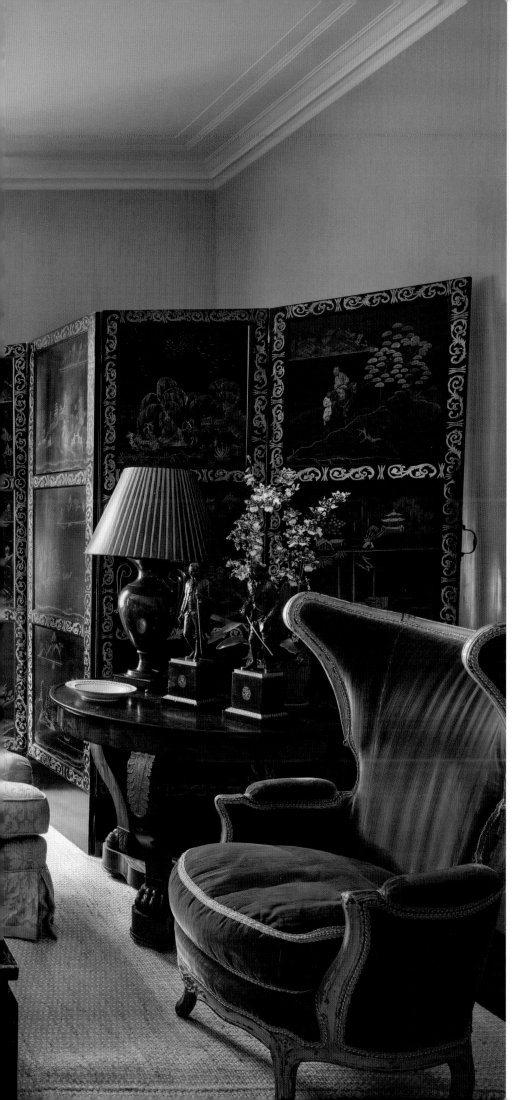

LEFT Folding screens not only help reshape a room and create cozier seating areas but also provide a handy place behind which to conceal files when storage is at a premium. This chinoiserie example in my living room does the job quite stylishly.

FOLLOWING PAGES A portrait by Nicolas de Largillière (left page) hangs behind an eighteenth-century French wing chair in the living room. A detail of the chinoiserie screen (right page), which I previously used at my second East Seventy-first Street town house.

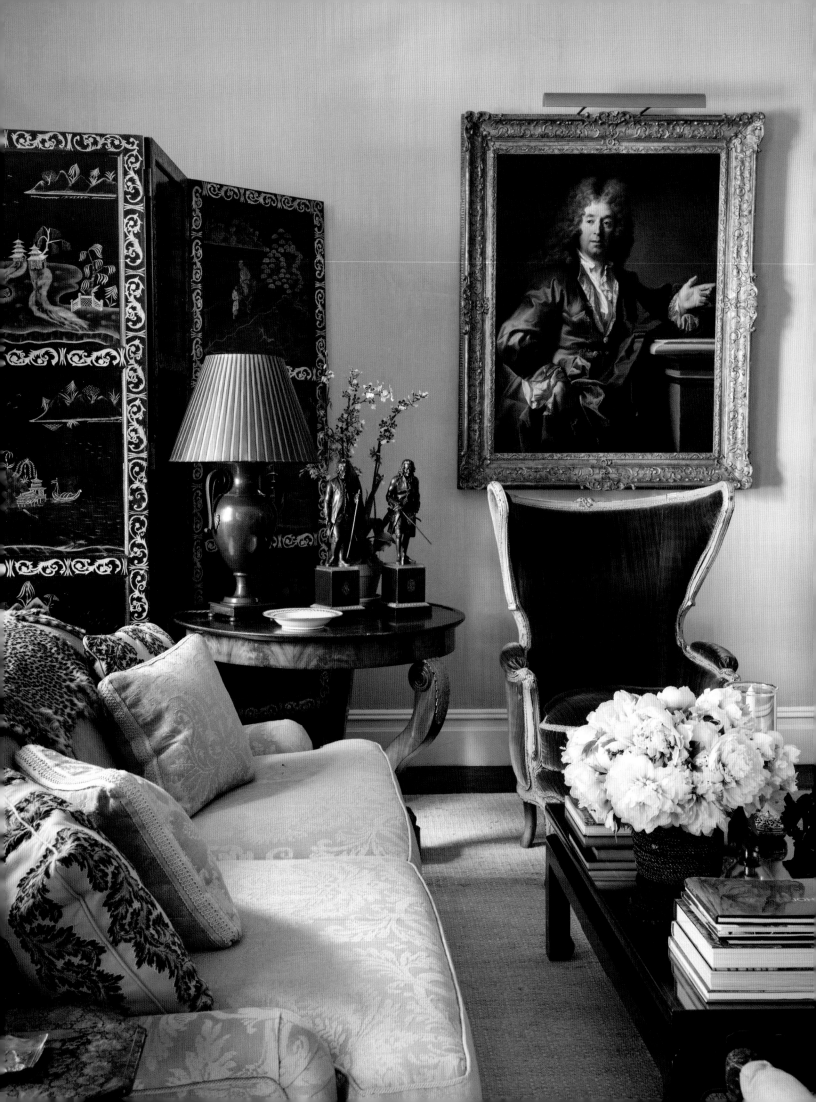

ABOVE AND OPPOSITE An eighteenth-century mirror surmounts a commode with ormolu mounts in the dining room (above). The space, crowned by a Russian chandelier, is small but lively in execution. Samarkand by Le Manach upholsters the walls, which also host a John Wootton landscape. China and glassware are stored in the nineteenth-century Austrian cabinet.

The main bedroom is smaller than the one in my previous upstairs residence, having been divided into two spaces by me before I moved in. That being said, Susan and I re-created the earlier bedroom as closely as possible, with the same Julia Gray bed and its lace hangings. The only significant changes were to use a different carpet and to dress the walls with a greige woven rather than pale blue faux horsehair.

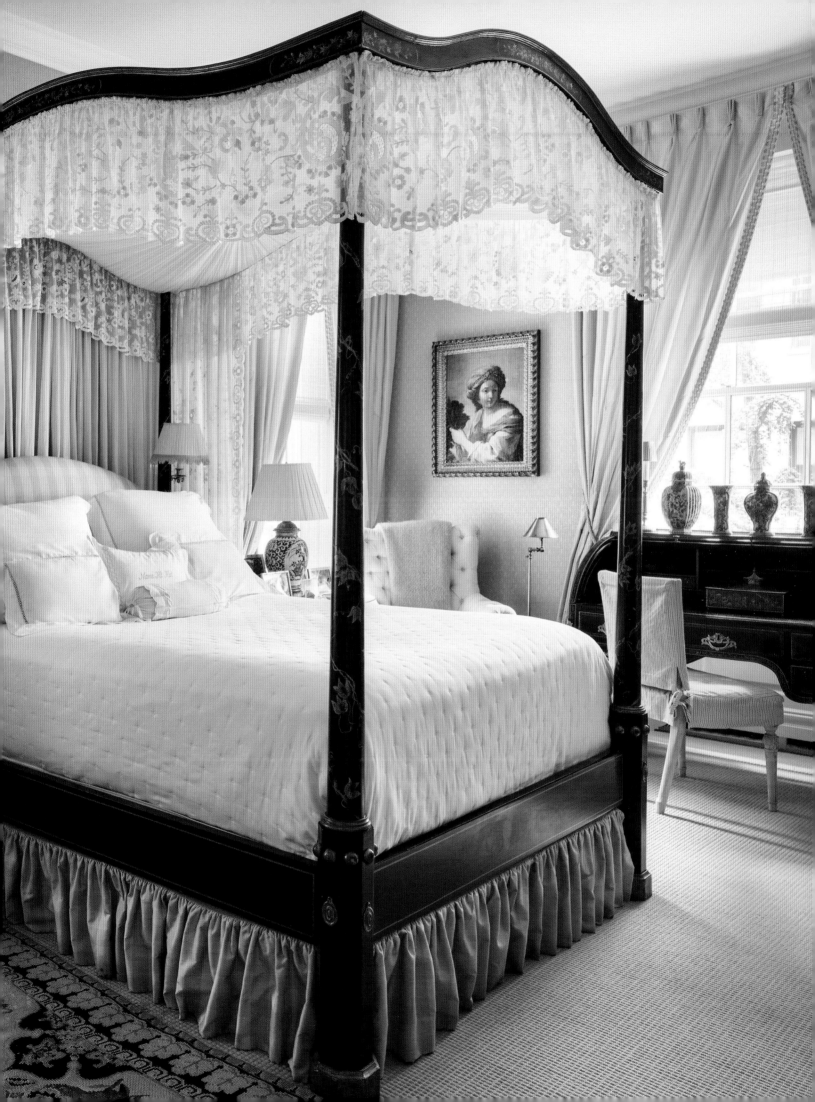

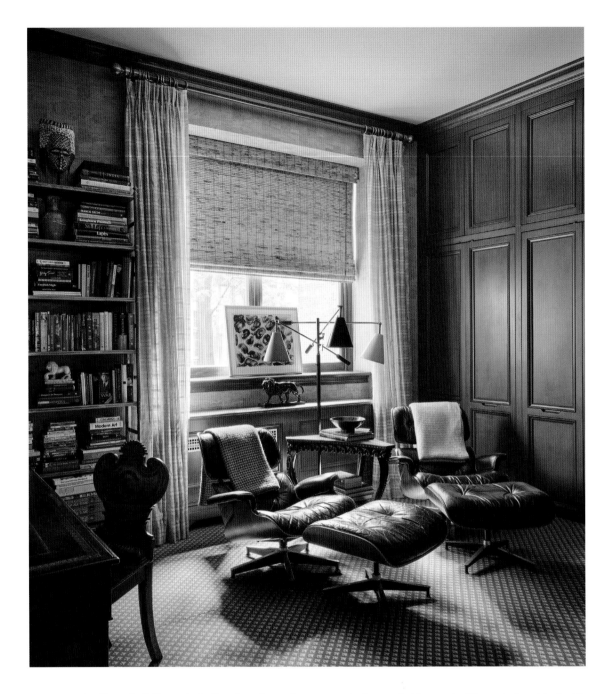

ABOVE *Significantly different in feeling than the main rooms—darker and richer—the library is furnished with 1950s Charles Eames lounge chairs and ottomans and carpeting by Tapis d'Avignon, a French manufacturer.*

OPPOSITE *The guest room was created when I had the space sectioned off from the main bedroom. A printed floral enlivens the walls, curtains, and daybed, simultaneously diffusing the architecture while also establishing a sense of coziness.*

FOLLOWING PAGES *A wonderfully odd European painting of children at play in a classical space is displayed above the guest room's steel-and-gilt-bronze campaign daybed.*

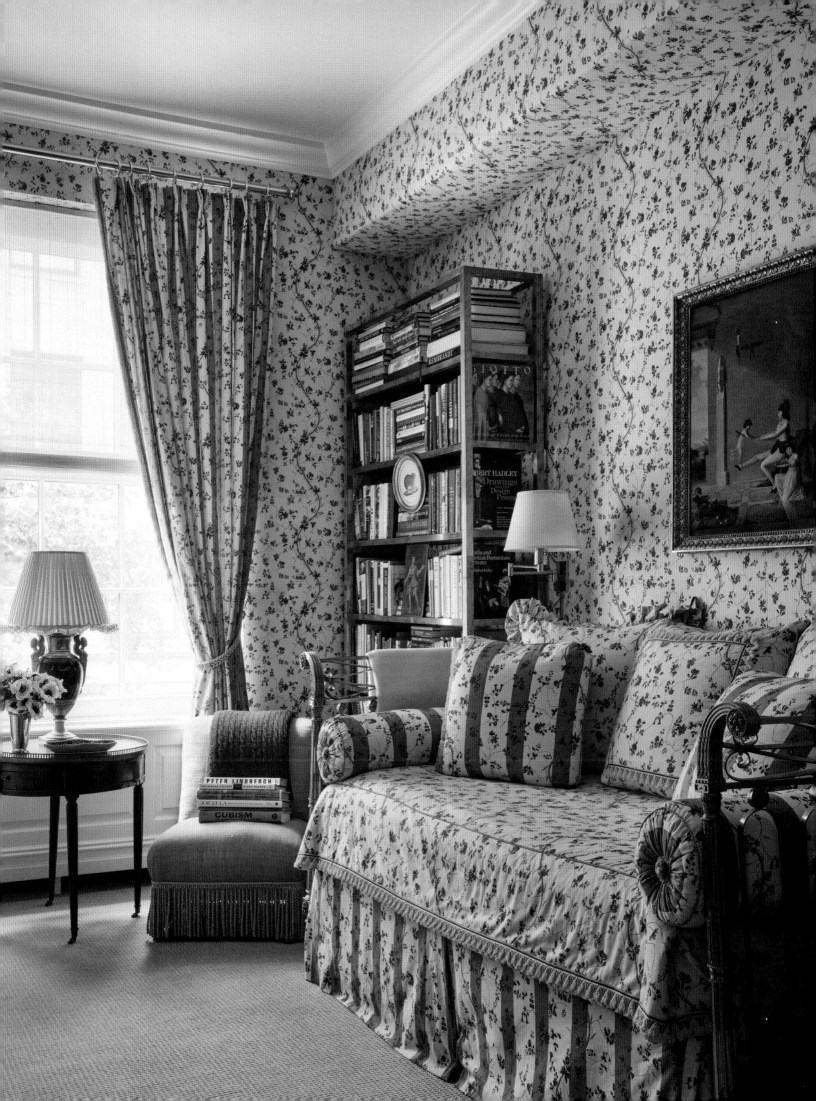

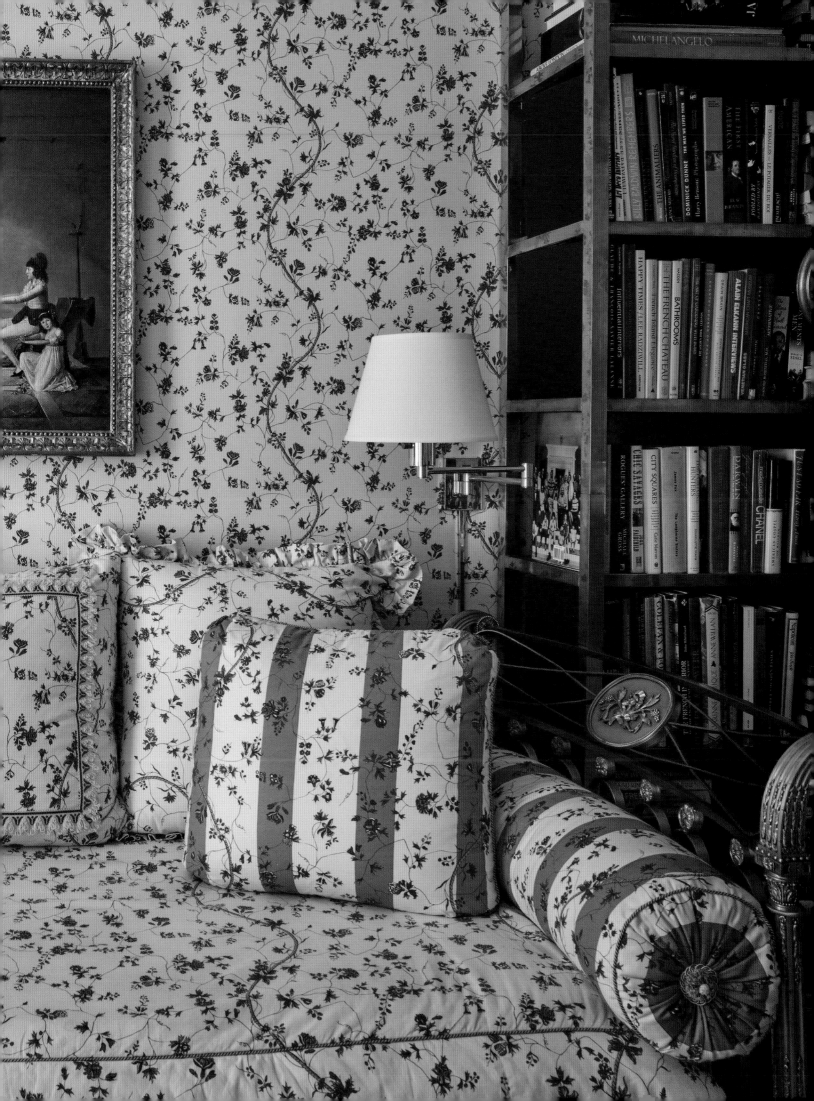

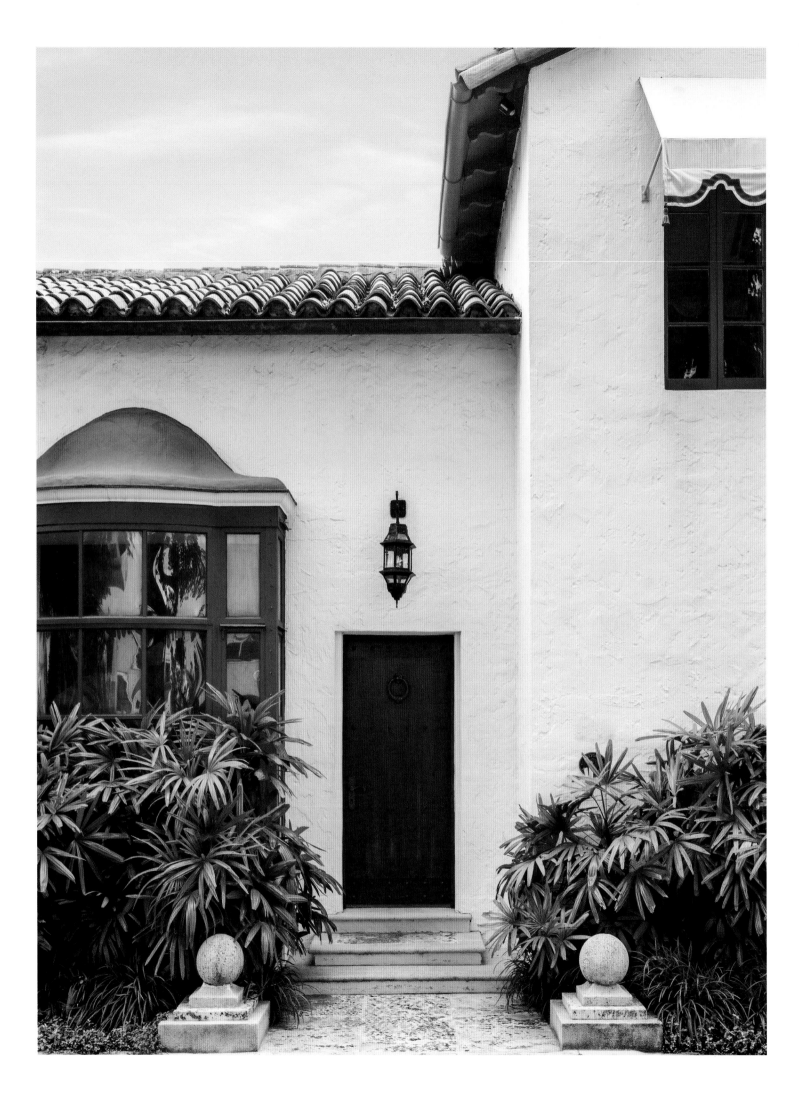

PHIPPS PLAZA

Palm Beach | 2012–present

Palm Beach is famous around the world for its architectural fantasies come to life. On what other little island in the United States can you find streets lined with houses in so many styles? This place has it all, or so an afternoon stroll can suggest: Venetian, French Provincial, Spanish Colonial Revival, Louis XVI Revival, Monterey Style, Georgian Revival, Bermudian, even a few of those combined into picturesque forms that are otherwise unclassifiable. All of these are tucked amid palm trees, ficus hedges, and bougainvillea of every color—not the sort of landscape where you'd expect to find, say, a Tudor Revival house.

The house where I now live in historic Phipps Plaza is just the sort of building that defines the early days of Palm Beach as a resort colony. Located right in the heart of the town, it is very clearly Mediterranean in style, but it is not a mansion like so many of the other houses that were designed by architect Marion Sims Wyeth. Dating from 1926, it is a small, precisely designed house, typical of the architect: white-painted stucco on the outside and topped with a roof made of traditional rounded terra-cotta tiles, known as *tejas curvas*, that the pioneering Palm Beach architect Addison Mizner popularized in the 1920s. Patterned tiles frame one of the street-front windows, while another, beside the front door and located at one end of the living room, is a very romantic bowed window topped by a gently undulating canopy.

I bought the house when I was married to Damon and decided I needed a project—I thought I would fix it up to sell or rent it. Unfortunately, after a long illness, my husband died, and I chose to live in this house until I found another. I made offers on several other houses, but once they had been accepted, I changed

One of the striking aspects of my 1920s Palm Beach house, in historic Phipps Plaza,
is the unassuming but potent entrance: a modest front door, studded with nailheads, that draws
your eye and makes you wonder what's inside.

my mind. The neighborhood has an intimacy about it. Phipps Plaza is a cul-de-sac and several of the town's famous architects, such as John Volk and Maurice Fatio, had offices there; the building that Mizner designed there is now the home of The Carriage House, an elegant dinner club. My house, originally designed for an art dealer, appealed to me right away, as buildings with a lot of charm so often do.

Indoors, the house is classic Palm Beach, too. The ceilings are covered with pecky cypress beams and boards. Chocolate-brown glazed tiles pave the floors of the main living spaces, though terra-cotta tiles in a pattern of stars and crosses are used in the loggia. The walls are painted white, so the atmosphere is clean and fresh and very simple. I kept that feeling in the decor, wanting to echo the existing palette of chalk-white planes and dark framing elements. There would be nothing

Architect Marion Sims Wyeth framed windows with colorful tiles, glazed to reflect sunlight, inspired by Mudéjar examples seen in Spain.

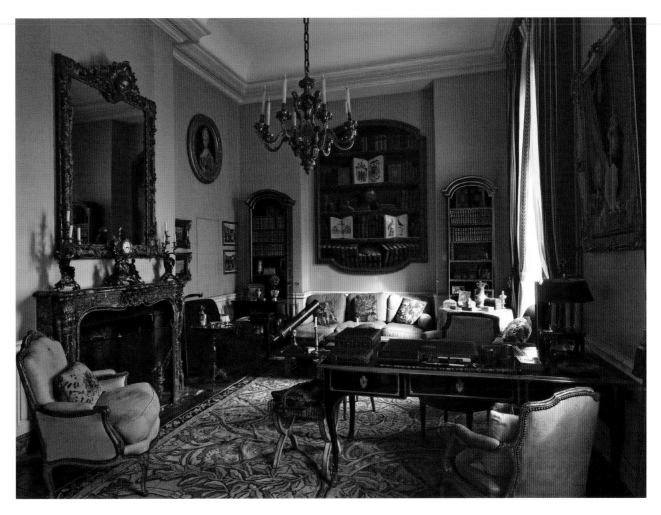

to disrupt the eye or cause the rooms to feel busy or complicated. What might seem spare to some eyes is perfect for me, especially in a house that isn't used all year long but only seasonally.

Keeping things simple doesn't mean that you can't have bits of fantasy, too. My canopy bed is made of polished wood turned to look like stalks of bamboo, a motif that complements the room's scenic panoramic wallpaper, depicting clipper ships sailing into a harbor fringed with palm trees. An antique trompe l'oeil painting of crowded bookshelves, which I bought from Susan Gutfreund, looks just as wonderful here, in casual surroundings, as it did at Susan's elegant Paris apartment. Sisal mats went onto the wood floors, and bamboo roller blinds grace most of the windows, save those that require curtains for privacy, such as the beige linen panels in the primary guest bedroom. Pulling them closed at night makes the most wonderful sound, almost musical, as the iron rings slide across the iron rods.

Most of the furniture's wood elements are dark, balancing the cypress ceilings and woodwork, but the styles of the pieces are varied, so the rooms, though restrained

An antique trompe l'oeil painting of bookshelves that hung in Susan Gutfreund's Paris library—and, earlier still, belonged to the Duchess of Windsor—now hangs in the living room of my Palm Beach house.

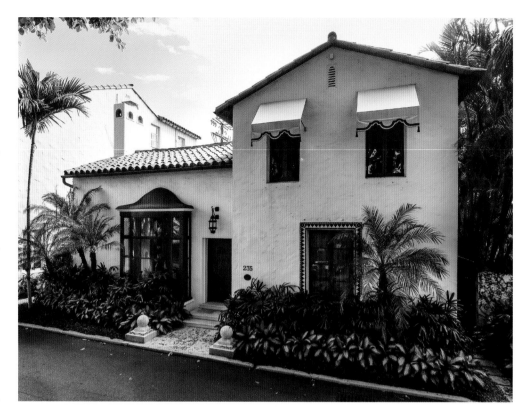

RIGHT Marion Sims
Wyeth designed the
house in the mid 1920s,
as the showroom for
an art dealer. The bow
window is its signal
feature, a charming
extension topped with
a shapely red roof.

OPPOSITE A Spanish
octagonal table occupies
the bow window, with
a flourish of tropical
leaves providing a
modicum of privacy
from passersby. Period
brown ceramic tiles
pave the floor.

in color, feel animated. In the pale-yellow study, which also serves as a second guest bedroom, a Victorian bamboo-style daybed—upholstered in a tropical-motif fabric by Braquenié—is joined by big welcoming French Art Deco armchairs covered in chestnut-brown leather, while the writing desk has a Georgian feeling.

The loggia is a tile-floored space open to the elements, in the form of a shallow garden with a small fountain shaded by palms and banked with philodendrons and other tropical and semitropical plants. It's furnished with a collection of unrelated but happily married furnishings and objects. Dark-stained rattan armchairs and a matching sofa make the space livable in all weather. Flanked by bamboo plant stands and topped with faux-bamboo lamps, the console table is surmounted by a green-and-yellow painting by Catharine Warren of the top of a palm tree. In one corner stands an Indian folding screen made of carved teak panels that looks like brown lace. It is a combination of objects and materials that, combined with the leafy green view, could be in any tropical spot in the world, from Vietnam to the Yucatán. But it is in Palm Beach, that most American of architectural melting pots. 🌴

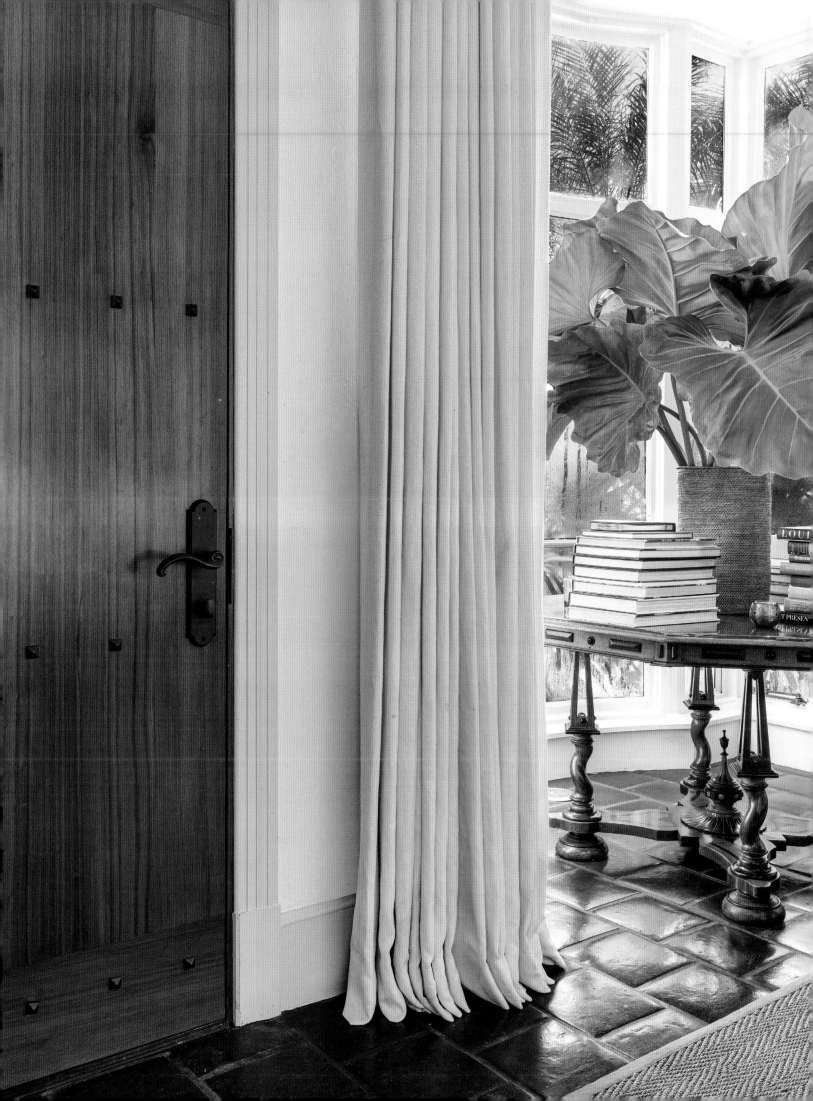

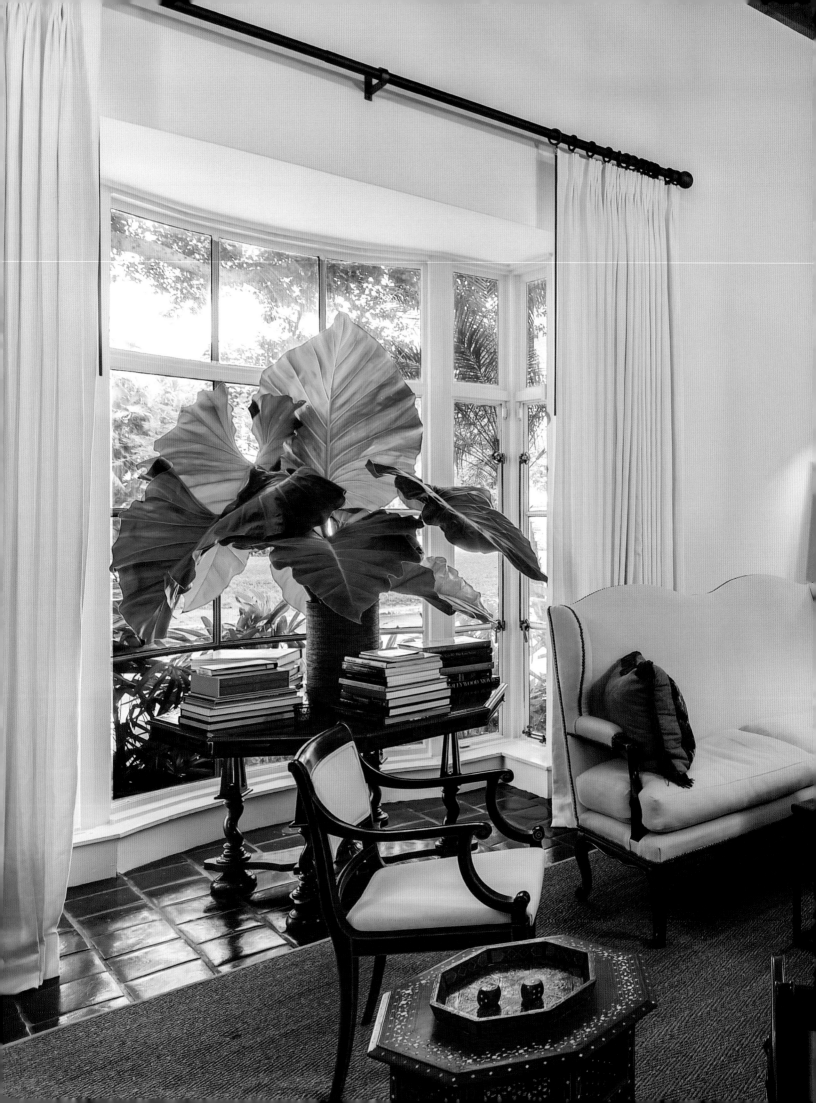

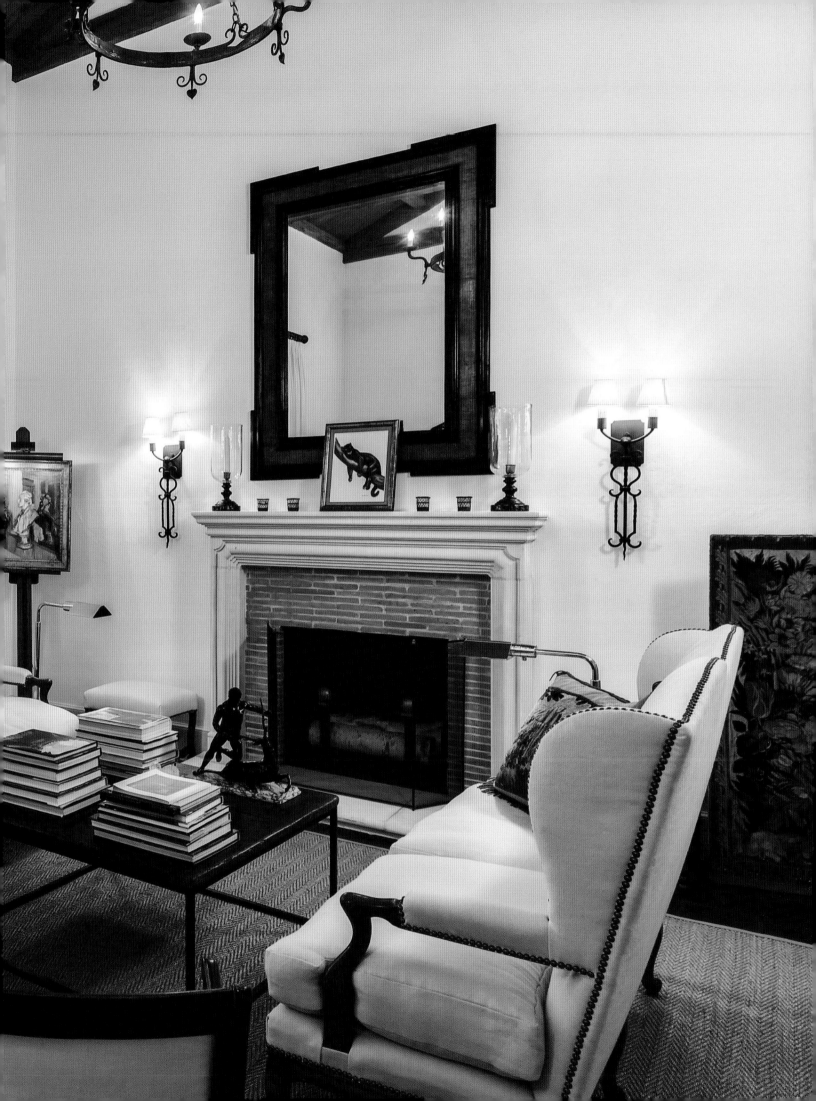

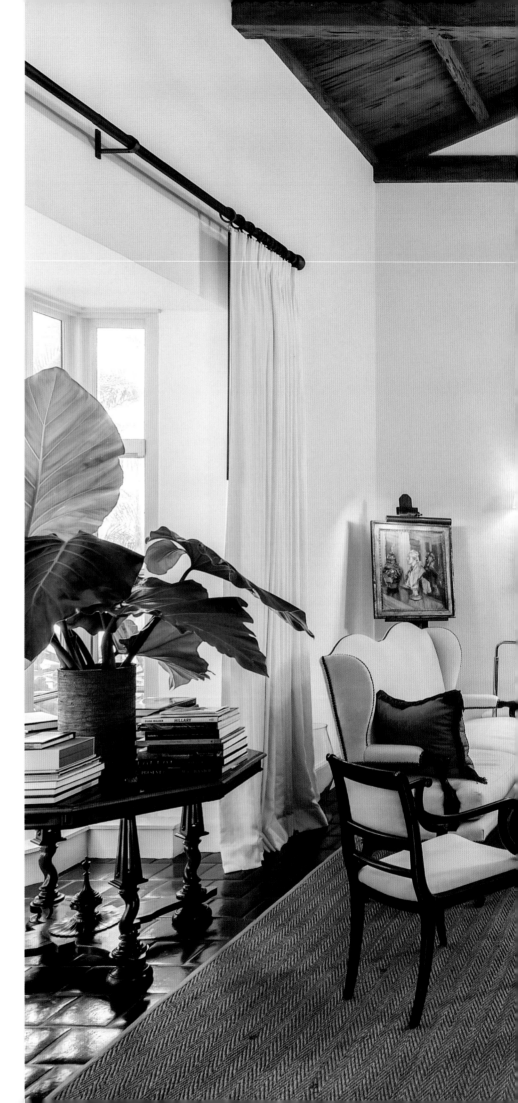

PRECEDING PAGES AND RIGHT *The living room utilizes French and English furniture, spare and simple, that I have used in Palm Beach at various houses. Any period context is toned down, though, through the use of plain linen upholstery and a herringbone sisal carpet. A classic element of Florida architecture, a pecky cypress ceiling shelters the room. Susan Gutfreund's trompe l'oeil bookshelves hang above a bench (at right), its size balancing the bow window opposite.*

FOLLOWING PAGES *The dining room is as monastic as the living room, furnished with just enough rather than too much. Again, despite the antique furniture, the atmosphere is fresh and timeless and very relaxed.*

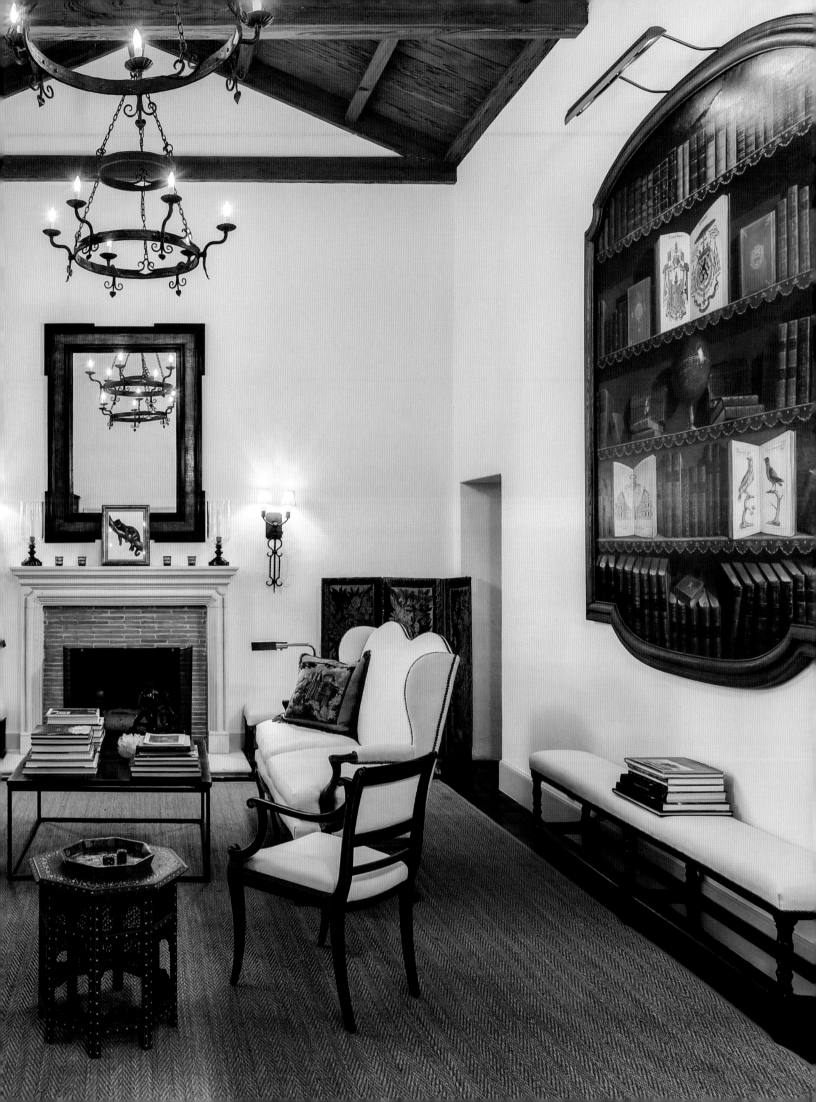

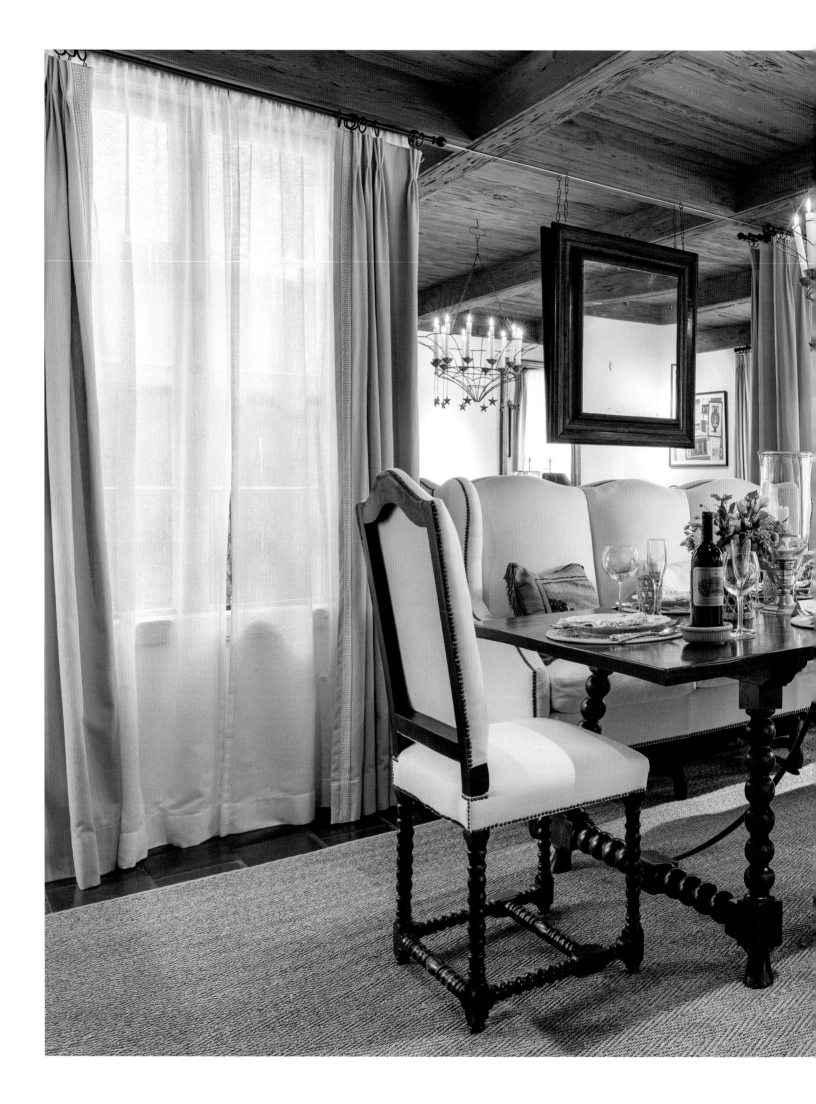

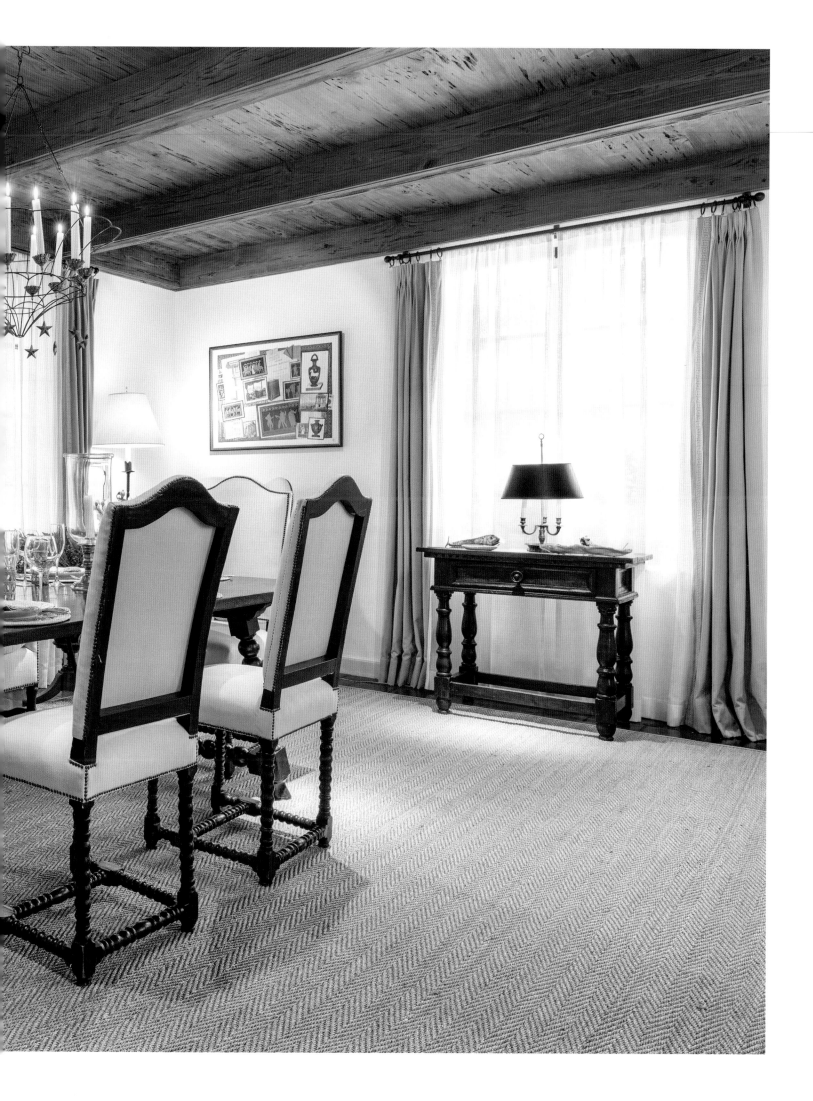

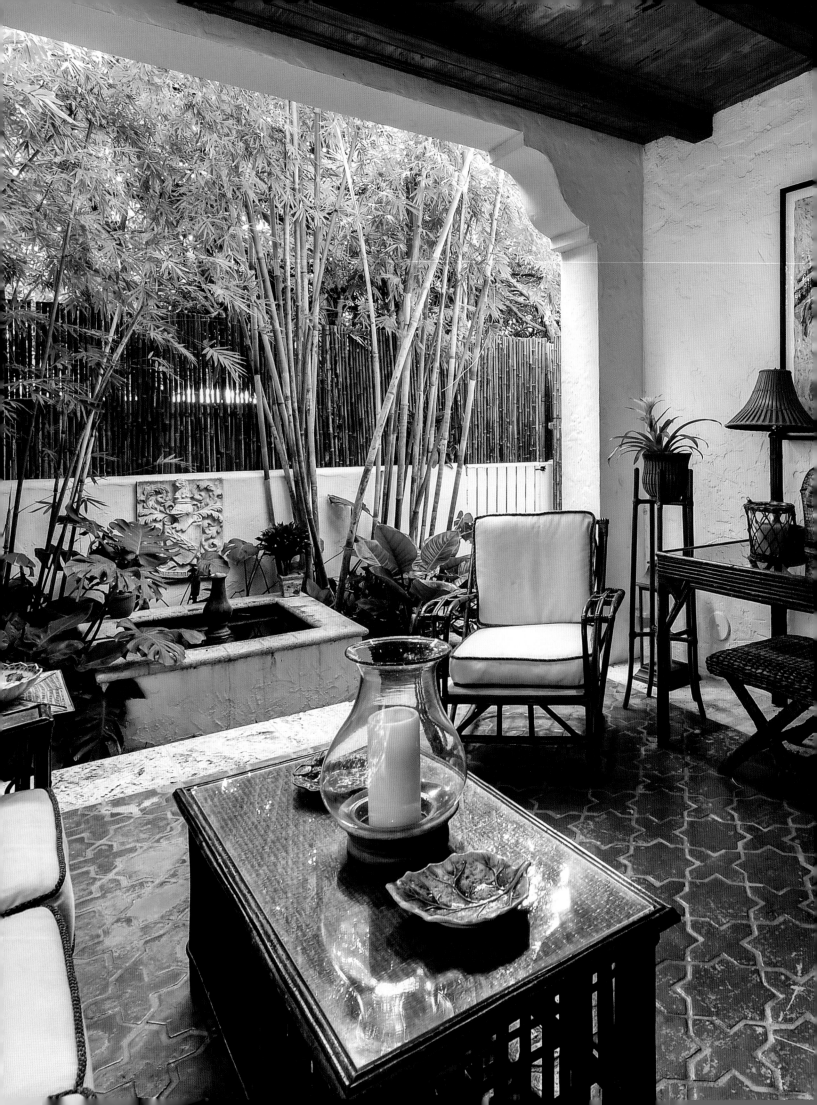

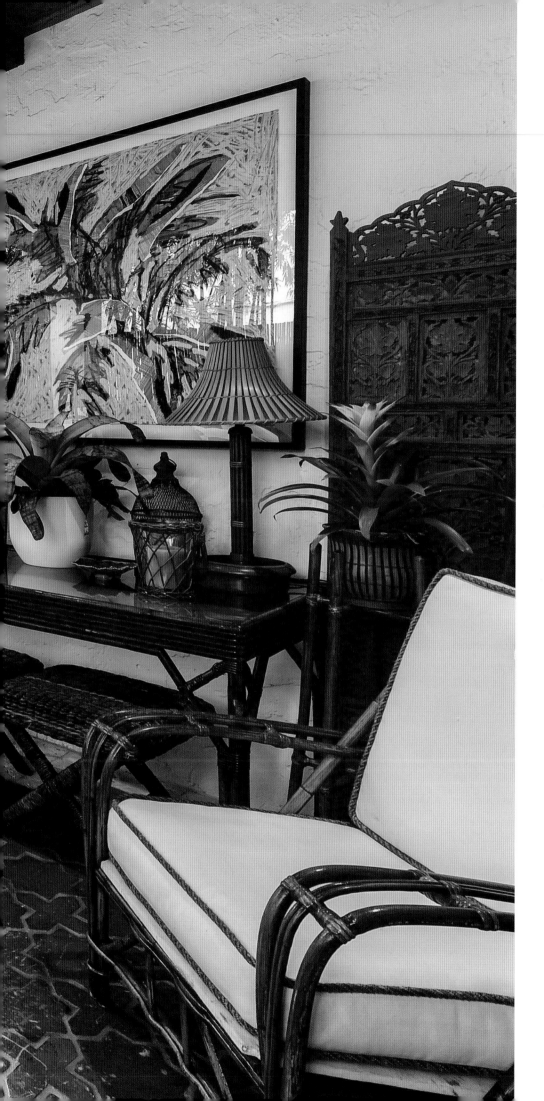

LEFT A painting by Catharine Warren overlooks the tile-paved loggia at the rear of the house, a living area that surveys a fountain and a heraldic panel of the sort that Palm Beach architect Addison Mizner might have used back in the day.

FOLLOWING PAGES A scenic panoramic wallpaper surrounds my bedroom, the subdued tropical scene rather like Palm Beach's own. The bamboo-turned bed underscores that feeling, as do the louvered doors and shutters.

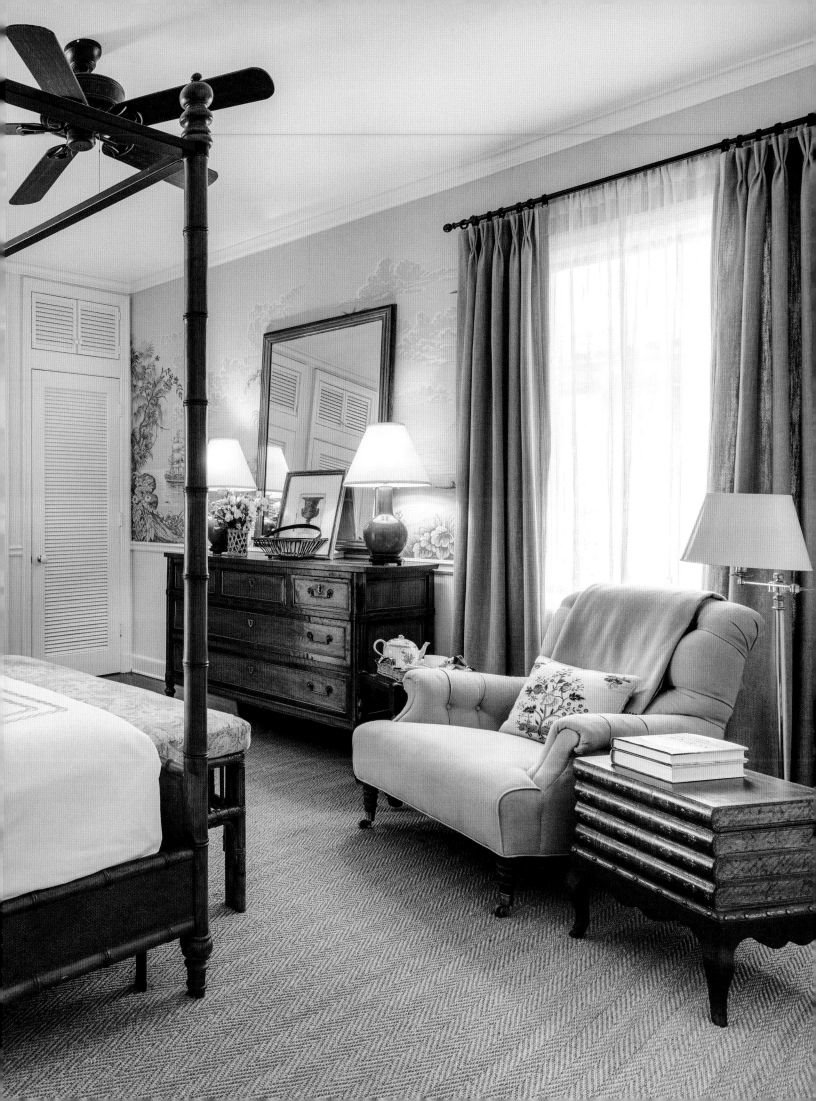

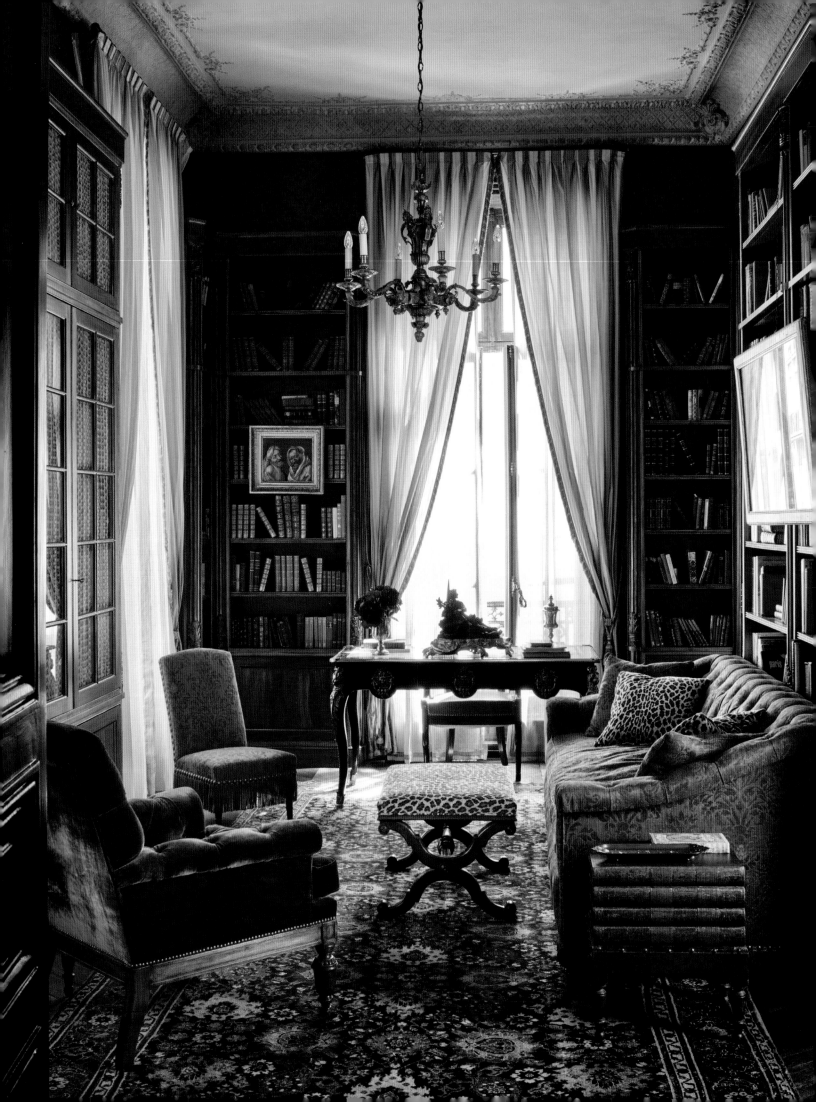

RUE DE BELLECHASSE

Paris | *2013–present*

Renzo Mongiardino, the legendary Italian interior designer, had a sense of style that has captivated me, and many other people, for decades. Everything he did was a masterpiece of atmosphere and romance, from apartments and houses to stage and movie sets—his work on Franco Zeffirelli's films *The Taming of the Shrew* and *Brother Sun, Sister Moon* saw him nominated for Academy Awards. Mongiardino famously brought the past into the present for his clients, but with a great deal of surprisingly creative license, such as aging a textile by crosshatching its surface with pens or creating a beautiful wall of seeming Islamic tiles that were actually the work of a decorative painter. It was an arsenal of theatrical techniques not usually seen in rooms that you actually live in. I was lucky enough to have met Mongiardino once—at a coffee shop—in Milan, where he had his office, but I never thought to ask him if he'd be interested in decorating a place for me, despite always dreaming about doing just that.

One morning, though, not long after my late husband, Damon, and I had purchased a two-bedroom apartment on the Left Bank in Paris, I was reading a magazine article by my friend David Netto, who is a wonderful decorator as well as a gifted writer. His subject happened to be Studio Peregalli Sartori, a design firm that was founded by Roberto Peregalli and Laura Sartori Rimini. They had worked closely with Mongiardino, who died in 1998, and were keeping his spirit alive in their own projects, from their own office in Milan, commissions that David described as "deeply poetic." So I made an appointment to show Roberto and Laura our new apartment whenever they were next in Paris.

With its button-tufted upholstery and eclectic array of periods and styles—Louis XVI chandelier, Louis XV desk, seventeenth-century painting, nineteenth-century Persian carpet—the library of the apartment on Paris's rue de Bellechasse evokes the time of Marcel Proust.

Damon and I had already met with a few decorators at that point, and none of them were a perfect fit. One suggested painting the main bathroom black and installing white fixtures and lining the dining room with banquettes that could be used as beds for overnight guests. Both suggestions seemed a little extreme to us, given that the building dates from the eighteenth century—and I don't know many people who would be comfortable sleeping in the same room where they had just had dinner. Historic buildings just seem more appropriate with decorating that complements the past, rather than fighting against it, and Studio Peregalli Sartori embodies that ethos. Roberto and Laura spent about a year renovating

Artisans developing Studio Peregalli Sartori's scheme for the salon. The one on the scaffold is gilding the cornice, while the one at right is working on the plaster walls.

the apartment, which seems unbelievably brief, given all the work that was done. Their artisans enriched the rooms with all the lessons that Roberto and Laura had learned during their association with Mongiardino yet have made their own.

It's easy to rave about a room when it's been completed, but every time I walk into the Paris apartment, it's impossible not to remember its raw state and the months of labor that changed largely white spaces into a collection of jewel boxes and all the pleasurable hours spent browsing the neighborhood *antiquaires.* Observing and learning are two of the most enjoyable aspects of working with decorators and architects—seeing the painters paint, the carpenters build, and the gilders gild. Studio Peregalli Sartori took that to another eye-opening level. I'd never before worked with a designer who made his own fabrics or printed her own wallpaper. That being said, Roberto and Laura began furnishing the rooms in classic fashion, from the floors up, but not before they replaced the splintered old wood with beautiful antique parquet laid in various patterns, from diamonds in the dining room to starbursts in my bedroom.

Once the parquet was installed, in came the carpets, and from those, the color schemes were developed. But the fabrics we settled on do not match precisely. The dull golds of the antique Aubusson carpet in the living room, for example, are echoed, much more brightly, in the lemon-yellow taffeta curtains. A few structural changes had to be made, like raising the flat ceiling of the dining room into a shallow barrel vault, so the room could accommodate a chandelier, and lowering the existing kitchen cabinets, which were mounted so high I would have had to use a ladder to reach into them. The spare room had no closets, so the designers constructed two at either end of the room. Their presence happily created a central alcove—the rear is mirrored to add visual depth as well as a silvery shine—that is the perfect shelter for the curtained daybed.

Most of Studio Peregalli Sartori's changes, though, were decorative, and I can't think of one that isn't hand-wrought. What looks like a diaper-and-rosette wallpaper covering the living room walls is actually a raised pattern, a sort of

For the bedroom walls, Roberto Peregalli and Laura Sartori Rimini of Studio Peregalli Sartori designed a hand-painted canvas that was inspired by the percales that were popular in eighteenth-century France.

bas relief, that was applied to the walls like the piping on a cake. Panels of smoky mirrored glass, hand-painted with colorful flowering vines that remind me of crewelwork, line the dining room, expanding the narrow space with reflections that just go on and on. At night, when the space is lit only with candles, it feels a bit like a scene from Stanley Kubrick's movie *Barry Lyndon*: romantic, mysterious, and flattering. 🌡

RIGHT A detail from the salon shows the intricate wall panels, a custom-made wallpaper that is hand-painted with a diaper motif. The gilded table is French, topped with a marble bust of a Roman emperor, and above is an antique etching of Castel Sant'Angelo.

OPPOSITE In the entrance hall, a nineteenth-century French armoire stands against a wall covered with two custom features: a custom-made wallpaper and a hand-painted wainscot emulating marble.

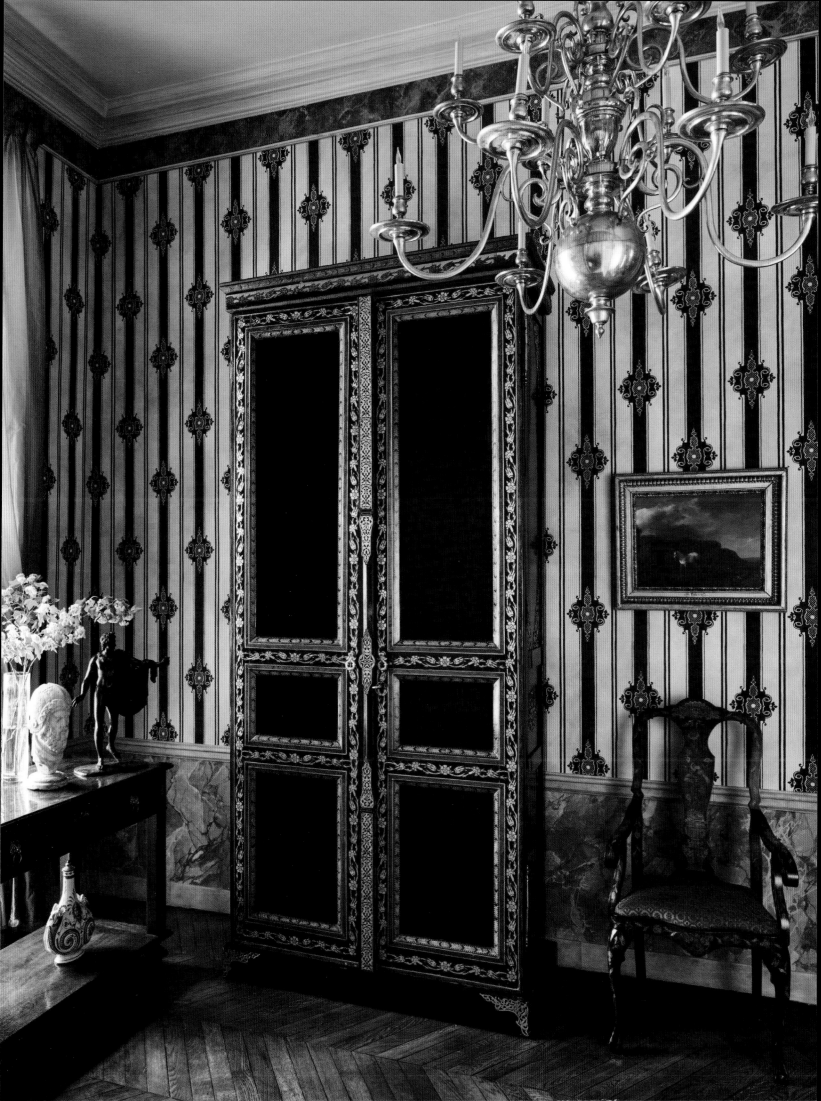

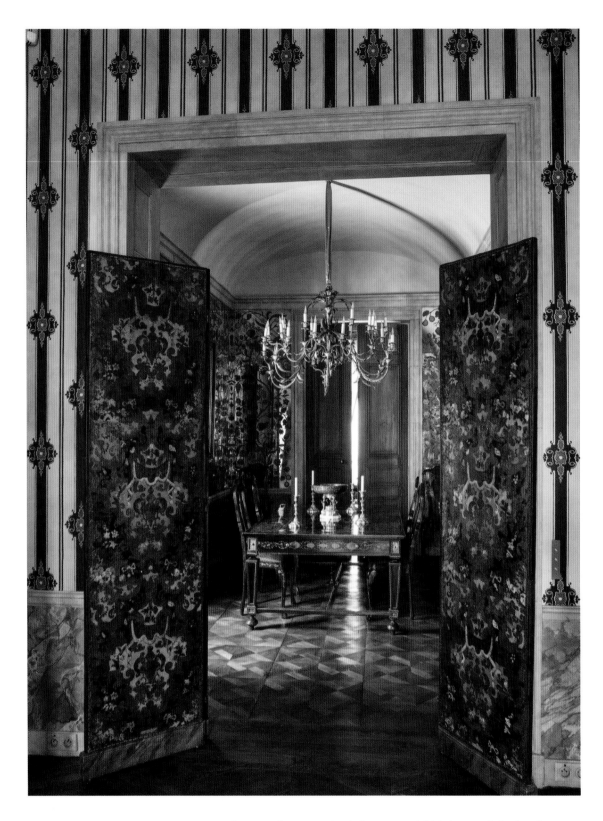

ABOVE AND OPPOSITE *An antique four-panel screen—divided in two and folded around the doorframe—announces the entrance to the mirrored dining room, where a barrel-vaulted ceiling replaces the former flat one. Artisans painted the wainscot to resemble marble, and also painted glass panels with tapestry-like floral motifs. The dining table is a nineteenth-century French roulette table, and the chairs are Flemish of the same period.*

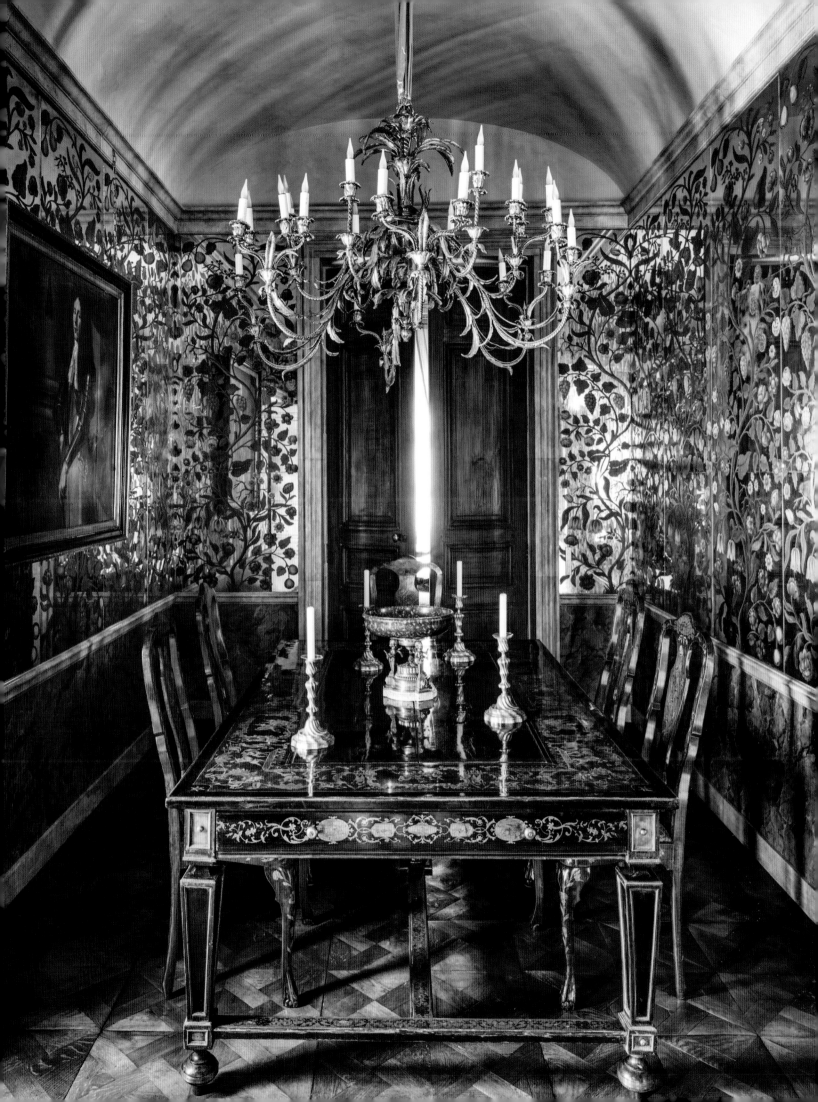

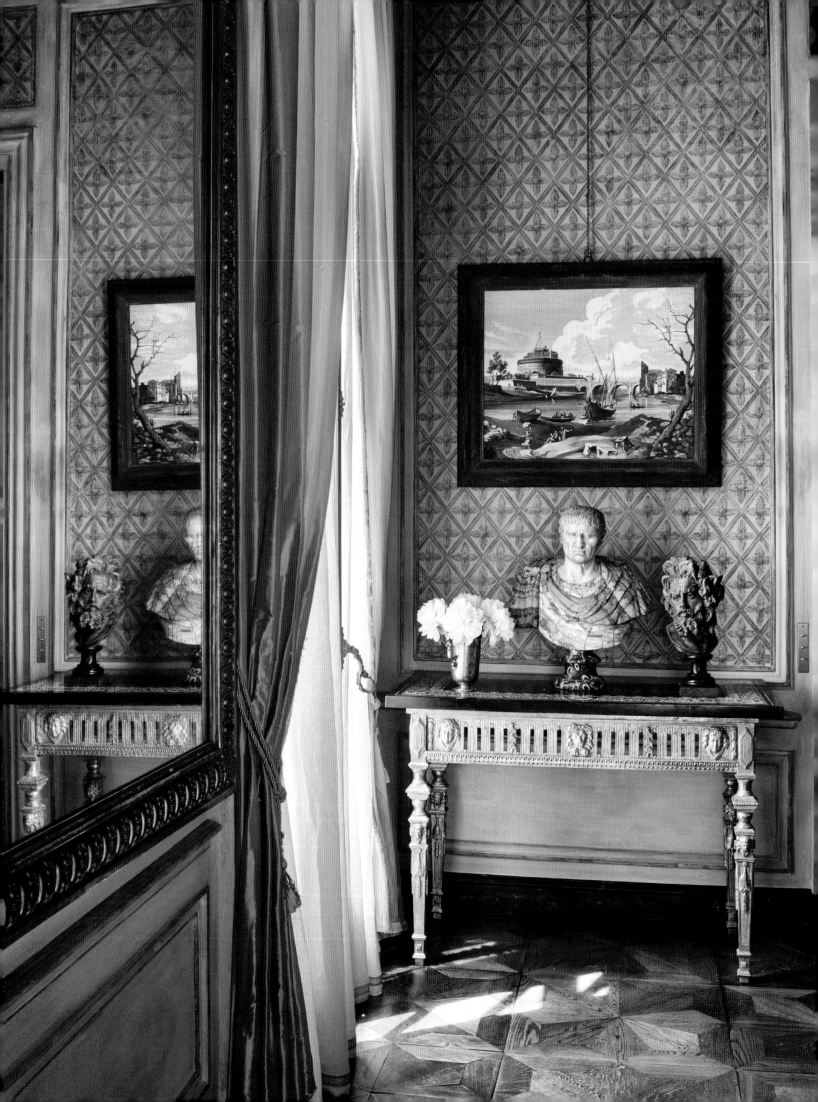

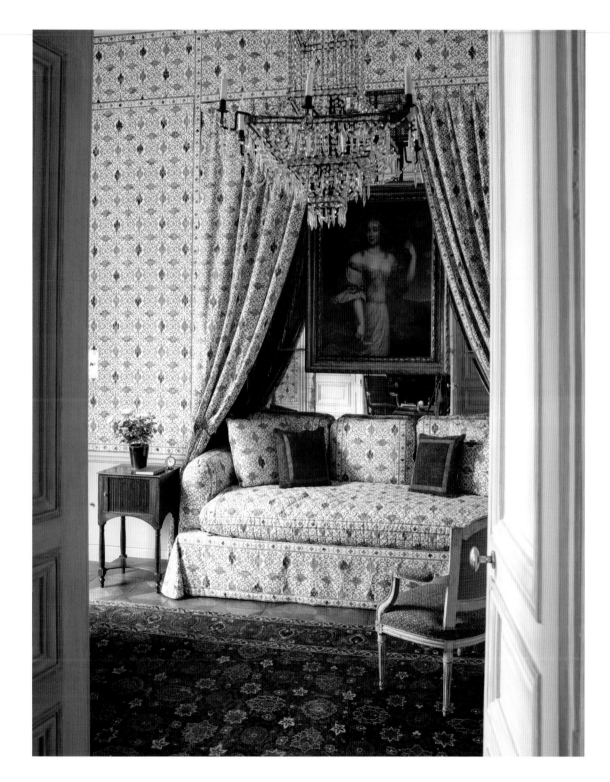

PRECEDING PAGES AND OPPOSITE *Yellow curtains, unlined to cast a golden glow, hang at the windows of the salon. The room's palette—green, pink, yellow, and plum—was taken from the carpet. Studio Peregalli Sartori replaced the worn original flooring with antique parquet that they sourced in Italy.*

ABOVE *A diamond-patterned fabric, a hand-printed cotton, was created for the guest room, where the daybed is set in a mirrored alcove between two newly constructed closets. For the bedcover, the same fabric was quilted for contrast. The seventeenth-century Gilbert de Sève portrait depicts a woman costumed as the goddess Diana.*

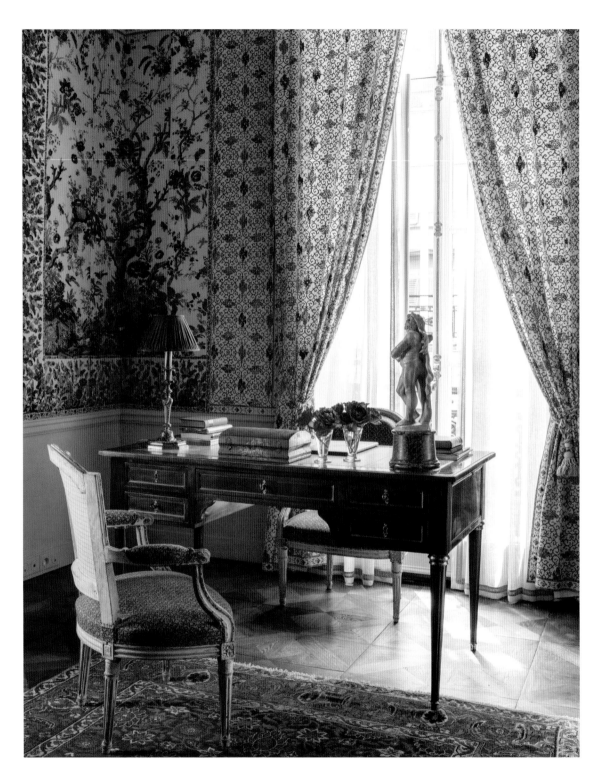

ABOVE AND OPPOSITE At one end of the guest room stands an eighteenth-century French neoclassical bureau plat. The fabric on the walls alternates with antique textile panels that were found at Fremontier, a Paris dealer. Across from the bureau plat is a hidden door that opens to a bathroom. The tapestry was cut to allow the door to blend more fully into the wall. The eighteenth-century Tilly Kettle portrait depicts an Englishman.

FOLLOWING PAGES The kitchen is accented with antique Portuguese tiles, paintings associated with food and cooking, and a Napoleon III brass chandelier. Studio Peregalli Sartori redesigned the cabinets.

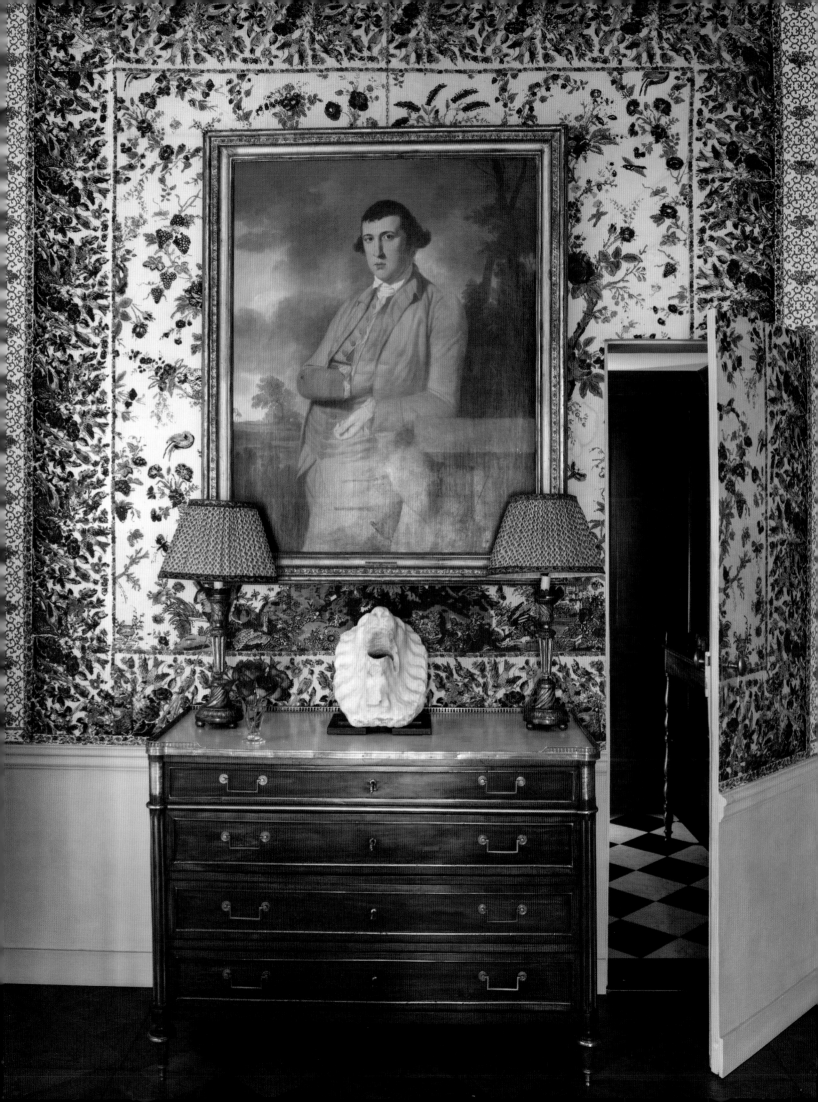

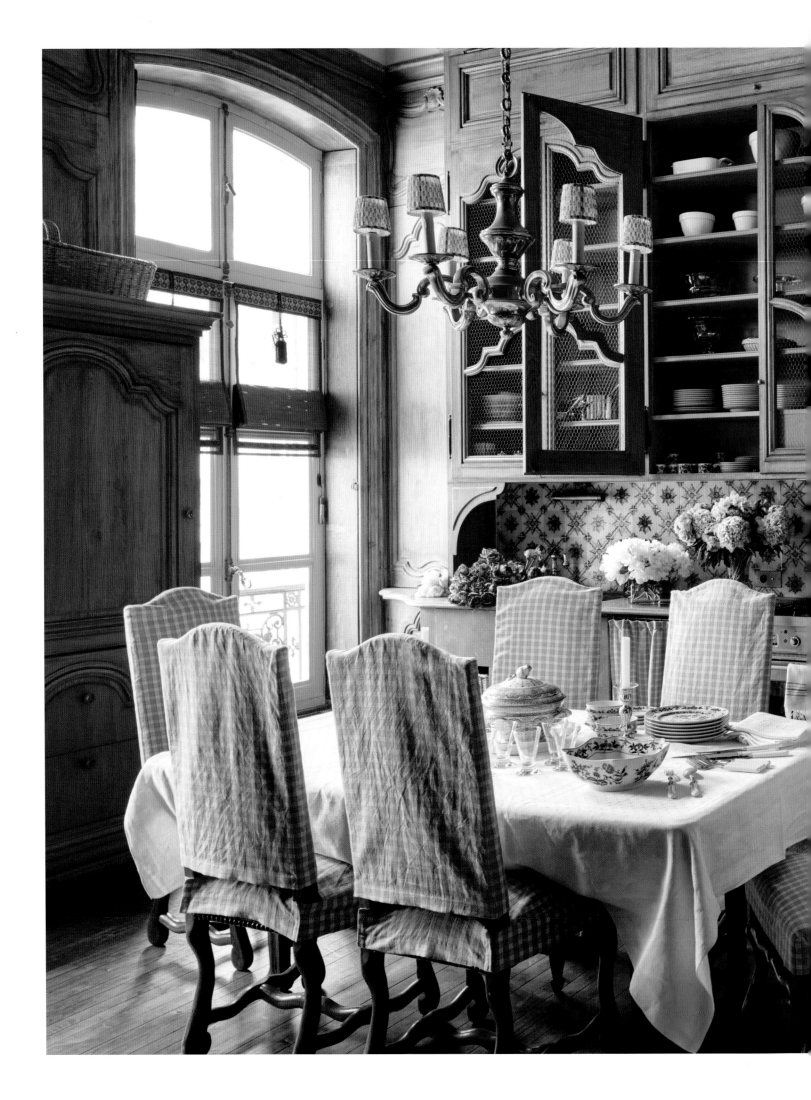

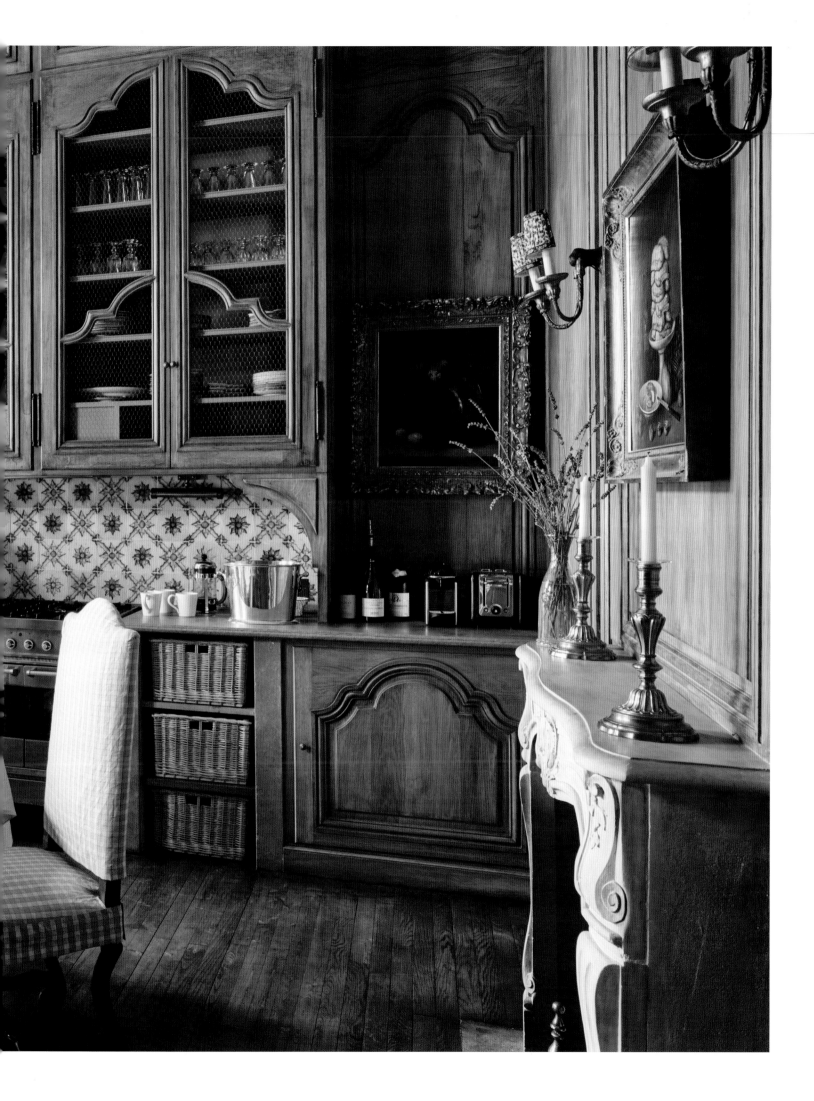

ABOVE A French cotton print tents the dressing room, where storage is concealed behind curtains. The curved panel underscores the tent inspiration, though it was designed to partly conceal the space from the bedroom.

OPPOSITE Hand-painted stripes line the main bathroom. The antique table hosts a fine dressing table mirror.

FOLLOWING PAGES The main bedroom is connected to the library and the salon via double doors. The boiserie is infilled with hand-painted wallpaper in the Persian style, and the bed is nineteenth-century Italian. The custom carpet is based on a paisley pattern that was associated with French tastemaker Madeleine Castaing.

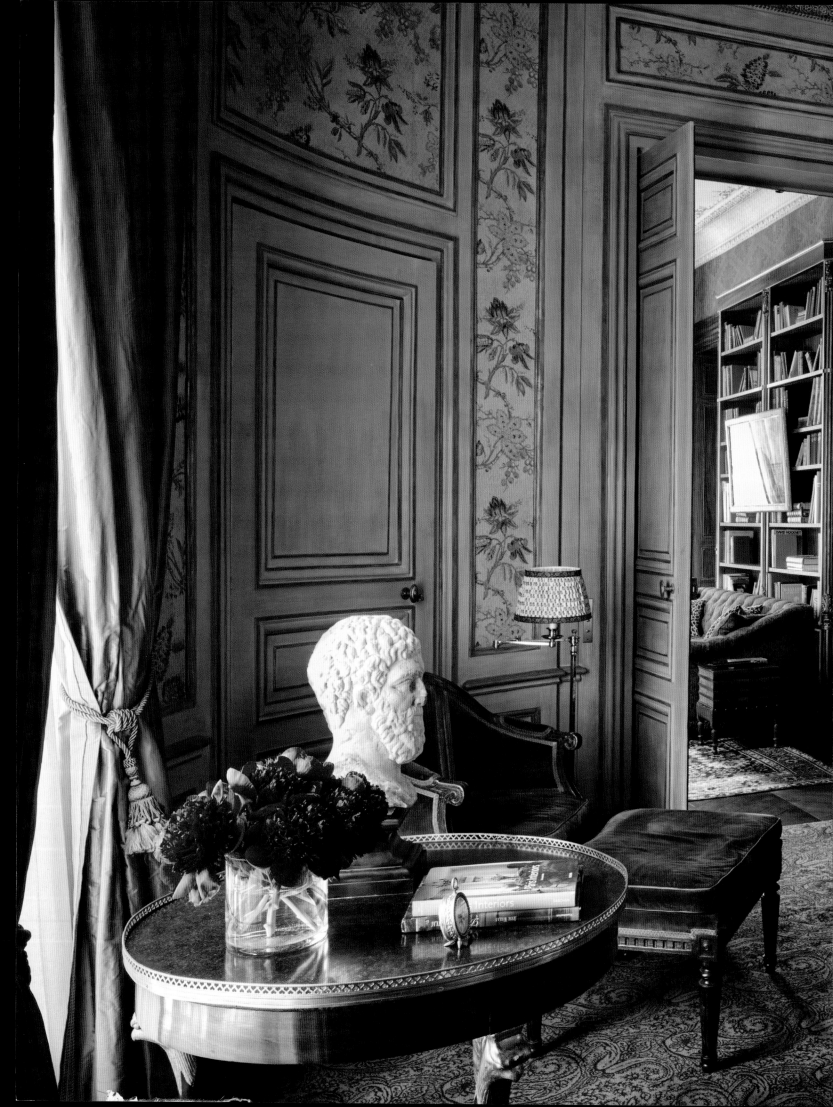

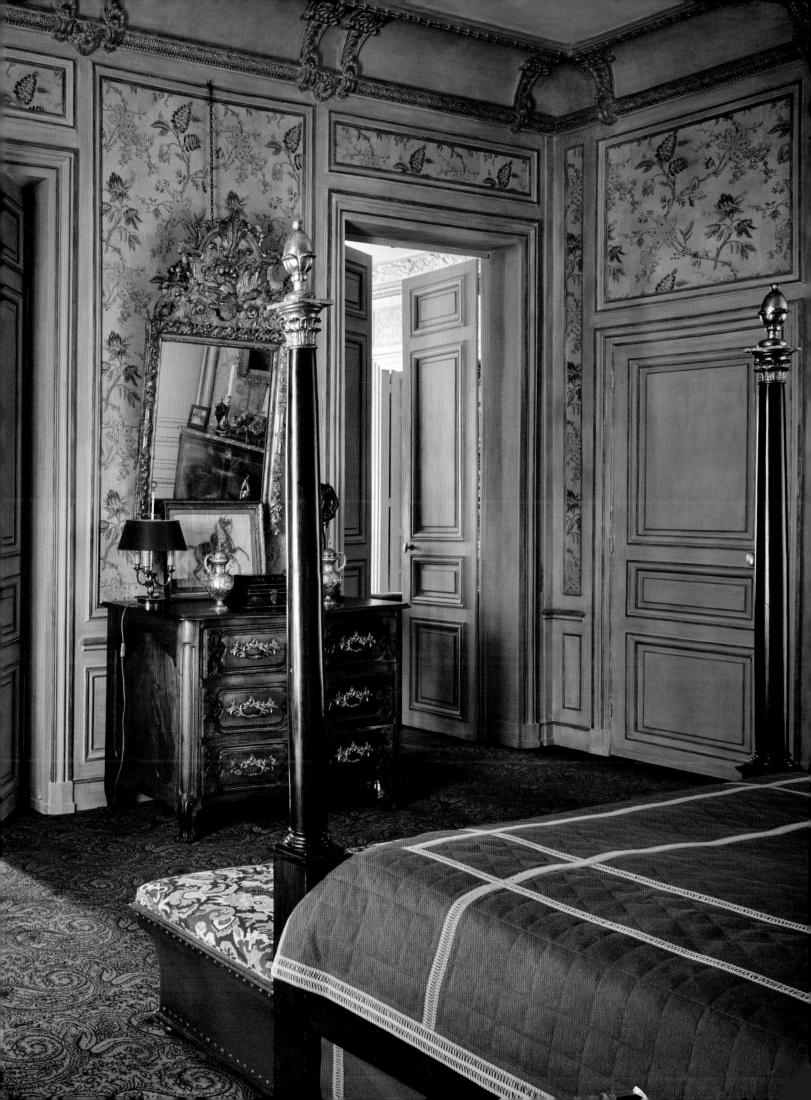

AFTERWORD

An Inspiring Tale of Ignorance, Squalor, Education, and Redemption

For much of my life I knew nothing about interior decorating, thinking it was frivolous, superficial: a silly pursuit for socialites obsessed with appearances, neat freaks always arranging and fluffing pillows, or those snooty magazine design twerps at *House Beautiful*, where I lasted two days as a fact-checker.

I was proud to have no idea what chintz, sconces, William Kent tables, Queen Anne chairs, trellises, and porticos were. I happily wallowed in hellholes, pigsties, rattraps. All I needed was enough room for a mattress on the floor and a litter box for the cat.

Oddly enough, the decorator Mark Hampton loomed large during my youth. Before my mother, Katherine Bryan, moved to Belgium in 1991, there was a going-away dinner party at Doubles. After Tom Wolfe gave a very funny toast in which he affectionately teased Mom about her numerous residences, Mr. Hampton toasted her generosity and expertise in the art of design and entertaining. Among other things, he said there were always "fresh towels" in her guest rooms.

The guy had star power: obvious substance, breeding, manners, erudition, sartorial perfection, wit, and charm. But I thought: fresh towels? What's that all about? I mean, you take a shower, you dry off with whatever's around, washcloths, a bathmat, paper towels if need be, or you just drip dry, end of story, right?

Mr. Hampton decorated places for Mom in East Hampton and Brussels, as well as two town houses in New York, one on East Seventy-first Street and a Louis XVI Revival behemoth on East Ninety-sixth. The latter, the so-called Cartier mansion, was designed in 1916 by Ogden Codman Jr. (who wrote *The Decoration of Houses* with Edith Wharton). It had thirty-thousand square feet, thirty rooms, eleven bathrooms, and a pipe organ in the living room. After Mark questioned Mom's interest in the property ("You're not Jayne Wrightsman!"), her resolve was emboldened.

Soon, things began arriving from Sotheby's, Christie's, and Dalva Brothers. Mr. Hampton was around all the time, having meetings with Mom about Louis XV–style chairs, bouillotte lamps, boiserie panels, Sultanabad carpets, velvet- and damask-covered chairs and sofas, an octagonal mahogany table for the octagonal dining room, the pair of silver gilt candelabra on the white marble mantel above one of the seven fireplaces.

In 1995, I tagged along to Elio's restaurant, where Mark's stunning wife, Duane, and their lovely daughters, Kate and Alexa, met us. That was the last time I saw Mark, who died less than three years later.

A decade later, while still living in places that resembled my room at the fraternity house, I began taking an interest in decorating, perhaps as a profession that would pay more than freelance journalism, which wasn't really working out.

It turns out that unlike, say, real estate or medicine, you don't need a license to be a decorator. So maybe it was time to enhance my two-room dump in Park Slope with a little beauty and comfort? I asked my then-fiancée, Hilly, what she thought of my design aesthetic. She decried all my efforts.

In 2012 I came across *Mark Hampton: An American Decorator* (Rizzoli, 2010), by Duane Hampton. I loved that book. The text and tone were great, the pictures interesting to look at (two of Mom's former residences were featured). "It was nice to write about Mark, not sad," Duane told me. "I wanted to do it to ensure that he would be in the history of decorating."

Mark Hampton, celebrated interior designer, writer, and artist, joined by two feathered friends.

We were sitting in her Park Avenue apartment, which hadn't changed much in the past three decades. In her bedroom were fifty-two scrapbooks chronicling her life with Mark. On the bedside table, in a small silver frame, was their motto: "I don't believe that less is more. I believe more is more, that less is less, fat fat, thin thin, and enough is enough!"

I asked for help with some decorating terms. After Duane explained *Palladian*, *en suite*, *Natchez*, and *William Kent table*, I worked up the courage to ask what the hell *chintz* is. "That's one of my favorite things," she said. "It's a material that's printed, often flowery, not always, and has a glaze that makes it semi-shiny, which also protects it, and keeps it going for years. That's chintz." Apparently, I was sitting on some.

"You know what a trellis is, right?" she asked.

"Vaguely."

"Do you know what lacquer is?"

"Sort of. Is it shiny?"

"It's a paint finish that's very shiny and hard," she explained.

I excused myself. "You know, every time I use a fresh towel I think of Mark," I said, after returning from the bathroom. "There's nothing like a fresh fluffy towel, except maybe a brand-new pair of white tube socks. It really makes a big difference. When you use the same towel for a week, it's just not the same."

"I think you're making progress," Duane said.

Things improved after Hilly and I were married, our son was born, and we moved into a lovely apartment on the Upper East Side, which my mother spent two months decorating beautifully.

The apartment had a great layout and possibilities, but was pretty bland. It needed work and charm. By then I could speak *decorating* a little and appreciated Mom's genius taste and skills a lot. No longer did I take them for granted.

Mom hired a brilliant contractor, David Gonzalez, who by chance had worked on the apartment for its previous owners, and she brought in her friend, architect Pietro Cicognani, as a consultant.

First they took care of the basics, redoing the bathrooms and the floors and painting the walls. There was something off about the fireplace, and it looked much better painted black.

In the living room and bedrooms she decided on wool sisal carpeting. Awesome. With grass cloth wallpaper (which has a nice texture you want to run your hands along), she magically transformed the foyer into a room you'd want to hang out in, not just dump stuff and pass through.

In the primary bedroom is a magnificent floral bedspread and matching curtains in Roses & Pansies (favored by Mark Hampton) by Colefax and Fowler in London. (See? I know the lingo now.) In our son Georgie's light-blue bedroom are the Mark Hampton blue-and-white striped curtains that had been in my younger brothers' bedrooms in Locust Valley, Brussels, and London, along with the same six framed pictures of Beatrix Potter characters.

To furnish the place, Mom used items that had been in her storage units for years. The living room is darker than the other spaces: charcoal sofas and coffee ta-ble, fur blanket, a huge black-and-white photograph of an Italian street scene and a smaller, striking one Mom took of the Arc de Triomphe on a rainy day, and the same two large mirrors Tom Britt found forty years ago to make the living room on East Sixty-third Street look bigger. Hilly and I had them on West Seventy-fourth Street, when we began dating, and they came with us to Roosevelt Island and Park Slope.

Mom turned a studio apartment on a lower floor into a civilized man cave, with a big TV, an Eames chair, a pull-out sofa bed, Bruce Weber photos of boxers, a 1910 painting by John Falter that my grandmother had owned, and a dot ma-trix photograph of Mom and me taken at Windows on the World in 1978.

I love this apartment and sometimes find it hard to leave. It's so cozy and elegant. I've also turned into a neat freak, always tidying up, fluffing the pillows, adjusting frames, making everything sym-metrical and just so—house-proud just like Mom! I realize she is happy to know that in my fifties I've finally learned the importance of correct laundry habits so that my towels remain fluffy and fresh.

George Gurley with interior designer Tom Britt, a longtime family friend and tastemaker.

George Gurley

ACKNOWLEDGMENTS

About ten years ago, my stepdaughter Alexis Bryan Morgan was spending a lot of time in the library at Condé Nast, looking for inspiration for fashion shoots at *Vanity Fair*, where she was the executive fashion editor. One day she came across photographs of Floralyn, my one-time home in Locust Valley, and got the idea to put together a portfolio of images as a present for family members. She came to my Manhattan apartment, intending to photocopy a stack of magazine articles gathering dust on a bookshelf and documenting the places my children and I had lived in over the years. And that's how *Great Inspiration* got started.

It never occurred to me to put together a book about my houses and apartments. But when I mentioned Alexis's project to my close friend Julie Britt, a pioneering fashion stylist, she suggested that a book might be a perfect project. Next thing I knew, she had put me in touch with Mitchell Owens, a prolific design writer and the author of *Fabulous! The Dazzling Interiors of Tom Britt*, a Rizzoli publication that was a salute to the work of Julie's former husband—who had also decorated a few places for me. Mitchell was enthusiastic about the idea, and so was Philip Reeser, a senior editor at Rizzoli. Both Philip and Mitchell have been patient, helpful, and lots of fun to work with. I so appreciate their kindness and input. Around the same time, Senga Mortimer, an interiors stylist who had left an impressive mark on *House & Garden*, *House Beautiful*, and other publications, called to say that she thought I should consider writing a book, too, given her memories of the projects that she had helped put into print.

Not only did Senga lend her support, she connected me with David Murphy, who worked at The Clark Art Institute in Massachusetts. He joined a growing team of talents that would result in the creation of this book: resourcing photographs, organizing new shoots, and becoming a great friend. I also couldn't have done this book without the insights and enthusiasm of Rizzoli's eminent publisher Charles Miers, skilled book designer Marlos Campos, and eagle-eyed copy editor Victoria Brown.

My entire family deserves many thanks, as well, for their encouragement, remembrances, and patience in revisiting the rooms that have been backdrops in their lives. I am hugely grateful to my sons George Gurley and Austin and Jack Bryan, and my daughters-in-law Hilary, Kristina, and Emily. My stepdaughter Jessica Mezzacappa, who co-owns the Paris apartment with me, kindly allowed reproductions of that property.

Annette Tapert, Carolyne Roehm, and Alex Hitz, all veteran authors, gave me great advice as the project developed. Julie Britt, Susan Gutfreund, and the late Millie Paxton did just as much for me in terms of decorating, in the past as in the present. And to Roberto Peregalli and Laura Sartori Rimini, I thank them for a foreword that expresses our work together on the Paris apartment.

A scrapbook about decorating as much as it is a memoir of where I've lived and how I've lived there, this book is a visual journey. I hope that it offers inspiration and ideas, and that it will prove that creating interiors for you and your family is a lifelong journey, not just a destination.

Katherine Bryan

THE FOLLOWING PEOPLE ARE AMONG THE MANY WHO HAVE INSPIRED ME:
ROW 1 Millie Paxton, David Murphy, John Byram, Philip Reeser, and Anne Bass and David Netto. ROW 2 Susan Gutfreund, Shelby Bryan and Alexis Bryan Morgan, Ashley Bryan, Christina Girard, and Hilary Gurley. ROW 3 Jane Byram, Austin Bryan with Johnny and Haven, Damon Mezzacappa, Emily and Jack Bryan, and Eileen Araskog. ROW 4 Carolyne Roehm, Annette Tapert, Loic and Rebecca de Kertanguy, Senga Mortimer, and George Gurley with Georgie. ROW 5 Mitchell Owens, Suzette Cruz (above), Catharine Warren (below), Julie Britt, Kristina Bryan with Johnny and Haven, and Alex Hitz.

IMAGE CREDITS

Pages 2 and 3: Francesco Lagnese
Page 5: Annie Schlechter
Pages 32–33: Courtesy of Colefax and Fowler

INTRODUCTION
Pages 9 and 23: Annie Schlechter
Page 10: Langdon Clay
Pages 12, 14, 16, 17, 18, 19, 21, 22, 24, and 28: Collection of Katherine Bryan
Page 13: Russell MacMasters
Page 15: Robert Phillips
Page 20: Jaime Ardiles-Arce / *Architectural Digest* © Condé Nast
Page 25: Durston Saylor / *Architectural Digest* © Condé Nast
Page 26: Horst / *Architectural Digest* © Condé Nast
Page 27: Mark Hampton
Page 29: Brantley Photography
Page 30: Pascal Chevallier
Page 31: Courtesy of Studio Peregalli Sartori

FEEKS LANE
A selection of photographs by Jaime Ardiles-Arce was originally published in "Observing Traditions" in the February 1991 issue of *Architectural Digest*.

A selection of photographs by Langdon Clay was originally published in "The Flowering of Locust Valley" in the July 1992 issue of *House & Garden*.

Pages 34, 37, 39, 40–41, 42, 43, 44–45, 46–47, 48–49, 50, 51, and 52–53: Jaime Ardiles-Arce / *Architectural Digest* © Condé Nast
Pages 36, 54–55, 56, 57, and 58–59: Langdon Clay
Page 38: Courtesy of Fortuny Inc.

EAST SEVENTY-FIRST STREET
A selection of photographs by John M. Hall was originally published in "As Time Goes By" in the October 1, 1989, issue of the *New York Times Magazine*.

Page 60: Marlos Campos
Page 62: Courtesy of Colefax and Fowler
Pages 63, 65, 66, 67, 68–69, 70, 71, 72, 73, 74, and 75: John M. Hall Photographs, MC 00685, Special Collections Research Center, North Carolina State University Libraries, Raleigh, NC
Page 64: Collection of Katherine Bryan

LILY POND LANE
A selection of photographs by Oberto Gili was originally published in "North by Northeast" in the April 2002 issue of *House Beautiful*.

Pages 76, 78, 80, 81, 82, 83, 84–85, 86, 87, 88, and 89: Oberto Gili
Page 79: Courtesy of Le Manach

EAST NINETY-SIXTH STREET
A selection of photographs by Durston Saylor was originally published in "The Decoration of Townhouses: Renovating a Manhattan Townhouse by Ogden Codman, Jr." in the October 1997 issue of *Architectural Digest*.

Pages 90, 94, 95, 96–97, 98, 99, 100, 101, and 102–103: Durston Saylor / *Architectural Digest* © Condé Nast
Page 92: Collection of Katherine Bryan
Page 93: Mark Hampton

EAST SEVENTY-FIRST STREET
A selection of photographs by Eric Boman was originally published in "Katherine Rules" in the February 2001 issue of *House Beautiful*.

Pages 104, 109, 110–111, 112, 113, 114–115, 116–117, 118, 119, and 120–121: Eric Boman Archive
Page 106: IKEA
Page 107: Derry Moore
Page 108: Francesco Lagnese

BAITING HOLLOW ROAD
Pages 122, 124, 126, 127, 128–129, 130, 131, 132–133, 134–135, 136, 137, 138–139, 140, 141, 142, 143, 144–145, 146, 147, and 148–149: Annie Schlechter
Page 125: Samuel Robins

SOUTH OCEAN BOULEVARD
Pages 150, 152, 155, 156–157, 158–159, 160–161, 162–163, 164–165, 166–167, 168–169 170, 171, and 172–173: Andy Frame
Page 153: Courtesy of Braquenié
Page 154: Collection of Katherine Bryan
Page 159: Howard Hodgkin © 2024 Artists Rights Society (ARS), New York / DACS, London
Page 162: © 2024 The Lucian Freud Archive. All Rights Reserved / Bridgeman Images

PARK AVENUE
Pages 174, 179, 180–181, 182–183, 184–185, 186, 187, 188, 189, 190–191, 192, 193, and 194–195: Francesco Lagnese
Page 176: Tom McWilliam
Page 177: Courtesy of Le Manach
Page 178: Horst / *Architectural Digest* © Condé Nast

PHIPPS PLAZA
Pages 196, 198, 201, 206–207, and 210–211: Danny Petroni
Page 199: Francis Hammond
Pages 200, 202–203, 204–205, and 208–209: Andy Frame

RUE DE BELLECHASSE
A selection of photographs by Pascal Chevallier was originally published in "Open to Interpretation" in the June 2017 issue of *Elle Decor*.

Pages 212, 216, 217, 218, 219, 220–221, 222, 223, 224, 225, 226–227, 228, 229, and 230–231: Pascal Chevallier
Pages 214 and 215: Courtesy of Studio Peregalli Sartori

AFTERWORD
Pages 233 and 235: Collection of Katherine Bryan

ACKNOWLEDGMENTS
Page 236: Collection of Katherine Bryan

IMAGE CREDITS
Page 239: Francesco Lagnese

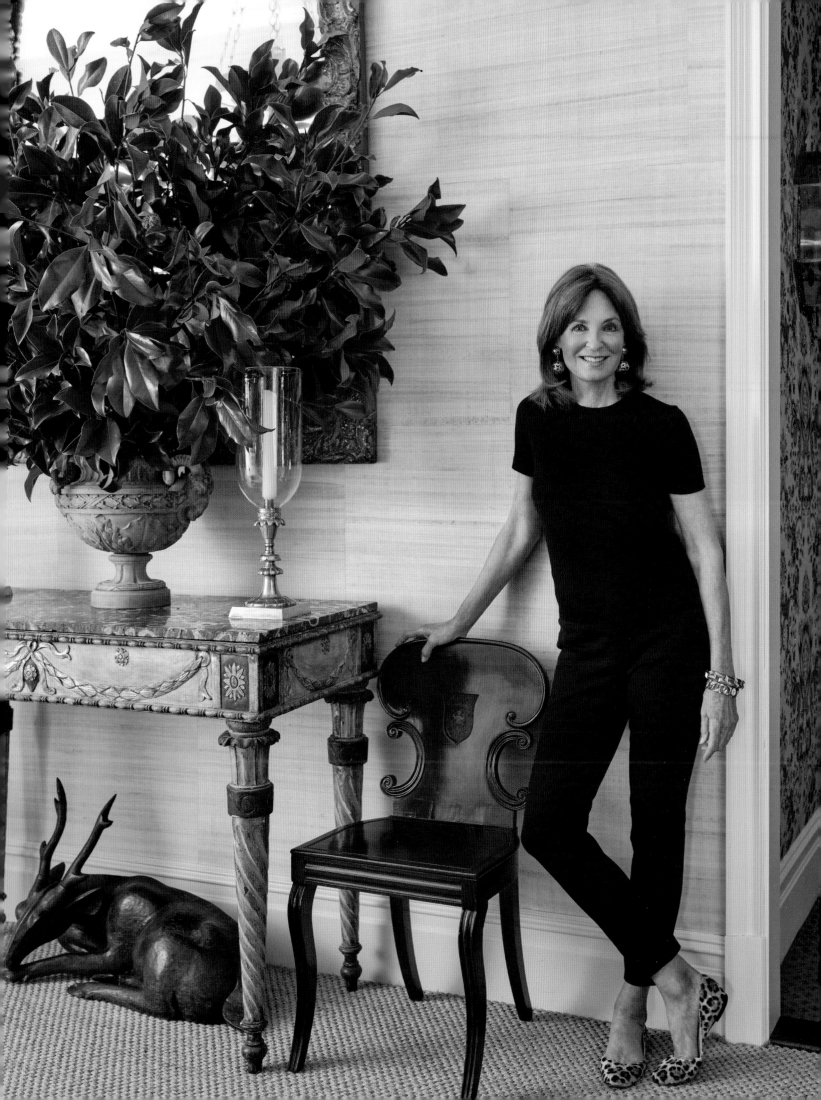

First published in the United States of America in 2024 by
Rizzoli International Publications, Inc.
300 Park Avenue South
New York, New York 10010
rizzoliusa.com

Publisher: Charles Miers
Senior Editor: Philip Reeser
Production Manager: Kaija Markoe
Photography Editor: David Murphy
Copy Editor: Victoria Brown
Proofreader: Sarah Stump
Managing Editor: Lynn Scrabis

Designer: Marlos Campos

ISBN: 978-0-8478-3641-3
Library of Congress Control Number: 2024931790

2024 2025 2026 2027 / 10 9 8 7 6 5 4 3 2 1

Printed in China

MIX
Paper | Supporting
responsible forestry
FSC® C104723

*PAGE 2 A gilt-bronze clock, surmounted by a representation of a fountain, stands on the
Park Avenue living room mantel.*

*PAGE 3 A portrait medallion of Louis XV of France has followed me to many residences
(see pages 112 and 181).*

PAGE 5 The Dutch door of the house on Baiting Hollow Road in East Hampton, New York.

PRECEDING PAGE Standing in the entrance hall of the Park Avenue apartment.